# Create
# Your Art
# Career

# Create
# Your Art
# Career

PRACTICAL TOOLS, VISUALIZATIONS, AND
SELF-ASSESSMENT EXERCISES FOR EMPOWERMENT
AND SUCCESS

## RHONDA SCHALLER

**ALLWORTH PRESS**
NEW YORK

Allworth Press books may be purchased in bulk at special discounts for sales promotion, corporate gifts, fund-raising, or educational purposes. Special editions can also be created to specifications. For details, contact the Special Sales Department, Allworth Press, 307 West 36th Street, 11th Floor, New York, NY 10018 or info@skyhorsepublishing.com.

15 14 13 12 11          5 4 3 2 1

Published by Allworth Press, an imprint of Skyhorse Publishing, Inc.
307 West 36th Street, 11th Floor, New York, NY 10018.

Allworth Press® is a registered trademark of Skyhorse Publishing, Inc.®, a Delaware corporation.

www.allworth.com

Cover design by Adam Bozarth

Library of Congress Cataloging-in-Publication Data

Schaller, Rhonda.
 Create your art career : practical tools, visualizations, and self-assessment exercises for empowerment and success / Rhonda Schaller.
    pages cm
 Includes bibliographical references and index.
 ISBN 978-1-58115-929-5 (alk. paper)
 1. Art--Vocational guidance. I. Title.
 N8350.S27 2013
 702.3--dc23
                                    2013000240

Printed in the United States of America

In loving

memory of

Emanuel Schaller,

1930–2012

# Contents

# PART I

## Who Are You?

*"What lies behind us and what lies before us are tiny matters compared to what lies within us."*

—Oliver Wendell Holmes

# ❦ 1 ❧

## *The Tools to Build Your Success*

*"A man's life is what his thoughts make of it."*
—Marcus Aurelius

Information is power. Knowing what you want and understanding the marketplace and what it needs is powerful. What are the directions available to you as you pursue your creativity in the workplace? Which will you choose and why? There are many tools and techniques to put into play to create a successful career. You have to know what you want and what success means to you. The tools in this book will guide you to this discovery and, from that place of knowing, will empower your creativity and lead you to create a career plan to build your success.

Throughout your career you will be called upon to reassess and change direction. It is never too early or too late and you are never too young or too old to adapt, become more knowledgeable, and refine what you want and what you do. You will clarify, reenergize and flesh out new directions and new ideas. This book will help you do that.

You'll start by discovering what a successful career means to you and what it might look like. Then, you will make a deal with yourself and with reality, choose a direction, and take action. Like a jigsaw puzzle, you'll piece together what you want to do and what is on trend, then prioritize and focus your goals. In today's world, how do you focus your goals to be a successful artist, to be creative? How do you start? You start with cultivating a heartfelt approach. You start with yourself.

## GET IN TOUCH

Get in touch with your passion and feelings for your work and let that encourage you and lead you forward. Then, allow your knowledge of the field, your flexibility, and your ability to change course and adapt be your guides along the way.

To be successful, you need to learn to build a bridge between your creative mind and your business mind. It is a matter of cultivating the ability to think and plan for yourself, and then expanding your reach to the community at large through your creative experimentation. As you hone your instincts, you learn practical business approaches, while staying in touch with what you want to share and with whom you want to share it.

You need dedication, you need to know yourself really well, and you need to learn about business. Start by nurturing your creativity and your inventiveness, exploring and developing a strong sense of identity, and creating a clear direction of purpose and meaning. Create a life plan. Create a business plan. Visualize and meditate. Keep a journal. Draw things out. Find the direction you want to go, and make a plan that you are willing to follow to take you there. That's what you will learn to do from reading and doing the exercises in this book. And through the tools and techniques we will explore together, you will find the courage to dream big and empower yourself so that you can realize your potential in the world.

## CREATIVE MIND AND BUSINESS MIND

I have counseled and coached professionals and students from all areas of the visual arts; fine art and design, print and motion, photography, film, and 3D, and I've witnessed the entrepreneurial spirit in every creative. Incorporating the tools I've developed and used myself for over thirty years, I've designed this book to help the beginner artist learn the basic business principles of setting up an art career, as well as those who wish to relaunch a reinvented career. I discuss how to define and write your business and life plan so it speaks to your meditations and visualizations and creates a pathway to bringing your dreams into the world. As you develop your dreams and plans, you will want to share them with the world, which requires a marketing plan and a social media plan, as well as knowing who your audience is or could be.

Heavy stuff. Needful stuff. Business stuff. Cultivating your business mind can grow directly out of your creative mind. To deepen your creativity and maintain a public role, we will visualize it together. To apply what you visualize and to build your business and career, we will make a ton of lists and use exploration exercises to ponder and prioritize. Opening up to your business mind is a learned skill, and making it real in the world will be the end result of the process. Creative mind and business mind together will become possible, through a series of steps, one step at a time.

HOW IT WORKS

This is a hands-on book filled with exercises and guided meditations you can easily learn and practice. Come back to them over time as your career changes and the needs of your creative expression develop and change. These techniques never go out of style or become dated. They apply to every medium and style and to all business models, including making art and exhibiting, commissions, earning extra money on the side, being a creative staff member or a freelancer, and running your own studio with a staff of your own. You will see that these techniques and tools will allow you to become fluid when you feel stiff, fluent when you feel blocked, and nimble when you feel stuck.

Let's start with a few definitions. According to the Merriam-Webster online dictionary,[1] a *tool* is an instrument, the means to accomplish an end. The *technique* is the method, the skillful and proficient use of that tool. When we know the techniques and tools at our disposal, when we know what to do and how to do it, we feel confident and we feel empowered. To begin the process of creating the life and career you want, you already have the most important tool you need: yourself.

You must have a willingness to look at yourself and at what matters to you. Being your own authority, and skillfully applying what you learn, starts with self-awareness. You cannot reach a destination until you know where you are headed and why. And you don't get there without a plan and a strategy.

But you start with a vision. Then you make a commitment. And you remember to breathe deeply.

TOOLS AND TECHNIQUES

There are three sets of tools and techniques we will be using in this book, and each comes with a set of exercises to practice. Let's take a quick look at each one.

VISIONING, VISUALIZATION, AND GUIDED MEDITATION

Richard Webster tells us in his book *Creative Visualization for Beginners* that visioning, sometimes called creative visualization, is the ability to see, imagine, and create images in your mind in response to a question or suggested idea. It is an excellent process when you are in need of inspiration, and I have personally used it for over thirty years. It is the process of making an idea visual.

Have you noticed that you sometimes think in images? Perhaps as you read a story, an image or series of images comes to mind, making the landscape, the characters, and the plot come to life. While talking to a friend, images usually float through our minds as we listen. If we think of a chair, a picture of a chair spontaneously forms in our minds. Using visualization purposefully, however, can transform these automatic mental images and can even change our habitual patterns of thinking. We can use visualization to move from negative ideas to positive ideas.[2]

Through focusing on positive imagery, we can redefine our expectations and fuel the changes we hope to create in our lives.

In each chapter, rather than thinking something through, I will ask you to allow your thoughts to become pictures and imagine them through to a happy resolution. Allow your intuitive processes to present information and ideas to help you understand and resolve the challenges you face.

Visualization used in career management can help you sidestep your judgment sensors—all those conditioned responses and expectations you've swallowed from society or family and friends—and get in touch with the real you. Getting in touch with what matters to you from deep within and allowing new images to form will help you move towards your goals. The mind moves towards what it imagines.

This art of creating pictures in the mind to teach you, guide you, and empower you provides a grounded and confident basis for self-understanding. It can be used as a guidepost to set milestones for your career and life management. You can call it a form of career mysticism.

## CAREER MYSTICISM

Career mysticism means putting relaxation, meditation, and creative visualization together for career clarity. The application of career mysticism will help you achieve a successful balance in your life. By meditating on an idea and visualizing the future as the present, you can uncover your right livelihood. Visualization is a process that creates focus and will, at times, surprise you. The images you contemplate can help you change direction or even attract what you most need for a meaningful and fulfilling career path. It helps you create confidence in the direction you have chosen because you have seen it first with your mind's eye. This reinforces your resolve to move forward and be yourself. Think of it as your internal GPS.

We will access many types of pictures and career goals through guided and creative meditations, relaxation exercises, and guided meditation journeys throughout this book. Often your response to the images and ideas will change through repetition. Like a jigsaw puzzle, you will need to piece it all together, then prioritize and focus on your goals.

Everyone can learn to visualize. The more you practice, the better you will get. Every time you daydream and pictures appear in your mind, you are visualizing. The next time you think about something, notice what happens; you probably create an image in your mind. You are visualizing. Those images represent your thoughts and feelings, which, in turn, determine the decisions you make, the choices you implement, and the actions you take.

Visualizing also helps you to relax and let go of stress. All of our visualizations will start with bringing our awareness to the breath, to watching the breath go in

and out; inhale and exhale. This is very relaxing and it is called mindful breathing meditation. It is the first step to visualizing.

## GUIDED VISUALIZATION AND MINDFUL BREATHING

Let's try a visioning exercise that introduces you to creative visualization and mindful breathing. You will learn mindful breathing first and then do a simple visualization where you will see yourself in a beautiful landscape, calm and happy and relaxed. I will guide you through it, and afterwards we will look at your career from that relaxed place. The only ground rule for visualizing is that the images you create are positive and happy. If you find negative images rising instead, stay with the mindful breathing to relax and let go of stress. Then try again.

To learn more about mindful breathing meditation, I highly recommend viewing the mindful breathing video offered on the stress management section of the Mayo Clinic website.[3]

## SET THE STAGE

Ideally, you should choose a quiet, calm environment with as few distractions as possible. A quiet environment contributes to the effectiveness of the mind letting go and the body relaxing. Starting out in a calm environment signals the mind and body that it is time to release tensions and allow insights to blossom. Your rational mind will enjoy this; it will give your thinking processes permission to shift into a different gear by setting the stage.

When you set the stage to relax, it is easier to shift your expectations.

Many traditions teach the practice of mindfulness and observing the breath, so you may already be familiar with this. In our first guided visualization we are going to learn how to focus on the breath. All you need to do is simply focus on the breath, feel it as it enters and leaves the body. If your attention wanders, it is OK. It probably will. Gently bring your focus back to your breath each time it wanders away.

To start with, close your eyes and focus your attention on the normal rhythm of the breath. Don't worry about whether you are doing it right or wrong. Just let it happen. By learning to focus on your breath, you will develop a calm, centered, and balanced perspective on your career and your life. This is the first step in meditation and visualization; learning to concentrate. Learning to let go and breathe.

You can train your mind to concentrate on generating positive energy, positive ideas, and positive feelings towards your ability to create the career you want. When you shift your perceptions and change how you think, you transform your life.

The most important element for you to learn and practice right now is developing a "witness" attitude, watching everything happen as it happens without

7

judgment. Distracting thoughts will occur. Don't worry about them. When they do, just return your attention to the breath.

For beginners, the key is to try. Open your mind and expectations to allow your feelings to be present, and try to see what you are imagining. Be open to whatever images your visualization process creates. Your images do not need to be elaborate or detailed at first. Eventually you will learn to clearly see, feel, or sense what comes up. Just starting out, it might be blurry or unclear or you might even fall asleep! Just be in the moment, be in the process, and see what happens.

## GETTING READY

Once you have a calm quiet room and have spent a few moments focusing on your breath, you are ready. I will refer to this process as *getting ready* before you start each visualization. That will be your cue to shut off your cell phone, sit, and focus on quieting your mind with your breath.

## HOW TO DO THE VISUALIZATIONS

You can do them with your eyes open or with your eyes closed. You can read the visualizations very slowly to yourself, imagining as you read, or you can alternate between imagining, reading, and imagining again. You can have a friend read them to you, or record them yourself on your iPad, iPhone, or computer so you can listen to your own voice guiding you.

After each visualization, write down what you experienced so you can track your discoveries and insights, as well as your process and ideas, for later steps. This will help you to make sense out of the directions you envision, and help you to prioritize the actions to take.

## LET'S START

This is a simple breathing and relaxation exercise and a start to creative visualization. This is a wonderful way to start or end your day, relaxed and open. It is also an excellent first step in career planning—to start your planning process from a relaxed and open space.

Get ready, and then begin.

---

## VISUALIZATION—MINDFUL BREATHING IN A BEAUTIFUL LANDSCAPE

*Get comfortable in your chair; loosen any tight or uncomfortable clothing. Take a few deep breaths, let them out. Let your arms rest loosely at your sides or in your lap. Don't worry if you are doing it right or not, just let it happen.*

*Remember you are developing a "witness" attitude. Just let it happen as it happens. Watch it all happen, without judgment, without worry. And bring your attention to your breath. Watch your breath as you inhale through your nose. Watch your breath as you exhale through your nose. Let yourself take a few deep breaths in, and, as you do so, allow your eyes to close a little bit, so you are only focusing on your breath. Inhale, notice your stomach rising. Exhale, notice your stomach falling. Rising, falling, rising, falling, with each breath in and each breath out. Slowly. Comfortably.*

*Feel a pleasant wave of relaxation drifting into every part of your body. It's pleasant and comfortable for you to simply relax. Just let the strains and tensions of the day fall away as you breathe. Take another deep breath, and, as you exhale, let another wave of relaxation wash over you. Enjoy this pleasant feeling of calm and relaxation. Feel and imagine that you are releasing worries, deadlines, tension from your toes up to the top of your head. Just let go and forget about your body.*

*And now imagine. Form a picture of yourself in a natural setting, perhaps on a hilltop or mountain top, or in the most beautiful landscape you've ever seen or experienced. Feel the earth, grass, or stones beneath your feet. Smell the fragrant air. There are flowers everywhere, and, as you look around, you see the most gorgeous view. Imagine it, create this picture. Spacious and beautiful.*

*Feel the beauty that is all around you and listen to the quiet sounds of nature. Notice the sounds of water or birds soothing you, lulling you, relaxing you even more. Feel the serenity of being part of the beauty that surrounds you and the peace that lives within you.*

*Gently take a few deep breaths, in and out, and then pause for a moment. As you resume breathing normally again, remember that you can return to this place at any time. This peace and calm that you feel is here whenever you need it. Your breath will bring you back. Feel the rightness of this process as it flows within you.*

*And when you are ready, at the count of three, you can open your eyes. One, two, and three.*

Excellent. You just did your first mindful breathing and creative visualization. Focusing on the breath and seeing yourself in a peaceful environment will help you relax and begin your career planning from a calm mind, free of stress or anxiety.

Now holding onto this feeling of relaxation, let's focus in on your art career.

## VISUALIZATION—ARE YOU READY TO CREATE YOUR ART CAREER?

*Take a few deep breaths, in and out, slowly, feeling your breath, bringing your awareness, the focus of your mind, to the inhale and exhale. Just let your mind rest on your breath and observe your breath as it comes into the body. Observe the breath as you exhale, as it leaves the body.*

On the next breath, allow yourself to find a very comfortable count as you breathe in and out. Inhale to a count of four or six, and exhale to that same count, either four or six. And just follow your breath as you count for three more breaths. Then let your breath return to normal.

Breathing naturally, start to imagine. Form a picture in your mind's eye of yourself waking up in the morning. Imagine you are happy. You are joyful, content. See yourself sitting up in bed and stretching and getting ready to get out of bed. And as you take a deep breath, feel contentment spread throughout your mind and body. You are looking forward to starting your day. Everything is as it should be, everything is right just the way it is.

See yourself getting out of bed, showering, and getting dressed. Move through your home, make breakfast, all is well. See this all unfolding in your mind's eye as if you are watching a movie.

Now see yourself going to your studio or out into the field to shoot pictures or to a job you love, simply ready to create; you are loving your designs, your photos, your work, loving your images, loving what you do. You are a maker. A creator of artwork, or services, or products that you love.

See your entire day, your ideal day, doing your ideal work, unfolding from start to finish. Imagine it in detail from the moment you leave your home to get on the subway or the path or the bus or your car or your bike—imagine your entire creative day from start to finish.

See every image you shoot. See every person you speak to. See every print you make, drawing you make, website you create. At the end of your day, you feel satisfied, invigorated, fulfilled. You are content. Your work has meaning. You feel a spaciousness within you and a sense of purpose around you. You feel alive.

You are living the career that you have always wanted. Imagine this is true. You help people in ways that you have always wanted. You are a force of creative light, creative imagery, and creative purpose in the world. Imagine yourself on the right career path, with a clear sense of direction. All is as it should be. Success is on your terms. Your creativity flows and is bountiful and appreciated.

Imagine you are successful, productive, and creative. Imagine that your confidence grows with every breath in and every breath out. You believe in your right to be successful. You believe in your right to be productive. You are ready to create, define, and reinvigorate your art career. Image this amazing feeling of knowing who you are and what you want.

And at the count of three, you can open your eyes. One, two, and three.

---

Take a deep breath. Stretch. Smile. Congratulations, you just did a creative visualization and meditation for career success.

JOURNAL NOTE:
*Take a moment to write down how it felt or anything you saw, heard, or discovered.*

Our goal throughout this book is to utilize creative techniques to give you the tools to create a new vision of what is possible and then take the steps to make it happen. There is no wrong way to do these exercises. You are opening up your intuition, your "inner eye," to allow yourself to dream on paper. That's what brainstorming is all about. One of my favorite quotes from *The 7 Habits of Highly Effective People* by Stephen R. Covey is "Goals are simply dreams with deadlines."[4] Creative visualization is a process to identify and experience your dreams so you can translate them into goals.

## GOAL SETTING, SELF-ASSESSMENTS, AND SELF-EXPLORATION

The next set of tools and techniques are paper and pencil exercises designed to help you uncover what really matters to you—your interests, passions, and values—and how they impact your career planning. These are the traditional building blocks of all career management systems. You will learn how to apply your answers from these exercises to update your creative and business goals. You will also learn how to schedule your next steps.

Your visualizations will help you determine what you are trying to accomplish and will give you a sense of why it matters to you. The self-assessment and exploration exercises will add a deeper understanding to the "why factor" and give you the focus to set priorities. Translating dreams into goals allows you to create a series of doable bite-sized steps.

We will have step-by-step exercises in each chapter to take you through this process from the start to the end, finishing with more steps to take. You can have a dream and imagine great things for yourself, but you also have to have a system to put it into action. My system works great for me—visualize, plan, and then do it. Start with an understanding of what matters to you and why it matters to you, then sketch out how you will accomplish it and when, so you can put it into action steps.

You need to actualize your creative potential to feel fulfilled. You need goals, self-determined deadlines, and a system to rely on in order to gain the momentum to do it.

Here is a simple self-assessment exercise to get you started. Get in touch with yourself, and revisit your creativity from a childhood point of view. Then set two simple goals to launch your creativity out into the world now. This one little step can revive your creative spirit.

## EXERCISE—WHAT DO I WANT TO BE WHEN I GROW UP?

*What did I always want to be when I was a child?*
*Why?*
*Find the threads in that childhood dream. See how it relates to your current creative career idea. Write it down.*

*Now set two simples goals for yourself to accomplish this month.*

*My First Goal:*
*I will:*
*When I will do it:*

*My Second Goal:*
*I will:*
*When I will do it:*

MIND MAPPING, VISION BOARDS, AND JOURNALING

I love mind maps for brainstorming options and outlining potential roads and paths to take. Originally developed by Tony Buzan,[5] mapping out your ideas and plans using words or creating vision boards with pictures, shapes, and colors is both fun and incredibly effective. For me, I find this process works much better than spreadsheets, flowcharts, and tables. I see things better as they flow out of my brain in different directions, rather than in one direction, as in a flowchart.

You can mind map by hand or use software. There are many products out there. I use MindNode, developed by Marcus Muller, of the software company Ideas on Canvas. There is both a freeware version and a pro version with added features that I use at home and in my classes. It is a way of thinking visually that, according to their website, allows you to "collect, classify, and structure ideas. You can organize, study, and solve problems."[6] I love it.

Mind maps can be used for many different tasks. I put an idea in the center and then branch out with individual components that I will need to consider to make it happen. I separate them so I can create action steps and prioritize my focus on different branches. I'm a natural multitasker and work on lots of projects at once, so mind mapping helps keep me organized and energized.

We are going to mind map for creative marketing strategies and developing our creative career ideas. See the example on the following page.

# My Inspiring Creative Idea

**Key Moves to Take:** What can I do today to get started?

**Audience:** Who will I sell to?

**Goals:** What do I want to accomplish?

**Marketing:** How will I get the word out there?

**Products:** What will I sell?

If you can't or don't want to use the MindNode program, just grab some colored markers, colored pencils, or a simple pen and paper.

Let's try one together.

## EXERCISE—MIND MAP PRACTICE

*Start by drawing a circle and fill in the center with an idea. Let's imagine that your creative career idea is to open an Etsy shop. So you place "Open an Etsy Shop" in the center. Then draw a series of branches from that central idea to represent things to think about. Let it grow organically.*

See figure on page 15.

Start with something that inspires you; either a career direction or a project you want to bring to market.

In the above example, we named each branch off the main idea: Products, Audience, Marketing, Goals, and Key Moves. Ask yourself: What will I sell? Who will I sell to? How will I get my products and myself known? How many items do I want to sell this week, this year? What are the key moves I can take to get started? Then just let your ideas flow, write stuff down, fill in the circles or boxes, draw another arm, let the ideas flow into another branch, draw another circle or box, etc. No worries.

When we are mind mapping, we allow ourselves to jot down a list of our streamed ideas, by categories, as they occur to us. And since it is a visual system, we watch the ideas flow, branching out into more branches that then can flower at the right time. The trick to it is that there is no censoring allowed. Just ask yourself a few questions and allow yourself to think on paper and let a plan form organically. You will edit it later.

The best marketing plans I've seen have grown out of this process. You are creative. Mind mapping will transform that creativity into a planning process that you will enjoy. And more than just enjoy; learning how to creatively market your ideas and products will be an essential part of taking control of your career and your life. You will be taking the first steps towards building a sustainable career, all of which we will cover in great detail in later chapters.

Whether you are planning to attend a series of artist residencies to deepen your work flow and need to think about where to apply, what projects to work on while you are there, what contacts to make in the location, and how to market

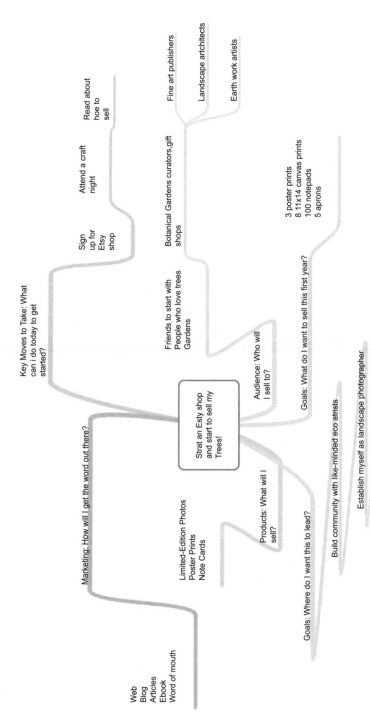

Strat an Esty shop and start to sell my Trees!

Key Moves to Take: What can i do today to get started?
- Sign up for Etsy shop
- Attend a craft night
- Read about hoe to sell

Marketing: How will I get the word out there?
- Web
- Blog
- Articles
- Ebook
- Word of mouth

Audience: Who will I sell to?
- Friends to start with
- People who love trees
- Gardens
- Botanical Gardens curators,gift shops
- Fine art publishers
- Landscape artchitects
- Earth work artists

Products: What will I sell?
- Limited-Edition Photos
- Poster Prints
- Note Cards

Goals: What do I want to sell this first year?
- 3 poster prints
- 8 11x14 canvas prints
- 100 notepads
- 5 aprons

Goals: Where do I want this to lead?
- Build community with like-minded eco atrists
- Establish myself as landscape photographer
- Creat a new source of income

your work when you are done, or are thinking about opening up a shop online, this process of mind mapping will be a huge help.

## JOURNALING

Journaling is another way to collect information that can be applied in your life and career plan. My favorite definition of journaling comes from *The Artist's Way*, where Julia Cameron calls journaling "morning pages" and suggests that journaling will set you free of what blocks your creativity and will help you to get to the other side.[7] I agree and have been journaling since I was seventeen years old. Journaling is the process of writing down how you feel and what you have experienced, so you can get the emotional clutter out of the way and allow yourself to reflect and create open spaces within you to move your career forward.

Creating a life and career plan starts with asking ourselves questions. Are we ready to succeed? What should I sell and to whom? How do I get into a gallery? How will I make a living with my creativity? Can I freelance and not lose my momentum? These are important questions. What drives you to be successful? What will enable your dreams to become goals? This is where journaling can help.

Journaling will allow you to brainstorm and understand what drives you to succeed, to sketch out your products and why you want to make what you sell, and to identify the qualities you resonate with in your ideal clients and why you share a belief system, etc.

Journaling provides a record of your discoveries, your thoughts, and tracks your growth while planning your business. In addition to describing your thoughts and feelings in a journal, you will develop insights to better understand what you bring to market and why it is important to you and your audience, and allows you to unfold a creative stream of understanding on how and why you need the right audience.

Let your journal entries emerge in their own way as you record your experiences from the guided visualization exercises. At times you will find yourself writing and uncovering deeper feelings and ideas and spontaneously coming up with new plans to initiate in your business plan. Add those notes to your journal as well. Allow your writing to reveal associations, memories, dreams, and desires that you can actualize in your business planning. You can then add these to your mind maps.

Record whatever strikes you as you answer the questions presented, do the meditations, and elaborate on your visions and planning process. Particularly note

your flashes of insight, any idea, no matter how out of the ordinary it is for you. Anything can be accomplished with planning, grit, and funding.

---

## EXERCISE—JOURNAL ENTRY

*Today's Date_____*
*What does success mean to me?*
*Note how you feel after reading this chapter. What is your state of mind?*
*Expectations? Fears? What was your state of mind before starting this book and how is it changing? Make a note of what you intend to get out of it. Do you have a big creative career idea in mind already?*

---

PACE YOURSELF

Let this book guide you. Do it at your own pace. I recommend that you do the exercises and visualizations in the order presented. But see for yourself. There might be a different logical sequence that works better for you than for me. There might be certain chapters and exercises that truly resonate for you and others you could live without. That's fine. Think for yourself, trust your instincts, and listen to your own drummer. The key is to work with yourself and not against yourself, and find the tools that help you do it best.

Let your creative mind lead you to your business mind. I offer you a visionary process and a practical set of guidelines and action steps to allow you to make the necessary changes within yourself, in your thinking, and in your planning process. This will lead you to create a career and life that is successful, productive, and fulfilling on your own terms.

There are visualizations and exercises throughout each chapter. It is important that you give each one your best shot, depending where you are on a given day. If you feel the need to redo an exercise, do that. This is your career plan and development process; there is no right or wrong turn here, unless you blow the whole thing off. And then, where would you be? Just where you are. If you like where you are, stop here.

If you would like to create something new, make a change for the better, and evolve your vision and your presence in the world, then you will love this book.

So starting from today—suspend judgment by promising yourself that you will not judge anything that happens today. Promise that you will not judge anything that comes into your awareness from doing these exercises—today, tomorrow, next year.

## YOU ARE ALL YOU NEED TO BE SUCCESSFUL

My goal is to inspire you, motivate you, and teach you some tried and true steps to create an art career and keep it going. Take the first step. Connect with yourself and use the tools in this book to build your success and guide your planning process. You will reinspire yourself. This will lead you to a more meaningful career and a feeling of self-empowerment, which will spread into every area of your life.

# ❧2❧

## *Your Personal Vision*

*"Art evokes the mystery without which the world would not exist."*
—René Magritte

Allow yourself to delve deeper into the mysteries of what you value and what drives you to create. Look at what motivates you both in your life and in your career, and you will begin to see a thread that runs through your decisions. This thread is your personal vision. With focus, you can bring this vision into the world by making conscious choices. Vision creates focus. Focus deepens your vision. Goals motivate us, but our vision inspires us.

Your vision grows over time and deepens, strengthens, and lays the ground-work for all that you do. It is your internal guide to a meaningful career. You can follow it like a map that shows the path from your most fundamental values to what is meaningful and purposeful for you. It is the most important guidance system you have in your career management. It shows you the way forward, identifies where you are headed, and illustrates why it matters to you. I like to imagine it as a beacon that keeps you moving in the right direction toward future possibilities. Vision is an inspiring and motivating capacity in all of us.

Think about that for a moment. You have the capacity to guide yourself toward wherever you would like to go in your creative process, and create a career accordingly. You can build your career by letting your vision inform each step you take and make conscious career decisions that lead you toward a destination that you have defined.

By forming a vision that will focus you, you can explore your ideas about career success and life fulfillment by combining your capacity to dream and your deter-mination to make it real. Then, let your vision guide you toward your goals. With

your image in mind, you can take the first steps toward your dreams. In this way, your steps make sense to you because you are traveling in a direction paved with practical steps based on your own dreams and values. And that is awesome. Your vision inspires you. Using your skills and talents, you work hard in order to share your creativity with the community and with the world, based on what you value. This gives your vision power. Through understanding your vision, you can lay out those steps to make your art career authentic. Your vision is your authentic voice played in the public realm—the studio, marketplace, gallery, street corner, web, etc.

## PERSONAL VISION IN CAREER MANAGEMENT

Your vision is your creative practice and your role in the world. What role do you want? To connect your vision to the development of a career plan, you need to think about your role. How do you want to use your creativity in the world? A business mind starts with making your creativity a commitment and moving it to the next stage—into the public realm—based on your vision of what you want to do. Doing means taking action. Action based on your dreams. Action based on your vision. Going for it. Not talking about it, not thinking about it, but doing it. Giving it your best shot, with no regrets.

Excellent. Are you with me? Now you can begin to ask yourself some very important questions. The first question to help you express your authentic voice in a vision is one of my favorites. "What would you do if you couldn't fail?" Career coaches have been asking their clients this for years. For good reason, many people assume they will fail and do not let themselves get beyond the compromises they've already adopted.

But if you stop for a moment and, in a safe mental space, ask yourself this mind-blowing question, what happens? Instead of being stuck in "if only…," you move into "what if?" More possibilities to grow. And from these possibilities you can adapt a truer road for yourself. You start to form a vision. This leads to setting goals that matter to you.

Try the following exercise. Take your time to brainstorm answers to the questions below. Don't censor anything; just write, put pen to paper or fingers to keyboard, and let yourself go on autopilot and see what you come up with.

---

### EXERCISE—WHAT IF?

*What would I do if I couldn't fail?*
*What would my life and career look like if I could wiggle my nose like*
*Samantha (remember the TV show Bewitched?) and have anything appear?*
*Why is this important to me?*
*What if . . . (fill in the blank and write for ten minutes without stopping.)*

---

Think about what you wrote for a moment. Don't worry if your ideas are right or wrong, or whether they will work out or are realistic. You will make a deal with reality in the planning process later on, based on your vision of "what if?" There is always an adaptation and interpretation that can be made when you keep your focus on your vision. Right now, you want to use your ideas to form that vision. So, don't give your yearnings or ideas short shrift now.

Starting with a vision requires that you dream of possibilities. It is very similar to making that first mark on a blank canvas. Do you know that feeling? How hard is it sometimes to make that first mark? Very. But as you connect to what you need to say, and the creative impulse jumps through you like an electric shock, you commit. You do it. You commit to that line, to that first dab of color that holds the possibility of infinity. And the joy that follows that connection to infinity is amazing.

Career planning based on your personal vision can be like that. You connect to the infinite possibilities through visioning the role you want in the world and seeing yourself sharing your creativity. If anything were possible, what would it look like for you? You start there. That is your vision taking shape. As you imagine, you start each day with a clear understanding of where you are headed, and your vision evolves. You start to make different choices.

Each choice you make, each decision you make, can lead to following your vision. Imagine if each step you took brought you closer toward that goal you have in mind? When we vision the elements that matter most to us in our lives and careers, and can see ourselves taking those steps, we feel empowered. Confidence grows and momentum is fueled.

The high road becomes a career that has meaning for you. You can create your art career with purpose, meaning, and heart. All successful business people have a vision to lead them. To create a successful business, you clearly define what you want to accomplish. An art career is no different; an art career is a business. Whether it is fine art or design, you understand the products you want to create or the services you want to provide. You figure out who your audience or ideal clients or collectors are or could be. What section and demographic of that audience is your target market? You get organized. But it starts with a vision.

Don't let anyone tell you that an art career is not a business and that planning and vision is not necessary. We do our art students such a disservice when we further that mindset of the elite artist who magically makes it to the top. Talent is not enough. It takes vision, it takes enormous effort and perseverance, and it takes laugher and the ability to dream and adapt.

Now let's vision and focus on what you would do if you couldn't fail through a meditation lens.

## VISUALIZATION—WHAT WOULD YOU DO IF YOU COULDN'T FAIL?

*Get Ready.*

*Bring your attention to the normal rhythm of the breath, simply focusing on your breath in and your breath out, relaxing as you breathe. Don't worry if you are doing it right or not. Just let it happen. You are developing a "witness" attitude. Just watch it all happen as it happens, without judgment. Promise yourself: today I will not judge anything that happens. Enjoy this feeling of sitting, breathing, and enjoying the stillness and a quiet mind. Breathe in and out. When you feel calmness and a sense of quiet, allow yourself to be in this stillness. Enjoy it.*

*You are ready. You write the story of your career. You have the power to create, to recreate, to write your own story. Feel how relaxed you are becoming; you are deepening your sense of self, your sense of relaxation, with each new breath in and out.*

*Ground yourself; feel your feet on the floor, the chair, or sofa that is supporting you as you sit. Open your heart and open your mind. There are endless possibilities available to you. You write your own story.*

*What would you do if you couldn't fail? Image it in your mind's eye, see it happening. See your great ideas coming out into the world. What would you if you couldn't fail? Imagine it. What do you see? Why is it important to you?*

*You are filled with clarity, hope, and confidence. Listen attentively. You hear a voice deep inside you, a wise and confident inner voice, advising you, leading you. What does it tell you? Bubbling up within you and within reach, you see an image of yourself, doing what you have always wanted to do.*

*You have plenty of time. You have the power to imagine wonderful things for yourself, your family, and your community. You can do anything. You can decide. What would you if you couldn't fail? What do you see?*

*What are the elements you need in your life to be successful and happy? See yourself having those elements. What is the career you have always wanted? See yourself living that life, having that career.*

*What leads you to your success? See yourself making the right choices to reach your dreams and goals. See yourself making a difference in your own life. See your life changing. See what you value. See what moves you. See what motivates you to keep going. What would you do if you couldn't fail?*

*And when you are ready, at the count of three, you can open your eyes. One, two, and three.*

JOURNAL NOTE:

*Take a moment to write down how it felt, or anything you saw, heard, or discovered.*

Take a deep breath. Stretch. Smile. Without judgment, allow yourself to sift through your thoughts and your feelings for a moment. Let the memory of this

visualization on what you would do if you couldn't fail be the start of forming your personal vision statement. Did the visualization bring up a different answer than the written self-exploration exercise at the beginning of the chapter? Did the visioning deepen it, change it, confuse it? Let's combine the two exercises now, and create a first draft of your personal vision. Think of this as your initial draft; there will be revisions as we progress through the book. You will have plenty of time to refine it, but let's capture your initial thoughts and feelings on paper.

---

## EXERCISE—MY PERSONAL VISION

*Based on your visualization and earlier exploration exercise, write one to three paragraphs describing what you would do if you couldn't fail? This is your personal vision.*
*Then answer the following:*
*If I followed my dreams, what would happen?*
*Is there anything I am afraid of?*
*If I followed my dreams, what would I have to look forward to?*

---

There are four core principles of any creative career. They are authenticity, value, market, and perseverance. We will explore authenticity and value here in chapter 2. Weaving these principles into your vision statement will ground your vision and lead you to create true goals for yourself.

### BUILD A FOUNDATION ON YOUR AUTHENTICITY

Authenticity is the bedrock of your creativity. What is real for you? How do you express yourself in your work? What is that special impulse within you; that need to communicate your ideas in the way in which you are compelled to express them? That is your authenticity. Not a commercial product, not an idea that you think will sell, but qualities of your own consciousness that take shape and form and say something.

This message within you is then translated by your hand and mind into art and design. It does not matter if you use the written word, typography, paint, photography, video, or crochet dolls. You say something in your voice, and when it is true for you—and you know when that happens—it is authentic. You can feel the creative flow when you are true to your authentic voice.

Each one of us has a unique voice and unique talents. Whether it is blocked or flowing freely is not the issue; it exists always, flowing through you onto the page or onto the screen and then out to the world. To create a viable career and follow your vision, you need to understand what your authentic voice is so you can bring others into your process and ideas. To bring others into your process and ideas,

you need to learn to talk about your work and write about your work. Expressing your vision to others is a learned skill, but by doing so you become a maker and a shaker. It's my intention to guide you to be both.

So, how do you begin to understand your authentic voice and how it applies to your vision and career path? One way is to dive within and explore from a completely different angle. Here is a fun self-exploration exercise that will help you do just that. Let your imagination run wild and see what part of your authentic voice you can hear!

---

## EXERCISE—AUTHENTICITY AND CREATIVE INSIGHT

*If your creativity were an animal, what would it be? If it could talk, what would it say?*

*If your creativity were a flower, what would it be? If it could talk, what would it say?*

*If your creativity were a building, what would it be? If it could talk, what would it say?*

*If you could become your designs, become your art work, what color would you be? If that color could talk, what would it say?*

*If you could become your designs, become your art work, what shape would you be? If that shape could talk, what would it say?*

---

Now let's take a look at your authentic voice through a visioning exercise. You have already used your imagination to begin to see your career path. Now let's use your imagination to literally become your artwork. I do this in the studio very often, and it helps me to clarify my composition and the effectiveness of what I have on the page. I become what I am doing. It is a creative meditation on process that you may enjoy.

Meditative exercises, journaling, answering self-exploration questions, and visualizing scenarios to uncover insights are all part of the creative process. They empower us to move outside of our intellectual perceptions and into spontaneous creativity and intuitive perceptions. In career planning, we combine the two for self-awareness, intellectual perception, and intuitive perception and create a vision-based career plan.

Career breakthroughs and moments of insight come in many forms and through many channels. Let's take a look.

---

## VISUALIZATION—MY AUTHENTIC VOICE

*Get Ready.*

*Bring your attention to the normal rhythm of the breath by simply focusing on your breath in and your breath out. Relaxing as you breathe. Don't worry if you are doing it right or not.*

*Just let it happen. You are developing a "witness" attitude. Just watch it all happen as it happens, without judgment. Promise yourself: today I will not judge anything that happens. Enjoy this feeling of sitting, breathing, and enjoying the stillness and a quiet mind. Breathe in and out. When you feel calmness and a sense of quiet, allow yourself to be in this stillness. Enjoy it.*

*And following your breath, let yourself relax. Releasing worry, releasing deadlines. Just taking this moment in time for yourself to explore your authentic voice. Take a few deep breaths, let them out. And when you are ready, let your breath return to normal.*

*Imagine you are looking at your body of work, at your paintings, photographs, designs, all of your art work, an entire body of work, and allow it to move across your mind like you are watching a movie. On this movie screen, see your work like a slideshow, one image at a time. Take a moment to clearly see your body of work in a series of images as each one moves and changes across the screen.*

*And now visualize how you made this work. On the screen in your mind's eye, watch a movie about your process, about how you made your work—the set, the stage, the studio, the tools you used, all of the props, the lenses, the lighting, the paper, the canvas, the computer. See every move you made in the making of this work.*

*And now, using your imagination, visualize yourself becoming very small and magical—see yourself as an angel, a fairy, a very small being with magical powers, and transform everything that you touch. Have fun with this image.*

*And now see yourself as this tiny magical being, jumping up onto the camera or paintbrush or computer tablet—any tool you use to create your art—and see yourself riding it like a spaceship. Allow this fantasy to unfold in front of you. You ride on each tool, and direct each motion of it, each click of the shutter, line on the canvas, or layer in Photoshop. Your magical self guides every move.*

*Each image, each element, each line you make is an aspect of you, your feelings, your ideas, and your insights. Each color and each shape is an aspect of you, your feelings, your ideas, and your insights. Each space between the objects you design, shoot, or paint is another aspect of you. The scene and the unseen are all aspects of you, your feelings, your ideas, and your insights. This is your voice. Your authentic voice.*

*The world you create is a mirror, a reflection of you, your feelings, your ideas, and your insights. This is your voice. Your story: each piece in your body of work is a chapter in your story. Become each subject, merge with the content of your image. What gifts do your images and subjects offer you? Offer others?*

*Become the work itself, its textures, its size. Feel this picture itself, feel it in your body, ask the work to tell you—what am I trying to say? What do I need to change to make this message clearer?*

*Feel it without judgment; let the separation between what is you and what is not you dissolve. Be your work. Be your voice. This is your authentic voice. Allow your creative insights to lead you; feel yourself stretching to greater heights of expression. This is your journey. Your personal vision is a journey into creativity and community. Feel this deep sense of connection*

*to your authentic voice. You know what you want to say. You know why it matters. You are your work. You are your story.*

*And when you are ready, at the count of three, you may open your eyes. One, two, and three.*

JOURNAL NOTE:

*Take a moment to write down how it felt or anything you saw, heard, or discovered.*

EXPLORE WHAT YOU VALUE

The next step is to explore what you value. What values motivate you in your career? Do you know? This will help you bring your authentic vision into the community and into the marketplace. What do you care about?

Every career management system asks you to identify your values. Our values drive us forward; they are our hidden motivation system. As you create and build your career, these values will guide you, letting you know that you are on the right road and on the right track. It is another check-in system to keep you moving toward what really matters to you in life and career versus what you think you should want. When you are aligned with your values, your steps and decisions feel right.

Sometimes we discover what we value by taking a look at what we are proud of. Try this self-assessment exercise. Complete the sentences below with a true statement about yourself.

---

## EXERCISE—WHAT I'M PROUD OF

*Whether I made money or not, whether I gained approval from others or not,*
*I felt a great sense of accomplishment when I:*
*I was really proud of myself when:*
*I was satisfied and very proud of this, too:*
*And I have to admit that I felt deeply moved and content when I:*

---

Do you see a theme in your accomplishments from the above exercise? Does anything jump out at you that might be similar in some way? Look for any threads that run through your accomplishments, perhaps in your motivation, or the subject, or the acknowledgement you received. The threads will tell you a lot about what you value.

Clarifying your personal and professional values helps you enormously to pick the right roads to travel, the right promotions to accept, the right community to join, and the right choices to make. You want to make choices that reflect what will make you happy. Choices that reflect your values will do that. So how do you know what you value? Two ways that I recommend are sorting and rating.

There is a wonderful sorting exercise on the web called the Personal Values Card Sort that was developed in 2001 by Miller, Baca, Matthews, and Wilbourne, a group from the University of New Mexico, which you can download for free.[8] You can also try rating a selection of the values listed in the exercise below. Be honest about the ones that you couldn't care less about. Rating your values will help you prioritize your steps and set the right goals.

---

## EXERCISE—RATE YOUR VALUES

*Mark your values with an A+ or a C + or an F*
*(A+) Vital; (C+) Maybe; (F) Couldn't care less!*
*Acceptance Accuracy Achievement Adventure Authority Autonomy*
*Caring Challenge Change Commitment Compassion Creativity*
*Eco-Friendly Excitement Fame Flexibility Fun Glamour Growth*
*Helpfulness Harmony Independence Inner Peace Intimacy Influential*
*Innovative Laughter Mastery Openness Passion Power Popular*
*Responsibility Risk Routine Safety Service Spirituality Solitude*
*Stability Tolerance Tradition Variety Virtue Wealth World Peace*
*Are there any values not listed that you want to write in?*
*If you had to choose your top five values, which ones would you choose?*

---

FROM VALUES TO VISION

Only you can guide your life and set yourself on the right career path. There are so many ways to be an artist in the world and to be creative in the community. When you can understand your values and articulate your authentic voice you can begin to activate the power of your vision. Let your personal vision become a beacon to guide you and mark the way. Check in with yourself: Are you being true to what matters to you? Are your top values a part of your personal vision? If not, what is missing? How can you add them to your vision draft?

Our values truly make us feel good about where we are headed. Fame, glamour, and influence are important if they are what you value. Being the best, innovation, and security are important if they are what you value. Staying in touch with what matters to you and what you value is key if you want to create an art career that is satisfying and fulfilling. Your personal vision needs all of these components to become vivid and energize your conception of your destination. Everyone's destination is different. Put your individual stamp on yours.

In later chapters, when we create a marketing plan and business plan for your work, your vision will lead the way. Consider these first drafts as a fleshing out period of what matters to you. There is no wrong way to do this, so no worries

and no pressure. You have a vision that is forming. There are things you want to make and ideas on how to make them. The qualities of life that you value in yourself and in others will help you shape these ideas into a vision that will guide your life, your role in the community, and your career. Let's write a second draft of your vision statement.

---

## EXERCISE—SECOND DRAFT OF MY PERSONAL VISION

*Write the second draft of your Personal Vision statement. What does your future look like? Include your authentic voice and your values because these are the elements that drive you to do your best every day, and that is what makes your vision successful.*

---

Congratulations! This is a great start. You are getting in touch with the core elements you need for success.

# ৰ3ৰ

## *You Are a Successful Artist*

*"As you proceed, golden opportunities will be strewn across your path, and the power and judgment to properly utilize them will spring up within you."*
—James Allen

The deeper you understand yourself and what drives you, the better you will be able to focus on a plan to achieve your vision. Success is your ability to feel fulfilled as you reach that vision. Your success does not have to be at the expense of others, or at the expense of your health, or at the expense of your state of mind. In this chapter we are going to devote ourselves to the many definitions of success and look at how you define it.

Success for our purposes is personal, reachable, and measurable. It is a creative career path that is as individual as the human heart. You will decide what makes up that career path.

WHAT SUCCESS MEANS TO YOU

Talking about success and planning for it takes effort. You have to look honestly at what you can do and what you need to do. This usually makes most people anxious. So before we dive in, let's begin this chapter with a relaxation meditation and visualization called Breathing into the Tides. This will allow you to look at success from a calm and relaxed place.

## VISUALIZATION—BREATHING INTO THE TIDES

*Get Ready.*

Bring your attention to the normal rhythm of the breath by simply focusing on your breath in and your breath out. Relaxing as you breathe. Don't worry if you are doing it right or not. Just let it happen. You are developing a "witness" attitude. Just watch it all happen as it happens, without judgment. Promise yourself: today I will not judge anything that happens. Enjoy this feeling of sitting, breathing, and enjoying the stillness and quiet mind. Breathe in and out. When you feel calm and a sense of quiet, allow yourself to be in this stillness. Enjoy it.

And following your breath, let yourself relax. Releasing worry, releasing deadlines, just taking this moment for yourself to explore your authentic voice. Take a few deep breaths, let them out, and when you are ready, let your breath return to normal.

Allow a picture of yourself at the beach to form in your mind's eye See yourself lying on the sand on a beautiful beach. You can hear the waves crashing in the distance. You can feel the sun playing on your skin, ripples of sunlight warming you. And you find yourself listening to the tides. Imagine that the tides are flowing, a steady ebb and flow, advancing up the beach and then back, receding into the waters. Imagine on the next wave, the water reaches the soles of you feet. And feel and see your feet bathed in water.

Allow this feeling of the waves brushing up and over your feet to relax you. And let the water rise and with the next wave, feel the tide gently and safely covering your ankles and feet, your legs, your stomach, your back. As it reaches each part of your body, the water completely relaxes you.

This feeling of relaxation, this deep feeling of relaxation, deepens as you see yourself now, floating, buoyant, simply floating safely on a vast ocean. Feel the ocean supporting your body. You are totally relaxed. See yourself, with your arms extended, perhaps you flex you feet or move your arms, you are floating freely. Relaxed and free, breathing deeply. Know no worries.

This is your natural state. Peaceful. Confident. Relaxed. You can accomplish anything from this, your natural state. Carry this feeling of relaxation within you, throughout the rest of your day, throughout the evening. Enjoy it. And when you ready, on the count of three, you can open your eye. One, two, and three.

JOURNAL NOTE:

Take a moment to write down how it felt or anything you saw, heard, or discovered.

Now ask yourself the following questions.

## EXERCISE—WHAT DO I WANT TO BE SUCCESSFUL DOING?

*What does success mean to me?*
*What kind of creative career do I want?*

*What kind of artwork, service, or product do I want to offer?*
*What would it take to turn my dreams into goals?*

Does success mean having work published? Do you see yourself having a large international audience or a small local niche audience? Do you see yourself telling a great story, a hard story, a story others may not want to hear but needs to be told? Can you imagine that your work brings illumination, understanding, edification, and inspiration, or confrontation and challenge to the ideas of others?

Does success mean working for yourself, with a team on assignment, or by commission? Do you see yourself maintaining strong relationships with editors, art buyers, art directors, gallery dealers, agencies, studios? Can you see yourself on staff in a large agency, magazine, or studio or working for a small startup? Can you imagine starting your own business, opening your own studio, becoming a TED fellow?

Does success mean having a commercial gallery represent you and exhibit your work? Does it mean having the space and time to deepen your message and make your work regardless of where its shown or if its shown? Do you see your work in the street or going viral? Is it for sale to collectors, individuals, galleries, museums, or in corporate collections? Can you imagine your work being funded and shown in public spaces? Does the art world even matter to you?

## EXERCISE—WHERE DO YOU SEE YOURSELF?

*Close your eyes for a moment. Imagine your work and let it be in the world. Where is the first place you see your work? Imagine that people are looking at it, who are they? How does this feel? Go with it for a few moments. Breathe. Imagine you are successful. Imagine you can see yourself as a successful creative in the world. What do you see?*

What do you think of when you say to yourself, "I am a successful artist"? Does the idea make you laugh, feel confident, or uncomfortable or weird? Does an immediate image come to mind? Is the image the same as where you see yourself? Many creatives have a hard time defining a concept for success. They either automatically feel that success is not possible for them or they have no idea how to make it happen. They simply do not know what it means or could mean.

A common thread amongst many artists is that they are afraid to define success for themselves and then be judged lacking by their peers or family. Does that sound familiar to you?

There are many routes to take to be a successful artist and many definitions of what a successful creative is and does. Earning a living from your creativity can be

one definition of success. Being known for your creativity can be another. There are many ways to earn a living and be known for what you create. I have known many financially successful creatives out there whom you may have never heard of or read about. There are also many successful creatives who have freelance or full- or part-time day jobs outside of their artistic fields. And there are those who define success by the satisfaction, contentment, and pure joy they receive from creating.

There is no one success formula or definition; no one way to live your artistic career or earn a living from your creativity. There are hundreds, even thousands, of ways, each as unique as you are. Perhaps your definition includes financial success and perhaps it does not. Perhaps your definition includes community renown or simply the peace of mind to work in your studio without guilt. Your career can be defined your way. This is key.

In my opinion, success in both life and career is at its root, the continued expansion of fulfillment, satisfaction, and happiness. It is also the steady progressive reaching of goals that means something to you. It is having a vision and living it. These root definitions of success are attainable for every artist. Success is as individual as the quality of your line on the canvas or screen, the composition of shapes and depth of your characters, or the clarity of light as it finds its way into form through your lens to the web.

## YOUR DEFINITIONS CREATE STRATEGIES

How do you start being successful? You develop a holistic view of what it would look like to be successful, and understand that success is an inner measure that you define. When you take the steps to achieve that definition, magic happens. Success can and should be magical. It is so many things to people. What is it to you?

It is possible that somewhere along the line you might have adopted a definition of what it means to be successful, one that has no relevance to your own artistic path or life goals. Your path to being a successful artist might start with identifying any mental blocks or emotional baggage you attach to being successful.

Create an image of success that is real and true for you. Can you risk breaking free of preconceived options that others have defined for you and step up to the plate? Can the real you stand up? Each choice you make, each decision you make, can be toward reaching that vision of success that is in your heart of hearts. Imagine that each step you take brings you closer toward the dream you have in mind. That is traveling the high road. You turn your dreams into action steps.

As you define what a successful career means to you, you will set goals. Your goals will motivate you to live your vision. When we are in balance with our definitions, our values and visions can lead us to set realistic goals even when we reach for the stars. You will measure what you achieve against a series of valuable milestones that you envision as part of a holistic picture of success. That is a success to be proud

of and to plan for. It takes the ability and willingness to think for yourself, define life for yourself, define a career for yourself, and define success for yourself.

Think of creating a successful career as an evolving story, made up of worthy goals and adventures, with milestones, heroes and heroines, a few villains, of course, but with your vision attained and lived fully. This will be your life plan. All along the way, you will feel fulfilled in what you attain because you are in touch with the creative spark within you and the image of what you are trying to accomplish.

The Merriam-Webster online dictionary defines success as:

1. outcome, result

2a. degree or measure of succeeding; 2b. favorable or desired outcome; also: the attainment of wealth, favor, or eminence[9]

How do these definitions apply to your definition of success? Answer the following questions to discover what success might look like for you.

---

## EXERCISE—SUCCESSFUL LIFE PLAN

*What are the accomplishments, impact, or results I am looking for from my art career?*

*How will I measure them? If I reach them, does that mean I am a success?*

*How will I know when I get there?*

*Do some matter to me more than others?*

*What am I looking for? Satisfaction? Recognition? Wealth? Acceptance? Fame?*

*Can I create a work/life balance that allows me to be successful in art, in home, in body, in spirit, in work? What would that look like?*

---

Now take a look at the following words that are related to success in Merriam-Webster. What images do they bring up in your mind's eye?

Synonyms: blockbuster, megahit, smash, hit, supernova, winner

Antonyms: bomb, bummer, bust, catastrophe, clinker, debacle (also debacle), dud, failure, fiasco, flop, misfire, turkey, washout

Related Words: blue chip, blue chipper, corker, crackerjack (also crackerjack), dandy, jim-dandy, pip, prizewinner; gem, jewel, treasure; marvel, natural, phenomenon, sensation, wonder; coup, triumph, victory

Near Antonyms: disappointment, fizzle, lemon, loser

Can you see yourself as a blockbuster, supernova. or winner, or do the antonyms such as washout, fizzle, or disappointment resonate more strongly with you? Be honest with yourself; do you feel you need help? Do you have a right to be successful? Do you feel you need a course correction? Do you feel you are all

that you need to be successful? If not, who else do you need? What else do you need? Achieving success and defining success are two different processes that must go hand in hand.

Wikipedia states that success might mean, but is not limited to:

- a level of social status
- achievement of an objective/goal
- the opposite of failure[10]

Social status is always a slippery slope for creative people. Do you stay true to your visions at the expense of social acceptance? Is what you make in tune with the consensus collective and therefore acceptable? Does that matter to you? Can you create financial goals and objectives that are counter to the norms and make it work for you?

You need to define success and failure and understand the standards that you have set for yourself. It takes nerve, commitment, and a comfort with uncertainty to be this honest with yourself. Take stock of yourself, be honest, and take a good look. Are you independent and inspired? Are you a planner or spontaneous? Are you outgoing and social? Or are you private and quietly determined? Confirm your nature and work with your wiring. This will also impact how you approach and define success. Success comes to those who know themselves and make choices suited for their own wiring and skill sets.

Know yourself and be authentic, and believe in what you value. Set the right goals for yourself and let your dreams guide you. Momentum can be created and maintained when you have a vision and a plan of steps to take. There are many ways to fashion a successful career from the possibilities in front of you. Take stock of where you are and where you need to get to, and make your choices purposeful. Your choices will determine your direction. And your definition of success will set your destination and give you a sense of purpose.

Let's do a visualization exercise on being a successful artist. In this exercise, you will see yourself turning your passions into a higher sense of purpose.

---

## VISUALIZATION—YOU ARE A SUCCESSFUL ARTIST

*Get Ready.*

*Bring your attention to the normal rhythm of the breath by simply focusing on your breath in and your breath out. Relaxing as you breathe. Don't worry if you are doing it right or not. Just let it happen. You are developing a "witness" attitude. Just watch it all happen as it happens, without judgment. Promise yourself: today I will not judge anything that happens. Enjoy this feeling of sitting, breathing, and enjoying the stillness and a quiet mind. Breathe in and out. When you feel calmness and a sense of quiet, allow yourself to be in this stillness. Enjoy it.*

*And following your breath let yourself relax. Releasing worry, releasing deadlines. Just taking this moment in time for yourself to explore your authentic voice. Take a few deep breaths, let them out, and when you are ready, let your breath return to normal.*

*And imagine a beautiful sphere of light between your eyebrows, and allow that to be your point of focus as you breathe. Keep your attention on that point of focus, and find a rhythmic count that works for you. Either four or six. So, as you breathe in, you are counting, and as you exhale, you are counting. All to the same count. And this will allow you to relax even further and deepen your focus while watching your breath. And do that for a few breaths on your own. Breathing in and out through your nose. Find a count that works for you, and breathe in two, three, four and out two, three, four. And do that on your own for a few breaths. And then when you are ready, with the next breathe, allow a picture to form.*

*See an image of yourself in a very serene and beautiful place. It is quiet, and sunny, just lovely. Imagine it in your mind's eye. Imagine there is a perfect breeze blowing. You feel relaxed here; this is a place you find to be very beautiful.*

*Allow yourself to almost smile as you picture this place in your mind. And, as this image becomes clearer and more vibrant, feel yourself relaxing more deeply. You are part of this beauty. Allow your mind to think about how right it is that there is so much beauty and peace in this world, in your world. It feels right. It's perfect.*

*You are a creative and successful artist, in your heart, in your mind, in your spirit. Say this to yourself silently, I am a successful and creative artist. What does your life look like when you are successful? Allow any image to arise in your mind's eyes. Imagine you see your entire creative career before your very eyes. You can imagine every skill and every ability—all comes to your mind's eye. Before your very eyes, you can see yourself making the perfect work, for the perfect audience. Allow this picture to form.*

*There is so much more to you than you have ever realized. You are a successful creative, an artist. Repeat that to yourself. What does the perfect career look like for you? And now imagine you have many different and useful skills, special skills that lead you to success on so many levels. What are your specialties? Imagine that these specialties have made your career possible. What has made you so successful? Your work is unique.*

*Your talents are unique. What makes your work unique? You have many physical skills, intellectual skills, artistic skills, and people skills. Allow yourself to know all the skills that make your work unique. You are a successful creative, an artist. What does your unique skill set say about your career, about how you tell your story in your work?*

*Imagine you can see your clients, your audience, even see your family and your peers, appreciating you. Respecting you. Allow yourself to receive appreciation, respect, and understanding from everyone you know. For your work, for your ideas—you are enthusiastic and hard working. What does your success look like? Feel like? Describe it to yourself as if you were telling your inner child the story of your success.*

*And when you are ready, at the count of three, you can open your eyes. One, two, and three.*

JOURNAL NOTE:

*Take a moment to write down how it felt or anything you saw, heard, or discovered.*

Let's reflect on what success means to you and what failure means to you. Don't censor yourself; just go with the flow and auto-write your answers to the following:

---

## EXERCISE—MY DEFINITIONS OF SUCCESS

*My definition of success is:*
*My definition of failure is:*
*My successful career looks like this (write down as many details you can imagine):*

---

## SUCCESS IS AN EVOLVING STORY

To have a successful career, you need to be able to survive the creative and emotional ups and downs that inevitably arise in your process and progress. You need to ensure that the economic ups and downs are offset by a built-in support system. A built-in support system can be a group of friends or family or can be a career support group that helps you through rough times. You cannot do career alone, you really cannot. It takes a community, and, no matter how you define success, you will need a community for career connectivity and success over time. Ideally this community shares your definition of success and they are your cheer-leaders. The people in your life to whom you can tell your creative story and they get it, they "get you." Can you imagine that you are surrounded by people who really "get you" and understand why you do what you do?

Success in my view is an ongoing evolving story that is made up of a series of experiences connecting your vision and values to a community. The details of the story change with the times and the economy; the community might change as well, but not the meaning. The big picture continues to deepen and be shared. And that is profound. Life follows thought, which follows belief, which follows meaning, which leads us to satisfaction and success.

Techniques of visualization, mind mapping, and self-exploration bring focus to your vision of success and can give you clues to which path to take and when, and to whom to share it with. Are you ready to view your ongoing and evolving story? In the next visualization, let's take a look at your story as if you were watching a movie.

---

## VISUALIZATION—MY MOVIE TO SUCCESS

*Get Ready.*

*Bring your attention to the normal rhythm of the breath by simply focusing on your breath in and your breath out. Relaxing as you breathe. Don't worry if you are doing it*

*right or not. Just let it happen. You are developing a "witness" attitude. Just watch it all happen as it happens, without judgment. Promise yourself: today I will not judge anything that happens. Enjoy this feeling of sitting, breathing, and enjoying the stillness and a quiet mind. Breathe in and out. When you feel calmness and a sense of quiet, allow yourself to be in this stillness. Enjoy it.*

*And following your breath let yourself relax. Releasing worry, releasing deadlines. Just taking this moment in time for yourself to explore your authentic voice. Take a few deep breaths, let them out, and when you are ready, let your breath return to normal.*

*Now, with your eyes closed, use your imagination to create a mental picture of a large movie screen or large TV screen. And just see this picture—create it. And imagine you can see yourself. You are gently dusting off this screen; you are wiping it with a feather duster or dusting cloth. And it is big and wide, and you are very excited about this movie that you are about to watch. And when you finish dusting, imagine that you sit down in a very comfy chair, a cinema watching chair that you've always wanted to have, and you are ready for the movie to start.*

*And in the center of this screen, create a picture of yourself. Your movie is beginning. See an image of yourself as clearly as you can. Look at all the details of this image of you on the screen. Notice your clothes, your hair, and your demeanor. And, very slowly, allow the movie to progress through time and see yourself achieving your goals. You are the center of an action movie where you achieve your goals. Where you live your vision. See this on the screen in front of you.*

*You notice that some of the goals you reach are different than what you thought you'd reach. What are those goals? What are you doing? How did you get there? Why? How does this feel? Notice who else is there with you. What were the steps you took to get there? When did you take them? Who are you reaching?*

*And allow the story of your great achievements to unfold on your movie screen, step-by-step. You are watching a great classic movie of your life and your career. Watch it all unfold before your eyes, and as you lean back in your great comfy chair, observing your great movie, your path to success, enjoy it, take delight in it, relish in being the center of attention in your life, achieving your highest goals.*

*As you sit in your big comfy chair watching your movie, you notice there is a cup of coffee or tea on the table next to you and you take a sip. There is also a remote control on the table that you pick up and point at the screen. See yourself press the pause button. You are in control of your movie. You press the rewind button so you can go back and see again the steps you took to reach your goals. Stop—you found it. Press play.*

*Review the steps you took to reach your goals. What paths did you take that were the most successful, fulfilling, meaningful? Watch yourself taking these paths, taking these steps. Accomplishing your goals. Living your vision.*

*Do you want to change any parts of your movie? Do it. This is your evolving story and you can make it what you want it to be. Allow your success to be as clear as you can. See all the details as best as you can. What you do, why you do it, who you do it for.*

*As you watch your movie you can see so clearly that your creativity has a purpose. Your image making has a core, a story that compels you. As you watch your movie, you understand why you do what you do. And like a flash of insight, your focus is sparkling clear; you know the paths to take.*

*Your movie comes to a beautiful ending. A successful happy ending. You feel great. Imagine that you pick up the remote control and shut off the screen. See yourself sitting back, feeling fulfilled and satisfied. And at the count of three, you can open your eyes. One, two, and three.*

---

JOURNAL NOTE:

*Take a moment to write down how it felt or anything you saw, heard, or discovered.*

Success is a commitment that needs replenishing. Through silence, through sleep, through contemplation, through being in nature. Make time for yourself to retreat so you can reconnect to your vision of what you do and why. Reconnect to being a person, a part of your family, a community member. Don't isolate yourself and drive others away while pursuing your goals. Any way that you can step back, observe, and participate in being the witness to your routines and day-to-day presence will help.

This does not mean that you cultivate an obsessive self-focus. Creativity is a conversation with others. Your core is the fuel of that conversation, of what you offer others, give others, sell to others, and teach others through your work, services, products, and personhood. People do business with people. A meaningful exchange is created of your talent, your products, your meaning, and your message in return for money, appreciation, recognition, satisfaction, etc. Your definition of success will set the basis for this exchange. Your market becomes a part of your movie.

Keep asking yourself: what does success mean to me, what do I value, where am I headed and why? As you do, you will uncover meaningful ties to achievements that will have a greater purpose in your career strategy and success.

Are you—right now—who you want to be? Are you doing what you dreamed you'd be doing? Where are you in your movie? Can you make new choices to move toward a new direction? It's easy to get caught up in life, in the "busyness" of routine and survival, in the busyness of being busy. Check in with your definition of success and how you see yourself as a creative professional. It can and will change over time. Don't judge, don't censor. Go for it and see what comes. Then adapt and try again. Let your dreams become goals and your knowledge lead you to action, which will then lead you to success. When you define what success means to you

and let that definition evolve, you will have uncovered your self-determination, a great force inside you. And there will be no stopping you.

Let your answers to the following questions guide you:

---

### EXERCISE—WHAT WILL MAKE ME HAPPY

*What am I doing right now with my creativity? Does it make me happy? Do I feel fulfilled?*

*What do I keep dreaming of? Is it different from what I am currently doing?*

*What do I want? What do I want most for my life and for my career?*

*What do I value?*

*What do I need to accomplish in this lifetime to look back and really smile?*

*Is there anything I need to change in order to see myself as a successful creative?*

*What would be the perfect title for my movie?*

---

Connect with yourself and use the above tools for success to guide your planning process and reinspire yourself. It will lead you to a more meaningful career and a feeling of self-empowerment, which will spread into every area of your life.

In the next chapter, we will explore your unique talents in more detail and see what you are offering in this all-important exchange of talent for (you fill in the blank!).

# �20 4 �20

## *Your Unique Talents*

*"Artists are the medium through which artworks evolve."*
—Mihaly Csikszentmihalyi

There is far more to you than you might have realized. We all have many different and useful skills and talents. As you enhance your understanding of the nature of your skills and broaden your definition of your talents, you are going to come up with a unique value proposition. A unique value proposition is a statement of your authentic voice, how you express it, and the unique talents you have to bring to the community and to the market. You use this unique value statement to communicate just about everything about your work.

To market your unique talents to people who want to hire you, buy something from you, exhibit you, or commission you for a project, you need to you understand what is unique about your value and that you need to project that value. You project it via your creative process and skill set in tangible form. You incorporate it into the products you create, as well as in your personal branding and your marketing. You use this information to consistently present your work to creative directors, publishers, art buyers, editors, gallery directors, clients and collectors, and grant and fellowship panel reviewers. You use it to write your artist statement, your emails, and your networking banter.

It demands that you ask yourself the following questions: What are my strengths? What are the things I can't and won't walk away from, that I love to do, and need to do, and I am good at? What do I need to improve on, up my skill set in, learn more of? There are things you must get better at in order to remain unique and consistent throughout your working life. Do you know what they are? Does anything come to mind? Don't hide from this knowledge.

Taking this kind of inventory is essential. Allow yourself to ponder at least three directions in which your creative career could go; come up with a few possibilities you could pursue given your financial and economic realities that would utilize your strengths. Get good at knowing what matters to you and why it matters to you and the strengths you have that will let you build on them. In this way, your vision is connected to a foundation of beliefs, as well as skills and talents. You can write an effective, unique value proposition and artist statement, and you can develop a good elevator pitch that integrates both vision and skills.

## RECOGNIZE YOUR TALENTS

The first step in this process is to take a creative inventory. Do you understand what your unique talents even are? Let's brainstorm. Make a list of your skills, talents, and strengths. Don't worry about priority order or what you do best; just make a really big list.

---

### EXERCISE—MAKE A LIST OF YOUR SKILLS, TALENTS, AND STRENGTHS

*My skills are:*
*My talents are:*
*My strengths are:*

---

Get a sense of yourself based on your talents, skills, and strengths. Which ones do you want to use every day, or as often as possible. Circle those on your list. Which ones do you not want to use? These are the skills, talents, or strengths you have but don't feel the need to use very often, if at all. Draw a line through the ones you do not want to use.

For example, I'm really good with numbers, but I don't want to create budgets and enter them into an Excel worksheet on a daily basis. I can do it; it's a skill I have, and sometimes I enjoy the order and understanding I gain from numbers all adding up, but if I have a choice, I'd rather not use that skill every day.

Take a look at what you circled and what you crossed out. Any surprises? Are there skills and talents you have that you would like to develop further, push to a new level? Underline those. These are the ones you want to study and raise the bar on. How about those that you know you need but don't have a clue? Write those in.

Let's do a visioning exercise and take it a step further by seeing your skills in action.

## EXERCISE—VISIONING MY SKILLS IN ACTION

*Close your eyes and picture yourself working, using the skills and talents you identified on your lists. See yourself using all of the talents that you have circled or underlined. What images come to mind? See the projects, see the environment, see the tools. Which skills, strengths, and talents do you use most? What project or type of projects are you working on? Which talents, skills, and strengths do you use? See what are you working on in as much detail as possible and notice why you are doing the various tasks and projects. See who you are doing it for, and notice if anyone else is with you.*

*Now let's take a look at your talents and skills from another angle.*

*Think about the times in your creative work life when you felt great or really satisfied with what you did, produced, or accomplished, and totally enjoyed doing it. Remember when your life and your skills felt rich and creative and you had momentum to keep moving forward. What were you doing? Where were you? Were you in school or working at a job or in your own studio?*

In Kate Wendelton's *Targeting a Great Career*, she notes that "knowing our patterns gives us a sense of stability and helps us understand what we have done so far."[11] Kate founded a wonderful job placement organization called the Five O'Clock Club and developed an exercise called the Seven Stories Exercise, which I've adapted in my own practice and in my own career planning.

Telling stories is a great way to get to know yourself and what makes you happy. From there you can make better decisions about your future. When doing the Telling Your Life Stories exercise below, keep in mind that it doesn't matter what other people thought, or whether this was for yourself or for a client, whether you were paid, or even if you were a young child when it happened. All that matters is that you felt happy doing whatever it was. You thought you did it really well and, most importantly, that you experienced a sense of flow, of accomplishment, a feeling of "*ahh*, that was good. Where did the time go?"

I do this exercise a lot to get back in touch with the talents I have that really make me want to get out of bed in the morning and apply more in my work life. Inevitably, I come up with times from my childhood that still teach me a lot about my unique value proposition.

For example, the time when I was eight years old and played a song I wrote on the guitar for a group of family friends. On the surface, this might not appear to apply to my career! But it does. When I look back at this, I was terrified but I wanted to please my family. I pushed through the fear and enjoyed it and actually did it well. I learned that if I muster the courage to conquer _____ (fill in

the blank), I feel great. In my creative life and work life, that is a constant. I haven't met a challenge I haven't risen to. The more I push the boundaries of my resistance, the more balanced and harmonious I feel. Ironically, it calms me and opens my creative juices. I also like making people happy.

So what does that mean? The more I can inspire, challenge, and motivate myself, the better my work gets. The more I can inspire, challenge, and motivate others, the more successful I become. And that is a big skill I have, no matter what my medium, no matter what the project or context. So, I now recognize inspiration, motivation, and challenge are a huge part of my unique value proposition. All of this from analyzing a story from my childhood. Now it's your turn.

---

## EXERCISE—TELLING MY LIFE STORIES

*Pick five life stories and write about them. Be specific—what did you do? Why did you do it? Who did you do it for? How did it feel before you did it? How did it feel after you did it? What was the result? What did you learn? Why does it matter? My Life Stories:*

1.

2.

3.

4.

5.

---

## LEARN FROM YOUR ACCOMPLISHMENTS

You have a unique way of expressing yourself and sharing what you know. We learn by doing. Can you get a glimpse of that from the above stories about your accomplishments?

Everyone has a purpose in life, a unique gift, and special talents to give others. When you blend this gift with your career goals, you begin to create a career with meaning. And you set goals that have energy and staying power. As you review your life stories, what do they have in common? Are there skills and talents that came up in more than one story? Are there any surprises?

Now it is time to see the threads that run through your stories. Let's look at:

1. Skills used
2. Talents expressed
3. Values that motivated you
4. Results or accomplishments you felt good about

Here is a chart to help you. Fill in your answers.

## EXERCISE—MY LIFE STORY CHART

| My Life Stories: | Skills used: | Talents expressed: | Values that motivated you: | Results or accomplishments you felt good about: |
|---|---|---|---|---|
| 1. | | | | |
| 2. | | | | |
| 3. | | | | |
| 4. | | | | |
| 5. | | | | |

We learn a great deal from reviewing our impact on others and taking stock of our tangible accomplishments and the talents we used to make a difference. It gives us the fuel to target new goals that have meaning and momentum. Add your personal vision to the mix, and you have an awesome combination of tangible productivity, inspired motivation, ideas to communicate, and the perseverance to nurture your career path. Your confidence builds. Take note of your answers reflected in the above chart. You will come back to this when we start to set goals. For now, just let it in and begin to marinate a bit while we do a visualization meditation on self-worth and confidence.

## VISUALIZATION—I AM ALL THAT I NEED TO BE SUCCESSFUL

*Get Ready.*

*Bring your attention to the normal rhythm of the breath by simply focusing on your breath in and your breath out. Relaxing as you breathe. Don't worry if you are doing it right or not. Just let it happen. You are developing a "witness" attitude. Just watch it all happen as it happens, without judgment. Promise yourself: today I will not judge anything that happens. Enjoy this feeling of sitting, breathing, and enjoying the stillness and a quiet mind. Breathe in and out. When you feel calmness and a sense of quiet, allow yourself to be in this stillness. Enjoy it.*

*And following your breath, let yourself relax. Releasing worry, releasing deadlines. Just taking this moment in time for yourself to explore your authentic voice. Take a few deep breaths, let them out, and when you are ready, let your breath return to normal.*

*Imagine there is a bright white light way above the top of your head flowing down toward you. When it reaches you, allow your imagination to see and feel this light filling your mind and your intuition, your heart, filling your entire body. You are filled with the essence of creativity.*

*Say to yourself: I create wealth and abundance with the flow of my creativity.*

*Stay with the image of light filling your mind and body. Allow a sense of openness to career possibilities and wisdom to open within you. Feel yourself letting go of worries, of concerns, and allow yourself to fill with abundance and creative success. All else floats away.*

*Say to yourself: I am worthy of the best of everything, my creativity sustains me.*

*Stay with this feeling of flowing openness and creative abundance. Release any doubts and allow any resistance to growing, changing, or using your talents to float away. Acknowledge your gifts.*

*Say to yourself: I have the talents, skills, and momentum to attract to myself everything that I desire in my career and my life.*

*Then, ever so slowly, see the flow of light radiating from your body, from your mind's eye, like a great circle of light. A beautiful circle of light surrounds you, filling your home, your studio, your town, your imagination with light. You are at the center of this light, at the center of your creativity.*

*See yourself sharing your gifts, sharing your talents, sharing all that you create with your community, your market. See yourself in your mind's eye as talented, gifted, and skillful. All that you are, all that is around you, all that you do in your work and in your career is filled with this great light and abundance. You are talented, gifted, and skillful. Allow this image to form and take hold. See your gifts, see your accomplishments, as if they were filled with light.*

*Your creativity is filled with light. Your goals are forming, and they are sustained by this inner light of your creativity. Your momentum rises from deep within you; deep within your inner light is the reason you create.*

*Say to yourself: I believe in my creativity, in myself. I am talented, skillful, and gifted. Every day and in every way, I achieve my goals.*

*Imagine that the essence of your creativity, your creative process, and your creative output is filled with energy, with a sustainable momentum to reach your goals. Your talents and skill sets are visible and recognizable to everyone you meet. Your understanding of what you offer to your market, to your community, is awakening within you. You communicate your talents, skills, and gifts in all of your marketing, your branding, and your unique offerings to the world.*

*See your goals as they are forming in your mind's eye. Say to yourself: Every day and in every way, I am becoming better and better, richer and richer, clearer and clearer. I achieve my goals.*

*Say to yourself, "I am all that I need to be successful. I am worthy of being a success. I am filled and surrounded by abundance. I claim the abundance of life."*

*When you are ready, at the count of three, open your eyes. One, two, and three.*

---

JOURNAL NOTE:

*Take a moment to write down how it felt or anything you saw, heard, or discovered.*

*What does abundance mean to me?*

*What does success mean to me now? Has it changed from when I first started this book? If so, how?*

## COMMON THREADS FOR SUCCESS

I hope you are discovering a new way of thinking about your career and your talents and skill set by doing these exercises and visualizations for empowerment. The threads that run through them are going to be what drives you toward setting and meeting your goals. Driving you from the inside; from a solid foundation of belief and feeling. This is what a sustainable career is all about. You stay in touch with that unexplainable drive to keep going, keep creating, and keep finding a way. You set goals and use your ability for self-reflection and flexibility to market yourself and talk about your work in fulfilling ways. This is how you connect the dots. You create a unique value proposition.

## CONNECTING THE DOTS—YOUR UNIQUE VALUE PROPOSITION

When thinking about and eventually writing your unique value proposition, make it a statement of your authentic voice and how you express it using your unique talents. Write it out on a Post-it note and put it by your computer, hang it on the fridge, put it on your front door, and see how it feels. Type it in Notepad on your phone, or use it as a screensaver. Re-word it, try it out on friends. Remind yourself of what you are, what you do, and how well you do it. This is not hubris, it is fact. You are talented. You are skilled. You bring something out that needs to be shared.

Your job is to figure out where in the world and marketplace you want to share it and in ways that make sense for you. For some, that is working freelance in fields that resonate with your style and temperament. For others, it is exhibiting or selling, teaching from your own studio, or doing street performance. Not all creative work belongs in the same outlets. Not all outlets require the same talents or skills. All outlets, however, require a benefit to be met for a particular audience. You will use your unique value proposition to express that benefit, and it will be the bridge between what you make and how you market it.

---

## EXERCISE—WRITING YOUR UNIQUE VALUE PROPOSITION (UVP)

*What are the values, intentions, motivations that reflect what you are all about, what you are after, and what you want to offer others?*
*What are the benefits you bring to your clients, customers, and audience from using your top skills and talents?*
*Now put your answers to the above together in a logical sequence and you have your UVP!*

---

Your vision is your philosophy and your UVP is your marketing language. Both reflect your unique talents. Apply your gifts, skills, and strengths in your career and be fluid and nimble. The better you know yourself, the more your daring and sense of purpose will provide your stability.

What if you let your dreams position you in your field? Would you create adventurous goals that utilize your talents and values? If we can agree that goals are simply dreams with deadlines, can you let your dreams be based on your understanding of your unique talents and the values that motivate you? I think you can.

Take all the information you have gained in these first four chapters on who you are and the benefits you bring to the world through your talents and skills, and now apply them to where you are going. Prepare yourself to shine in a role as a creative, as an artist, as a designer—any arts profession involves setting clear outcomes for yourself based on an inner vision of what is possible as a creator, an image maker, and a vision maker—and then take it one step at a time.

Creating a career and living a creative life means understanding that creativity is in your blood and it flows within you always. Your creativity can and will take many forms. Make creative choices, be true to yourself, and then decide on your direction. Change your direction as needed. What direction should you choose first? Join me in the next section for Part 2—Where Am I Going?

# PART 2

# *Where Are You Going?*

*"I know where I'm going and I know the truth, and I don't have to be what you want me to be. I'm free to be what I want."*

—Muhammad Ali

# ❦ 5 ❧

## *Exploring Your Options*

*"Security is mostly a superstition. It does not exist in nature, nor do the children of men as a whole experience it. Avoiding danger is no safer in the long run than outright exposure. Life is either a daring adventure or nothing."*
—Helen Keller

Now that you have a foundation to work from—a sense of who you are and what you value—you can begin to chart where you are going. Career planning really involves a series of questions and answers to uncover what matters to you and give you a template to follow to determine your right direction. Then you create a list of action steps to move you in that right direction. Brilliant and amazing ideas abound in every Starbucks or local free trade coffee bar, but, unless you take the first steps toward making them real in the world, they remain just wonderful ideas. So how do you move them into reality?

You make a plan and you get organized. My goal is for you to end up with a plan that you create and are willing and happy to follow. The main purpose of doing visualizations and self-exploration exercises is to help you create your plan based on self-reflection so you can make the right career choices, the right creative choices, and the right life choices.

### SELF-REFLECTION IS NOT SELF-ABSORPTION

You want to build your confidence in your choices and then find ways to make them practical and of value to others. You have to make it work in the world, and building confidence will allow you to feel empowered in the process. When you feel empowered, there is nothing you cannot figure out and do. Without

that feeling of empowerment, it is more likely that you will continue sitting in Starbucks or the coffee bar talking about your great ideas. And if that is what you want, go for it. However, I want you to put your ideas into action. It is as simple as that.

To manage your career well, you need to create a vision and imagine how to use your talents, skill set, and unique attributes in the world of work. No one can tell you what your next career move should be, whether you should accept a promotion or start your own art/craft/design business, or apply for a residency or a Guggenheim fellowship. Your vision and knowledge of what you bring to the table will help you research and compare options. As you get comfortable thinking for yourself and become more self-reliant, you learn to trust your creative intuition and instincts. You get better at knowing which options are the best options for you and when is the right time to utilize those options.

In Part 1—Who are You? you did visualizations and exploration exercises (go back and do the exercises if you skipped them!) to create a vision and a unique value proposition. In Part 2—Where are You Going? you will explore options and brainstorm choices that reflect that vision, your interests, temperament, and style.

Being a visual person, I like to think of self-exploration as an anchor you can rely on. As you move forward in your career, perhaps you can think of yourself as a beautiful ship anchored in a shifting economic sea, fluid and nimble, moving with the waves, and totally unsinkable. Explore your options and sort your priorities from a position of "I am unsinkable." In this way, you can adapt to changing times; you can bend with the winds; you can be dynamic and still be flexible.

Flexibility means that you work on letting go of what doesn't work or hasn't been working and try something else. Resistance can lead to stubbornness and being stuck in a position that has passed its "sell-by date." Do you know what empowers you to let go and move forward? The visualizations and exercises in this chapter might help you find that impulse and trigger within you.

Let's start with a visualization to see yourself as unsinkable.

---

## VISUALIZATION—ANCHORED AND UNSINKABLE

*Get Ready.*

*Bring your attention to the normal rhythm of the breath by simply focusing on your breath in and your breath out. Relaxing as you breathe. Don't worry if you are doing it right or not. Just let it happen. You are developing a "witness" attitude. Just watch it all happen as it happens, without judgment. Promise yourself: today I will not judge anything that happens. Enjoy*

*this feeling of sitting, breathing, and enjoying the stillness and a quiet mind. Breathe in and out. When you feel calmness and a sense of quiet, allow yourself to be in this stillness. Enjoy it.*

*And following your breath, let yourself relax. Releasing worry, releasing deadlines. Just taking this moment in time for yourself to explore your authentic voice. Take a few deep breaths, let them out, and when you are ready, let your breath return to normal.*

*Imagine that you are floating on your back in a beautiful shimmering sea. Imagine this. Create this picture. You see yourself floating on your back in a vast and beautiful shimmering sea. You can feel yourself rising and falling with the gentle current. Floating freely and happily. You feel completely supported; the water is holding your body, gently but firmly. Allow yourself to create this image in your imagination, and feel yourself, every inch of you, as totally and completely supported. And let go.*

*Imagine that you are floating on the sea of your own creativity. Boundless and forever generating ideas, shapes, works of beauty and meaning. The water of all that is possible supports your every breath. Feel the wonderful expanse as you float. You are guided by a creative vision that directs every move you make. You know you are directed, you are guided. You know you will change with the times and find the right path for your work. And this fills your heart with joy.*

*Feel it as it flows through your mind and supports your head and neck; feel it as it flows through your hands, and supports your arms and back. Your entire torso is supported by this sea of creativity and your flexibility to find what you need and what the world needs from you.*

*Feel it as it flows through your lower torso and legs, into your feet. And you begin to kick your feet and move gracefully through the water. See this image shift. Under your own momentum, you are gracefully moving through the sea of creativity. You notice there is a boat anchored in the harbor waiting for you. And you float and move by your own momentum, all that you create and will create is supporting you as you move swiftly and easily to the boat.*

*You climb aboard, knowing that the boat is anchored by your skills, talents, and values. Anchored by your support system. You are well anchored and unsinkable. Your vision is your compass. You know you can change your direction at any time because you are so well supported. You can navigate through rough seas and calm seas. You are unsinkable in the creative sea. When you are ready, at the count of three you can open your eyes. One, two, and three.*

---

JOURNAL NOTES:

*Take a moment to write down how it felt or anything you saw, heard, or discovered.*

*Spend a few moments writing about what anchors you and who anchors you.*

*My anchors are:*

## MAP OUT THEMES, OPTIONS, AND POSSIBILITIES

It is time to connect the dots between your vision and your options. You have a big picture in mind and now we will look for the detail in the world. We look for overlaps and overarching themes. From there you can map out ways to reach the audience, clients, employers, gallery directors that might respond to your ideas and your work. You can find your market.

Let's take a look at where you are heading in two ways: linear and visionary. First we'll create a list of options and make a blueprint as a mind map to follow. Then we'll visualize it as being current and in the future. Think of options as possibilities. Make a list of all the possible directions for your career that you would love to pursue. Include jobs you would love to hold, any fine art, freelance, or start-up business ideas you have. The key here is to make a really big list; you don't want one option—you want many. Don't censor, don't judge, and don't worry. Just write down everything that comes to mind. Sharon Good, the founder of Good Life Coaching, taught me this exercise. Make a possibilities list.[12]

---

### EXERCISE—WHAT ARE MY OPTIONS AND POSSIBILITIES?

1.
2.
3.
4.
5.
6.
7.
8.
9.
10.

---

In earlier chapters we explored "What if?" You answered the question "What would I do if I couldn't fail?" Now we take that idea a little further. Michael Michalko's book *Cracking Creativity* has fabulous ideas on looking at perception from different angles. This is one I loved. Ask "in what ways might I . . ."[13] By asking that question you begin to open up to new options and possibilities that you might not have thought of before. I actually have this phrase written on a Post-it note on my desk! It is another way to ask yourself "how" you might do something.

We will use a mind mapping exercise to help clarify your "how" based on your options list. For example, one possibility you might have come up with is to open an art gallery. I did that for many years; opened my art studio to other artists and created an alternative art gallery that was quite successful. So, if we ask "in what ways might I open an art gallery?" (how will I do it?), we start to think about a few factors. Here are the elements you may want to consider for your mind map.

a) What would I like to achieve by doing . . . (fill in your possibility)?
b) What would I like it to look like?
c) What kind of work would I present?
d) Who might I want to serve?
e) Who would be my target market?
f) What would be my special niche?
g) What types of experiences do I want to deliver?
h) How would I run it, start it, get it going?

---

## MIND MAP EXERCISE
## IN WHAT WAYS MIGHT I . . . ?

*Place the first option on your list in the center of your map and then allow yourself to brainstorm one to three answers to each of the questions/elements listed. Allow both far-out and obvious ideas to enter the picture. Be as specific as possible. See the sample on the following page for an idea of what your blank template will look like when completed.*

---

The big questions are always about what we dream of doing. Then we come up with a list to ponder and consider and let those ideas marinate. I'm a big believer in letting ideas marinate by writing things down, drawing them out, and meditating on them. This way you don't have to keep thinking about what you can do and going over the same ideas in your mind. You can move onto how will I do it and parse out the details.

By creating a mind map for each of your options, you can plot out the possibilities and see what the priorities need to be. You will also get a feel for which possibilities you want to move forward with first. Just because you dream of it does not magically make it happen. It requires a lot of hard work and effort. But dreaming it allows you to see it from many different perspectives and gives you an opportunity to find a variation on the theme that you can make happen.

Imagine that five of your possibilities from your list could happen. Look at those five mind maps—is there any overlap? Do you see a theme? What do you

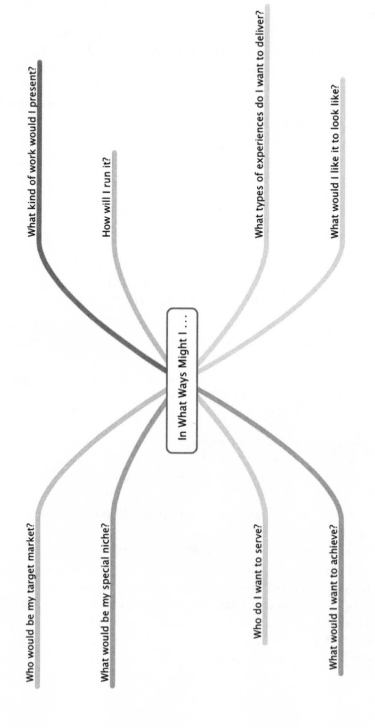

In What Ways Might I . . .

What kind of work would I present?

How will I run it?

What types of experiences do I want to deliver?

What would I like it to look like?

Who would be my target market?

What would be my special niche?

Who do I want to serve?

What would I want to achieve?

want to try first? Have fun with this. Stretch your mind and expand on your ideas. You want the law of averages to work in your favor by moving away from the "one and only successful career image I can have is _____."

Instead you want to be able to adapt your career ideas with a variety of options, environments, services, and products. The thread you want to add to your possibilities and options is flexibility. The beauty of asking "In what ways might I . . . ?" gives you a way to ask how will I do it and create a whole world of adaptations to imagine. Being creative in the world is never just this one time, just this one thing, otherwise I am not an artist and I have failed.

When we do that, chances are we become bitter and then blame the world and blame ourselves. Instead of playing the blame game, reach for the meaning in what you do and create a variety of ways to stay in touch with expressing it so whatever you do feels relevant and enlivening. And yes, if you have to do something irrelevant in order to pay the rent, you do it. But your focus and priorities are always on making your expressions count in the world. It is never I am too old, too young, too early, or too late. There is always a way to interpret a version of a dream to make it real.

VISUALIZE THE FUTURE

Once you've mapped out your options and possibilities, spread them out on the table and feel them out. Are there any that feel more "right" to you than others? Hold that thought. Next, let's meditate together and see what the future might hold and which of your possibilities arise in meditation. Ask yourself what you want, let it fill your mind and your heart. See it as if it already exists and this will help you to open the door to make it happen.

---

## VISUALIZATION—YOUR FUTURE UNFOLDS

*Get Ready.*

*Your eyes are closed, and your attention is on the normal rhythm of the breath, simply focusing on your breath in and your breath out. Relaxing as you breathe. Don't worry if you are doing it right or not. Just let it happen. You are developing a "witness" attitude. Just watch it all happen as it happens, without judgment. Promise yourself: today I will not judge anything that happens. Enjoy this feeling of sitting, breathing, and enjoying the stillness and a quiet mind. Breathe in and out. When you feel calmness and a sense of quiet, allow yourself to be in this stillness. Enjoy it.*

*And imagine as you breathe that there is a sphere of light at that space between your eyebrows, your third eye, and this ball of light is moving very slowly in space, turning in a circular motion. Let that turning sphere of light, that ball, be the focus as you breathe and as you count. As you focus on this very beautiful sphere of light turning, you are breathing*

in, two, three, four and holding, exhaling, two, three, four. And then do this on your own for about three to four more breaths.

With your next breath, feel your relaxation deepening and spreading throughout your entire body. You just let go. Allow that circular light, that ball of light that was your point of focus with your breath, be a "you" light that you draw into yourself. Draw this light into your forehead and let it fill your head and neck, so it can illuminate all that you wish, all that you desire, and relaxes and deepens you, all at the same time.

Allow this light to flow down your neck and shoulders and your arms. Imagine it, picture it, and create the image. So you can sense and feel and see the best you can, your entire body filled with light—down your arms and hands, your back and spinal cord, your torso, your waist and your hips, and your legs, down to the soles of your feet. Filled with light. Illuminated and shining from the inside out.

And now allow a picture to form in your mind's eye. Imagine you are sitting in a very comfortable chair; picture yourself sitting, deeply nestled, and totally relaxed. See an image of yourself. You are happy, content. And imagine now that it is five years in the future. Imagine it. You are five years older, it is five years in the future, but you are watching it, seeing it, and feeling it as if it is right now.

A deep sense of contentment fills your mind and heart. You are successful and prosperous, whatever that means for you. You have worked hard and achieved your five-year plan. Many milestones have been reached. What five-year milestones did you reach?

Now imagine you get up from your chair, you look around your home, notice where you are living, what is hanging on the walls, the colors of the pillows on the couch. Is anyone else there? A partner, children, pets? Let the images unfold of your five-year plan being achieved. Happy, fulfilled, and content. Take stock of your life, your work, and what you are most proud of.

Imagine you look out the window and you love the view. See it and sense it in as much detail as you can. Imagine your life, your home, the view, the feel of the carpet or wood floor as you walk to the window. Feel a gentle breeze on your cheek as you stand next to the open window, smell the flowers in the vase on the table next to you.

You hear laughter and smile to yourself. All is well in your life and career. It has been five years since you embarked on this refocused career path. What is your business now? What are you doing with your artwork? What job do you hold? What are you looking forward to doing next?

You go back and sit in that comfy chair, deeply nestled and totally relaxed. Allow yourself to move forward in time; it is now fifteen years in the future. Feel that reality, feel that deep sense of accomplishment and awe. You have lived and accomplished a great deal in fifteen years. Imagine you are sitting in that comfortable chair, nestled and relaxed, happy and productive.

Imagine you are fifteen years older, but you are seeing it, feeling it, as if it is happening right now, as today. A deep sense of contentment fills your mind and heart. You have worked hard, and

*achieved your fifteen-year plan. Successful and prosperous. You have reached many milestones in the last fifteen years of your life and career. What milestones have been the most fulfilling?*

*You look around your home, and notice where you are living, notice the artwork hanging on the walls, the colors of the pillows on the couch. It is fifteen years in the future. Notice who else is there—a partner, children, grandchildren, pets? Let the images unfold as you move around this room that you love, taking stock of your life and your work. What are you most proud of having achieved? It is fifteen years in the future since you embarked on this refocused career path. What are you doing now with your business? What is happening with your artwork? What job do you hold? In the fifteen years you have been focused on creating a new art career, what has made you the happiest and the most fulfilled?*

*See yourself walking to the window in this room and looking out, and you just love what you see. Let the memories of all that you have created in these last fifteen years wash through you, fill you with contentment. What do you feel yourself gravitating toward next? How has your life and work changed over the years? What do you most value about this time that you have spent creating, working, and growing? What do you need to accomplish in these fifteen years? What do you need to understand in order to have no regrets?*

*And you return to that comfortable chair once more, deeply nestled and totally relaxed. You sit there and see an image of yourself closing your eyes. You move forward in time once more, and it is thirty years in the future. Amazing. You can feel this reality. Imagine it is thirty years in the future, and you are sitting in a comfortable chair, happy, fulfilled, with a deep sense of awe at all that you have lived, all that you have achieved. Feel the reality as if it is right now.*

*You have worked hard and loved and achieved many milestones in these thirty years of life, these thirty years of refocused career and art and life. You have done so much. What are you most proud of?*

*You look around your home and notice where you are living, notice what is hanging on the walls, the colors of the pillows on the couch. Notice who else is there—a partner, children, grandchildren, pets? Just let the images of your life unfold, thirty years from now. What is next for you? You ponder your next steps as you rise and go over to the window. You look out the window and just love what you see. Your heart is happy. It is thirty years in the future but it is happening today, right now, before your very eyes.*

*See it in as much detail as you can imagine. Feel the breeze on your cheek, smell the flowers in the vase on the table next you, you can even smell the cooking aromas coming from the kitchen. You hear laughter. Your life is good. Your career is sound and fulfilling. Your role in the community is sound and fulfilling.*

*You breathe deeply and smile. You are content. You have done well. It has been thirty years since you embarked on this life, this refocused career path and role in the community. What are you doing with your art? See it. What are you doing with your business? With your job? In the thirty years that you have been focused on creating this new art career, what has made you the happiest? The most fulfilled?*

*Let the images unfold as flashes of knowing.*

*You now know that there is plenty of time to achieve all that you dream of. You know deep in your bones that you can create the role in the community, the career, and role in life that reflects your values and your astounding creativity.*

*As you imagine what you want as if it already exists, you have opened the door to letting it happen. You know this to be true. To be your own guide, all you need to do is close your eyes and remember. Remember who you are.*

*When you are ready, at the count of three, you can open your eyes. One, two, and three.*

---

JOURNAL NOTE:

*Take a moment to write down how it felt or anything you saw, heard, or discovered.*

*Write down the achievements you would like to reach in five, fifteen, and thirty years. Use your visualization experience as a guide for your automatic writing. And automatic writing means just that: just put pen to paper or fingers to keyboard. Don't censor or judge.*

---

## EXERCISE—MY CAREER MILESTONES

*1. My life and career in five years:*
*What are the milestones, major achievements, you reached (want to reach) in five years?*
*2. My life and career in fifteen years:*
*What are the milestones, major achievements, you reached (want to reach) in fifteen years?*
*3. My life and career in thirty years:*
*What are the milestones, major achievements, you reached (want to reach) in thirty years?*
*4. Which of the earlier possibilities that you mind mapped showed up in your visualizations? What does this tell you about your priorities?*

---

Priorities begin to unfold as we look at what we want to achieve and when. We take the steps one at a time and, before we know it, we've climbed a mountain. Our vision guides us, our milestones inspire us, and our goals motivate us. Your life plan, business plan, career plan consist of all three elements.

Now it's time to create goals based on your vision of possibilities and milestones. Don't get nervous. Goals are simply dreams with deadlines, remember? I'll take you through it one step at a time.

# ໆ6ŗ

## Uncovering Your Long-Term
## and Short-Term Goals

*"A bird doesn't sing because it has an answer, it sings because it has a song."*
—Maya Angelou

Now that you have visualized your life and career from now to thirty years down the road, it is time to set the stage to define your short- and long-term goals. You've visualized your day-to-day life and the accomplishments that will matter most to you. Let's focus in and explore them in more depth.

### CREATE GOALS THAT MOTIVATE YOU

Goals motivate us to reach our visions. No one can tell you what your goals are or should be. It is very similar to defining success. Setting goals is very personal and clarifies where you are headed in the big picture. To make your goals specific and easier to manage, set them up from the start with ways that can be measured. That way, you know when you have reached them.

For example, my vision and my big picture is to teach and share creative visualization and meditation as creative deepening and career planning tools, so that creative people can have intuitive access to the world in ways that matter to them. That's my vision. My goals for the short term are to write books, create classes, and expand my audience through web TV and iTunes U. My goal for the long term is to create a meditation garden that serves as a sculpture museum and a residence program for creatives to attend, so they can have a tranquil space, time, and funding to write, make art, and create ideas that they can then share with the world. Those are my goals.

From there, I'll make them specific (the number of books I will write, the number of classes I will teach) and add dates (when I hope to publish and how often I will teach), so I can create milestones (stages to reach with each goal for this year, in five years, fifteen years, and thirty years), so I know where I am in the process and can feel successful.

Usually we measure how far we have come by outlining particular milestones—the key moves and accomplishments we need to reach along the way in order to achieve our goals. Again, using myself as an example, my milestones for this year were to write one book (this one), and add two classes to my schedule, which I have done. Over the next five years I want to add an iPad version of this book, create a new website with an online version of my classes, and begin planning an audio/video channel on YouTube of my meditations, etc.

You make your goals as clear as you can and you make them specific to your vision. As your vision becomes more specific, goals easily arise in your mind's eye and then milestones appear as things you want to do. Before you know it, you begin to recognize what you are looking for in the material world, and you feel lucky. You can start to recognize your opportunities that you have seen in your heart and mind.

When you can put your hand around your goals in your mind's eye and identify what they look and feel like, you can begin to intuitively know what is true for you. This is the start of recognizing opportunities as you meet them. The mind moves toward what it sees. You can switch out the details at any time because the vision that leads you forward is a concept that underlies all of your goals and dictates each milestone you reach for.

Initially, I worked it out through a mind map that I drew in my journal. See the following page.

From there I created my goals. I looked through all of my bubbles in my map and then made my goals list.

It works like this. Spell everything out as best you can, spell out your vision, your goals, your milestones. I let it all spill out on the page, as you can see from my journal shot above. And then ask yourself how you are going to accomplish these goals. As you turn your vision into concrete goals, you will decide what to act on now, and what you will leave for another day, many ideas need more marinating time. As long as you move forward knowing that not everything you want to accomplish needs to be acted upon right away, you don't get overwhelmed.

I've long understood that the act of writing things down clarifies my thoughts. It helps me develop a timetable and marketing language and ideas to sell my vision to others. I start scribbling and then I set priorities. It always starts with your vision and then moves to what you want to achieve.

Create Meditate

Classes
- webinars
- articles
- eBooks
- teleseminars
- coffee mtp
- blogs
- websites
- calendars

Meaningful moments
- community
- connect
- motivate
- inspire

Product
- Jewelry
- Books
- Statues
- Cards
- Food Gifts
- Videos
- t-shirts
- stickers
- plush toys
- carvings
- canvas

Topics
- unspoken serenity
- relaxation
- Vison
- community
- culture
- astronomy
- music
- physics
- philosophy
- subvise
- transportation
- walking meditation
- art
- spiritual
- visualize

Audience
- Creatives
- Artists
- Students
- Graduates
- Spiritual Seekers
- Meditators
- Yoga enthusiast
- Musicians
- Photography
- Moms
- Animal Lovers
- Rehab

Services
- Characters
- Speakers
- Sellers
- Reading
- coaching

Astronomy
Life

Start with your long view and then work your way to the present. For example, let's say that your thirty-year vision is to be known as the best painter in America. Why does that matter to you? Write down your answer:

*I want to be:*

*It matters to me because:*

Now ask yourself, how will I do that? What is essential to you in reaching that goal? If we continue with our example of being known as the best painter in America, in my view compelling, beautiful, successful work is essential to achieving that goal. You will also need a solid visibility and marketing plan.

Ask yourself again, how will I do that? How will I create compelling, beautiful, and successful work? Perhaps you have to make more time to be in the studio to make that work. Perhaps you need to up your skill set and take a digital media class because you've always been fascinated by tech and light and can see your paintings electronically activated, working with scientists and maybe engineers. So next, you write down your answers to the question of how.

*How I will do (fill in the blank):*

And again, how you will do the above, and again how, and again how . . . Keep asking how. Those will be the action steps you take and will eventually form into your milestones so you can measure your progress in reaching your goals.

Do you see how it's done? Simply break down your vision into a series of goals. Goals are what motivate you and ensure that you reach your vision. Asking yourself how you will do it will lead you to creating the milestones to mark your journey.

The next step is to add the element of time. Ask yourself:

1. What do I need to do now, this year, or the next?
2. How will I do it?

Give yourself a starting date and put it on your calendar! Some people like to assign themselves ending dates as well. Go with your wiring, every creative manages their time in their own way. I personally don't like feeling trapped by time: I like start dates and I am flexible with my end dates. For example, I'll set "finish one chapter per month" as a milestone for writing my book, but I won't set which day of the month. I want it finished by a certain date and work backwards. For my wiring, that is realistic time management, and I always reach my milestones and goals because my vision matters that much to me. As long as you are reaching for your goals, meeting your milestones, setting realistic dates, and changing them as you have to do (life always intervenes), you can accomplish anything.

SET INSPIRING MILESTONES

So go to your calendar and mark a date—I will start on:

Plug in an end time—I will finish by:

Let's do it together. It could look something like this to begin the process.

---

## EXERCISE—I WILL DO THIS

*My thirty year vision is:*

*Example: Be the best painter in America that I can be.*

*My goals:*

*The first goals I want to reach this year are:*

*Example: more studio time, learn about marketing, figure out my audience.*

*My milestones:*

*This is what I would like to create in the studio in one year:*

*This is what I would like to learn about marketing my work in one year:*

*This is what I would like to discern about the right audience for my work in one year:*

---

You see! Not so hard; you've taken your thirty year vision (in our example of being the best painter in America) and turned it into current and actionable goals for the upcoming year. And in the process you've broken it down into bite-sized pieces, your milestones.

Remember that your career is a work in progress. If you try to make each milestone a part of where you want to go, it will be happy making. Keep your goals aligned with your vision. Be the artist, the designer, the creative you want to be.

Based on your vision, let's lay out your goals and milestones. Using your answers from the Career Milestones exercise from chapter 5, let's do the following.

---

## EXERCISE—HOW I WILL DO IT

*The major achievements (goals) I want to reach in thirty years are:*

*This is what I need to accomplish (milestones) to make this happen:*

*a)*

*b)*

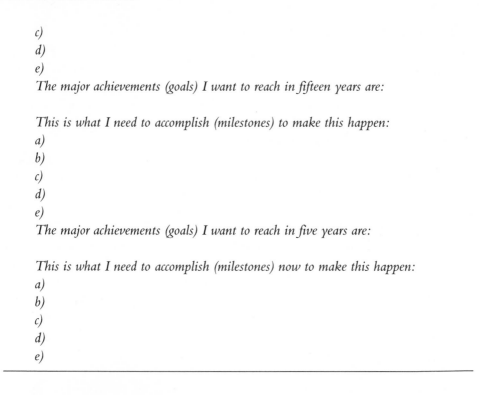

*c)*

*d)*

*e)*

*The major achievements (goals) I want to reach in fifteen years are:*

*This is what I need to accomplish (milestones) to make this happen:*
*a)*
*b)*
*c)*
*d)*
*e)*

*The major achievements (goals) I want to reach in five years are:*

*This is what I need to accomplish (milestones) now to make this happen:*
*a)*
*b)*
*c)*
*d)*
*e)*

Don't be afraid to set goals, because you can change them. It is your life and it is your career, so it is your timetable. It takes practice to set goals and milestones. We don't always get it right the first time. Sometimes we have to assess and reassess our goals and change course. That's OK. You can change your plans, adapt what you will do and when, and reorganize your milestones. It is your life and career plan, it is your vision and no one can take it from you.

You change as you grow. Your work and consciousness evolve and, over the years, you will change direction many times, change priorities, and make a few course corrections. Keep moving toward your big picture as it changes and the details will follow and fuel your momentum.

## DETERMINE WHAT IS DOABLE

Goal setting is a mix of visualizing staying on top of what matters so you are properly guided and setting up action steps to make it happen. Wishing your life into being is not the way. Visualize what you wish for, allow your intuition to guide you, and then determine what is doable and when. Then, with practical effort, make it happen. When you have tangible goals and a clear idea of what you're working toward, you can have bench marks to work with. This keeps you moving

in the right direction. You will know that your efforts are building toward a larger vision of the success that you have defined.

And I can tell you from personal experience that this is a wonderful feeling. Meaning and purpose are motivational qualities when they arise from within you. Sometimes life looks different from how you imagined it to be. That's OK. Adapt, express, make your world better. Life takes time. Take a deep breath and periodically allow yourself to reflect on how far you've come. We don't reward ourselves enough or give ourselves enough credit for the hard work we do.

The visualization and self-exploration work you've done so far will help you make your career and role in the community real in the world. Think of your goal setting process as a drawing, the sketches you do before a major work. The major work is offering the gift of your creativity through your career. For many creative people the visioning process is easy and fun and the focus on goal setting a bit more difficult and sometimes scary. It helps to energize the vision and know that your goals will make everything that much more doable and profitable.

Michelle Ward, the "when I grow up coach," has a series of great free exercises you can download from her website that help you remember why this matters to you.[14] Here is one I really like. Let's remember why you want this career and energize your vision in the process. Fill in your answers to the following questions:

---

## EXERCISE—ENERGIZING MY VISION

*I'm moving forward with this career because?*
*I can succeed in my career because?*
*I care about my career because?*
*I want to make a difference in my career because?*

---

Once energized, you can focus on your goals. Let's visualize your goals through the lens of your career destiny.

---

## VISUALIZATION—YOUR CAREER DESTINY

*Get Ready.*

*Bring your attention to the normal rhythm of the breath by simply focusing on your breath in and your breath out. Relaxing as you breathe. Don't worry if you are doing it right or not. Just let it happen. You are developing a "witness" attitude. Just watch it all happen as it happens, without judgment. Promise yourself: today I will not judge anything that happens. Enjoy this feeling of sitting, breathing, and enjoying the stillness and a quiet*

*mind. Breathe in and out. When you feel calmness and a sense of quiet, allow yourself to be in this stillness. Enjoy it.*

*And following your breath let yourself relax. Releasing worry, releasing deadlines. Just taking this moment in time for yourself to explore your authentic voice. Take a few deep breaths, let them out, and when you are ready, let your breath return to normal.*

*Imagine that you are sitting in a special screening room. There is a big screen on the wall in front of you, and as the lights dim you see the screen come to life. There is music and the screen lights up. This is the movie of your life and it is playing on the screen right in front of you. A movie you have written and directed.*

*It is your movie about your career and creativity, your life and happiness. You are excited and know this will be fabulous. You are moving forward with your career because it matters to you, and you know it is for the right reasons. You have a sense of mission in your career, your creativity, and your life is in balance. See this happening on the movie screen in front of you.*

*You can succeed in your career because of many factors. People you know, skills you have, circumstances you create and respond to. See all of these factors pass across the screen in front of you. You are well-known. You are recognized as an expert in your field. Notice what you are known for, how your fame came about, what you are respected for. It is for all the right reasons. See it all play across the screen in front of you.*

*Imagine that your caring and values are part of your success. It has taken time to make a difference in your field. It has taken time to reach your goals. Everything has come in its right season. Notice how you have maintained your momentum while reaching your goals. See the difference you have made in the world with your work, with your co-workers, your audience, your studio. See how many people you have touched with your work.*

*Imagine that your search for the right goals led you to create the right career path and destiny. See your goals culminating in a happy, productive, and meaningful career. See the story of your life and the reaching of all of your goals play on the movie screen in front of you. Be entertained. Be enlivened. Be inspired.*

*And when you are ready, at the count of three, open your eyes. One, two, and three.*

---

JOURNAL NOTE:
*Take a moment to write down how it felt or anything you saw, heard, or discovered.*

Your career destiny is a path you activate with confidence as you set goals and meet your milestones. You need a plan that can reflect your goals and milestones to bring any creative idea into reality. Without a plan most of us will not get very far.

An important skill to practice while you develop goals is clarity and turning vague goals into clear goals. You want your goals to be clear and specific, not vague and open-ended. Here are a few examples:

| VAGUE GOALS | CLEAR GOALS TO ACHIEVE IN SIX MONTHS |
|---|---|
| Plan my business | Write and finalize my business plan |
| Make money | Make $5,000 a month starting in 3 months |
| Sell my photographs | Sell two editions of 10 C-Prints |

Goals should also be measurable. The more concrete your goals are, the easier it will be for you to reach them. If they are too vague, you won't be able to gauge your success and maintain momentum. For example, set a goal to write and finish your business plan with a start date and end date within six months. Or set a goal to create an exhibition visibility strategy to implement in six months to get three new showing opportunities.

At the end of six months you'll know if you met that goal easily. You either did it or you did not. That is how you make your career plans, life plans, and business plans feel doable. You create a picture of what it looks like when it is accomplished, then set your goals and time frame so you can create key action moves and do them. Then see what happens. Afterwards you can evaluate. Evaluating means reassessing your efforts and creating new key moves. It does not mean blaming anyone or stop doing your work, simply adjust your goals as you need to, based on the market response your efforts generated.

Your goals are your friends and they are your allies. Do not look at your goals as adversaries you have to conquer or avoid. Good goals are effective and clear because they help you reach your vision. You can recognize when you have accomplished them. After you have written out a goal, ask yourself "Will I be able to recognize this if I reach it?" If the answer is yes, then you are on the right track. If your answer is no, then rewrite it.

Put your goals in front of you. Read them. Carry them in your wallet or tape them to the front door. Draw them as a picture. In later chapters, we will create a vision board for your goals. Goals can inspire you and you have a right to be inspired. There are so many wild cards economically that you have to work around, so this goal-setting process is an important factor in staying focused. Have you ever written a to-do list and then checked an item off? How did you feel? That is what you are trying to replicate with goal setting.

Pick one thing each week that you can do to move yourself closer to reaching your goals and milestones. Pick one thing each month that you can do. Pick one

thing each year that you can do. Perhaps your one thing is to meditate on your peace of mind and release doubts. Then do it. Perhaps it is going to the studio three times a week for the next three months until you create a new drawing and performance piece. Excellent, do it. Or perhaps it's attending a meet-up in your specialty and talking to three new people every month until your network has grown by fifty. Any action that moves you toward your goals is a key move for you.

Believe in your ability to be happy and succeed and believe in your right to succeed. Help yourself help yourself. Make goals that are clear and specific; create milestones you'll be happy to accomplish. Goals will give your personal vision momentum for each career stage you are in.

I know this part was not easy. If you skipped it, stop. Take a deep breath and go back and do the exercises. Take a stab at defining your goals as clearly as you can. In the next chapter, we will take it a step further and create strategies and outline tactics for your action steps.

# ❧ 7 ❧

## Develop Strategies and Tactics to Reach
## Your Dreams

*"They can because they think they can."*

—Virgil

We create our careers based on the roles we want to play in the world. Our visions reflect that dream of what we want to accomplish. Our long- and short-term goals illustrate how we will get there. To get there, to accomplish those goals, you need to develop strategies and tactics. You need to decide which actions you will take to reach your goals and how you will take those actions.

There comes a time when dreams need practicality, and this comes in the planning process. And the time for that is now. In order to build and maintain your career and role in the community, you need to make a plan. You need to draw on your resources, both internal and external, to form strategies to make it all real. Your self-confidence is one resource to draw on and your skills, talents, and strengths are another.

Your creative skills, talents, and strengths along with your self-confidence and belief in yourself can be utilized in your strategies and tactics. These personal resources are tangible and internal, and they are cultivated over time with maturity, experience, and determination. Visualizing yourself reaching your goals and affirming each step is one strategy you have been practicing throughout this book to build your self-confidence. Mapping out your ideas and key moves through written exercises and mind maps have been another.

Now you apply this self-knowledge as you review your life and career plan and set the strategies to reach your goals. This can have an inspiring and motivating effect and will help you create something real and valuable for yourself and your community.

Strategies always need to be prioritized and based on your wiring, then crafted into action steps. Your natural temperament will determine which strategy, which of your strengths and abilities you are more drawn to utilizing first and communicating. The strategies you are drawn to naturally are the ones you are likely to use, so those should be initiated first. That is why not every strategy you read about is for you. You need to be true to how you operate in the world. Work with your strengths. Work with your nature.

The best strategy in the world works with your personality, not in contrast to it. So it is a very individual set of strategies that you will need to develop. They will be tied to your definition of success and how you approach your inner resources and career.

The following is a summary of ways to approach your next steps and develop the strategies that are best for you. Joanne Wickenburg talks about finding a meaningful career through the use of astrology in her book *In Search of a Fulfilling Career*. It's one of my favorites. She came up with a wonderful set of metaphors for the elements of fire, earth, air, and water in career planning. These metaphors create great images for how we approach life and naturally get things done in the world. These images are described below.

Wickenburg tells us that all of our strategies grow out of our motivation to be ourselves in the world, and I agree. In the process of sketching out how to get things done, you will see that you are naturally drawn to one strategy more than another, although you will need to enact all in some measure for a balanced and centered approach to your life and career.

WAYS TO APPROACH YOUR NEXT STEPS: FIRE, EARTH, AIR, AND WATER

My goal here is to introduce you to these four elements as ways to look at approaching your career strategies for success. All of us need inspiration and opportunity (fire), practicality and value (earth), flexibility and curiosity (air), and flow and nurturance (water).[15] But we naturally use one element first and tend to prioritize our strategies accordingly.

To reach your goals, notice as you read through the descriptions below which ones you identify with and are drawn to first. Knowing what to draw upon within your nature, and the strategies to create for the outcomes you wish for, allow you to make a plan that fits you. This list of elements and metaphors apply so well to every aspect of career and creative work, from how we

get ourselves up for what we do, to how we actually get it done. Wickenburg describes them beautifully, and I've expanded on them below. Let's review them one at a time.[16]

## FIRE/INSPIRATION AND OPPORTUNITY

The first strategy is fire, representing inspiration and opportunity. When you use inspiration as your strategy to reach your goals, excitement and enthusiasm will lead you forward toward success. Use your inspiration and your openness to seek new opportunities to move you and others, to propel you and others, and to open your eyes to what might happen. Being open means initiating and starting things. I definitely relate to fire and, when I feel inspired, I can do anything. It is my main strategy to accomplish my goals. I have to be inspired or I fall into inertia and don't do anything. I know I have to create the space to encourage and inspire myself to get things done.

So if fire is your strategy, "you can do it" self-talk can keep your inspiration flowing. Create ways to access your inner cheerleader and be a cheerleader for others. That is an excellent fire strategy. Meditate on your creative potential and the potential that surrounds you and this will keep you moving toward your goals.

## EARTH/PRACTICAL AND TANGIBLE

The second strategy is earth. You can think of earth strategy as practical and tangible; something you can hold in your hand. When earth is your strategy, do something physical, make something tangible. Make it valuable to you and others. Hard work and the results of your hard work will lead you toward your goals. Perhaps you make a product or prototype, or a book or website, something that is useful and valuable to others is a great earth strategy. Earth strategies are slower than fire and more practical and tangible. If you are fire oriented and a dreamer, start with inspiration and then follow it up with earth. Get excited and then get practical.

An excellent earth strategy would be to evaluate your visions and meditations to date and pick one that feels possible and doable. Let your dreams and visions inform you and inspire you, and then let earth strategy connect you to the realities of what is valued today and use that knowledge to reach your goals. This will ground you and lead your dreams to success.

## AIR/FLEXIBILITY AND COMMUNICATION

The third strategy is air, which you can think of as flexibility and communication. Air is how we learn; our intellectual understandings and perceptions. Learning

how things work and seeing how they are all related. Connecting the dots and then communicating what we've learned. Using air as a strategy, you talk, you listen, you research, you study, and then you share. You use and develop social networks and put all of your social skills into play. You get the word out about your work. A great air strategy is talking and meeting people, networking, attending openings and benefits.

Another excellent air strategy is keeping up with industry trends and adapting to what you uncover. Let what you learn by reading, talking to people, and your innate curiosity guide you to be flexible on your career options and products. By being fluid and nimble you can meet your goals successfully.

## WATER/FLOW AND CARING

The fourth strategy is water, which is another way of saying, "find the flow of your process and care for and nurture your productivity." Plant the seeds of your intentions and water them so they can grow and blossom in their right season. How do you do this effectively? Your water strategy means you build a strong emotional foundation of support. You need to nurture your ideas until they mature and not give up on them or yourself. Go with the deep creative flow and relate your ideas to your goals while you nurture your creativity.

Pay attention to how you feel about your progress and focus your efforts on moving everything along. Build a supportive community that will help you finish what you start. When you use water as a strategy, you need to allow your deeply felt intuition to guide you to take the right steps to reach your goals. You develop trust in yourself and surround yourself with trustworthy supporters. I personally believe you can manifest what is meaningful for you, in your career and in your life, by applying water strategies. This means feel your way forward and use your ability to focus your intentions on your plans and action steps.

You can start from a place of inspiration and end with a supportive community. Or you can start from a need to create tangible value and end with curiosity and social networks. We use all four elements in our strategic plans and ways of thinking and making things happen. See which one you are drawn to and start with that. As you develop a better understanding of the strategies you use to expand your inner and outer resources, you become more productive in the world and this affirms your choices. You initiate the right action steps toward fulfillment and meaning in your career because you are intuitively working with your own wiring and those are the best strategies in the world.

Let's deepen your understanding of how each one works through the following visualization meditation.

## VISUALIZATION—MY STRATEGIES WORK; MY GOALS ARE MET

*Get Ready.*

*Bring your attention to the normal rhythm of the breath by simply focusing on your breath in and your breath out. Relaxing as you breathe. Don't worry if you are doing it right or not. Just let it happen. You are developing a "witness" attitude. Just watch it all happen as it happens, without judgment. Promise yourself: today I will not judge anything that happens. Enjoy this feeling of sitting, breathing, and enjoying the stillness and a quiet mind. Breathe in and out. When you feel calmness and a sense of quiet, allow yourself to be in this stillness. Enjoy it.*

*And following your breath let yourself relax. Releasing worry, releasing deadlines. Just taking this moment in time for yourself to explore your authentic voice. Take a few deep breaths, let them out, and when you are ready, let your breath return to normal.*

*Imagine that you have all the resources and talents you need to reach your goals. Your dreams are reachable. What would you like to reach by the end of this year? What personal goals do you have for this year? What creative goals? What business goals?*

*See yourself utilizing the strategies you most need in your life, creativity, business, personally, to bring you success. Do you need inspiration? See yourself using inspiration as a strategy to reach your goals. See yourself open to all the possibilities regarding your future. See yourself successful in the world because you can visualize your future possibilities, make new goals, and be open to what tomorrow might bring.*

*Imagine that your enthusiasm is contagious and that you can keep inspiration flowing. As you pursue your goals and see your future change, what do you do? How do you do it? See inspiration leading you to achieve your goals. What are the goals you achieve through inspiration?*

*See yourself utilizing the strategies you most need in your life, creativity, business, personally, to increase your success. Do you need practicality? See yourself creating something tangible and valuable; see it materialize as a result of your efforts. Imagine that you can achieve your goals through making something tangible and valuable.*

*Imagine that your strategy to reach your goals is to create a product or series of products that are useful and valuable to others. Imagine that you make something useful from what you have envisioned as possible. Imagine that your ability to be practical and productive is your ally to lead you toward your dreams. What are the goals you achieve through practicality?*

*See yourself utilizing the strategies you most need in your life, creativity, business, personally, to bring you success. Do you need flexibility and understanding to meet your goals? See yourself knowing things, understanding how things work and are related. Adapting easily to meet your goals.*

Imagine that have the ability to communicate and share your ideas and your work easily. Imagine that you are stimulated by what you learn and read and hear and can move your career plan forward with an open mind, motivated. You can achieve your goals and you can stay up on the trends in your field. See yourself using your innate curiosity as your ally and letting go of a need to stay with what you know. You meet your goals with curiosity and flexibility. What goals do you meet through communicating?

See yourself utilizing the strategies you most need in your life, creativity, business, personally, to increase your success. Do you need nurturing and perseverance to meet your goals? See yourself developing the perseverance to nurture yourself and your work to maturity. See yourself plant the seeds for growth and build strong emotional foundations of support and community.

Imagine that you can nurture your ideas over time and meet your goals. Imagine that you can pay attention and focus your efforts to meet your goals. Imagine that you have a supportive community that helps you meet your goals and that you can count on. What goals do you meet through perseverance and nurturing?

Affirm silently to yourself, "I am all that I need to be successful, I am worthy of being a success." Affirm to yourself, "I believe in my right overcome all obstacles and be a shining light in my community." What strategies and actions can you start taking now to ensure that you reach your goals?

And when you are ready, at the count of three, you can open your eyes. One, two, and three.

---

JOURNAL NOTE:

Take a moment to write down how it felt or anything you saw, heard, or discovered.

BASIC STRATEGIES AND TACTICS

As we practice seeing ourselves reaching our goals, utilizing the internal and external resources that come naturally to us we feel more confident. We are working with our wiring and not according to someone else's idea of how to get things done. All goals can be attained through initiating action, expressing yourself creatively, and expanding your belief in yourself. These are the basic strategies. Then you need to be resourceful, know your strengths, design practical techniques to share your skills, and build your reputation in the world.

You will do it through communicating, relating to others, forming relationships, joining groups, building community, taking leaps of faith. You will keep going by shoring up a strong emotional foundation, allowing yourself to handle change well, developing faith and commitment to your creative practice, and having a role in the world that matters to you, no matter what it is. And keep going, nurturing yourself and letting yourself stop when you are tired and start again when you are rested. Fail,

yes, at times you will. Success without failure is not real. It is necessary. Knowing that, will help you expand when you feel like contracting. These are the basic tactics.

INITIATING ACTION: MIND MAP YOUR WAY FORWARD

Let's make a mind map for success of our first year's goals, strategies, and tactics to implement. What strategies and actions can you start taking now to ensure that you reach your goals? Map it out. Use your visualization as your guide and fill in your strategies. In later chapters, we will make an action plan.

Your map should include what you would like to achieve in the first year. So fill in your personal goals, creative goals, business goals, and financial goals. Decide what you would like to accomplish this first year and put it on your map. Then think, which strategies will you use? Fill that in next on your map, add, subtract, multiply—have fun! Remember:

a) Fire Strategies/Inspiration and Opportunity
b) Earth Strategies/Practicality and Value
d) Air Strategies/Flexibility and Communication
e) Water Strategies/Flow and Caring

This is a map of how you will do it, so make sure you include what you think your key moves are. Make this work for you and have fun. It will guide you if you let it.

---

## EXERCISE—MY MIND MAP FOR SUCCESS: STRATEGIES FOR THE YEAR

*Place your goals for the next year on your map. Make a list, but differentiate between your creative, personal, business, and financial goals. Under each category, write in what your goals are and when you want to reach them—that means pick a date. Then allow yourself to brainstorm—one to three strategies for each of the goals listed. Move the types of strategies around so they reflect your natural inclinations and which goals they will help you reach. For example, practical and tangible strategies might be best utilized for business goals, but you might prefer to use practical strategies for creative goals. So, add that type of strategy to creative goals if that feels right to you, and subtract the ones that do not feel right. Maybe you don't want flow and nurturing goals for creativity. Subtract that one, or move it to personal goals if that feels right. Do you get the picture? Make the map work for you. Go with it, have fun with it. Allow both far-out ideas and obvious ideas to enter the picture. Be as specific as possible. See the sample below, for an idea of what your blank template could look like.*

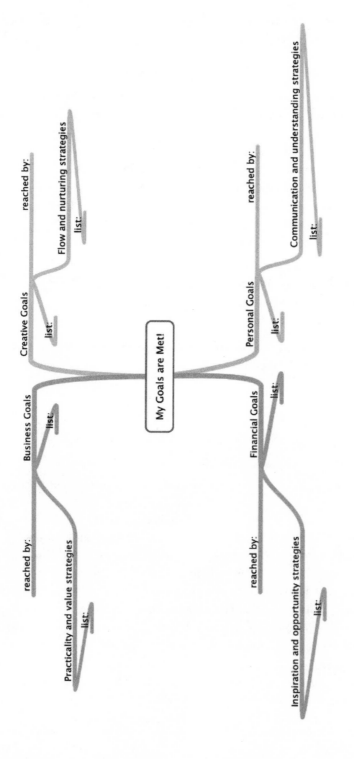

My Goals are Met!

Creative Goals
reached by:
Flow and nurturing strategies
list:
list:

Business Goals
reached by:
Practicality and value strategies
list:
list:

Personal Goals
reached by:
Communication and understanding strategies
list:
list:

Financial Goals
reached by:
Inspiration and opportunity strategies
list:
list:

TIMELINES AND BUDDIES

How do you keep it all on track? My favorite recommendation is to draw a time-line to help you stay organized. I like seeing from start to finish what I'm planning and the flow of it. You can draw it as a fish from tail to head or an arrow moving from left to right. Or a straight line or a circle. Create a shape you love, that you are drawn to. A spiral would work nicely as well. The function of a timeline is just how it sounds, it's a guide from start to finish that helps illustrate the movement of time. It will show you how to move along the map you created for yourself to reach your goals. It has start dates and mid dates for milestones and end dates. Yes, we have reached the "when" factor.

---

## EXERCISE—MAKE A TIMELINE

*Draw a shape on a piece of paper. And then create a series of cross hatch marks across the outline of the shape you choose. Decide what dates to plug in, so those cross hatch marks represent the milestones you've outlined. Then define each mark, write in the goal, the key move and the milestone. You have a time-line. It could be in the shape of a Buddha or a fish or an ocean. What image do you want to use for your timeline? Pick one and then place your dates along it.*

---

A timeline can be used to help you work with inertia, procrastination, and distractions. You want to encourage yourself to be productive in moving your life and career into those meaningful pathways you've spent so much time visualizing. Make your timeline beautiful. Make it tangible and physical. Use beautiful colors or make it textured, use fabric or felt, or rice paper. Timelines are a great way to help you with any project or to produce your work or project. What do you want to end with, and when do you want it done? Start there, and then work backwards to the beginning.

If you find that you have set unrealistic dates for yourself as you review your timeline, then change the dates. Create a new timeline to follow, change the hash marks—make it work for you.

Setting realistic timelines with start and finish dates is important. Remember, you are trying to help yourself move forward, not set yourself up for self-sabotage. When you set unreachable or unrealistic timelines, you set yourself up. Many art-ists do this without even thinking about it; we set the bar too high and too soon, and then get depressed and frustrated. What is helpful in setting up a realistic timeline is that it gives you a chance to review your steps and strategies, and break them down into smaller and more doable key moves. The smaller the moves, the

clearer the desired outcome will be. And that is good. You can measure those much more easily, so make sure you have bite-sized steps to take rather than giant steps, and place them on your timeline.

Sometimes, in addition to timelines, we need buddies or meeting with a creativity or career coach to help keep us on track. Trying to build your career alone does not often work; you will need a support system. Knowing this in advance will help you create an effective timeline. Put meeting with your buddy or coach on your timeline. Identify where and when you will need help, and who can and will help you. Be prepared to be surprised, because you will be successful. As you find the right pace for yourself and identify with your message, collaborate and redefine your business model, both your creative work and your timeline will evolve.

## GOALS ARE DYNAMIC

Reaching your goals is a dynamic process; they change all the time and your route to them changes as well. Allow change to be your friend. Consistency comes from a strong foundation of belief in your work and in yourself. The actions you take to making it happen in the world are changeable. As you bring your consciousness to bear on your art and design practice, your creative career building will bring a feeling of self-reliance that will be your bedrock.

Once you set out on your action steps and start to move along your timeline reaching your goals, notice what actions you took. Pay attention to which key moves worked and which ones did not. See if some of your goals led to more successful outcomes than others. Ask yourself if you can create variations on these themes so you can repeat those successes. You plot out steps and you take chances. Then you assess your strategies, see what you need to change, and you turn the wheel again. Some things you will repeat, others you will not. You learn from your mistakes as well as from your successes.

Your creative mission is based on what matters to you: your vision. And it's a great feeling to lay out a timeline and a course of action based on a vision. That vision is your heart happy, personally defined, successful route to your right livelihood. You've proven yourself to yourself.

Whether it's trying new marketing efforts or new day jobs, creating new work in new mediums for new audiences, your timeline will help you return to a place you can call your own.

So now you have a vision, you have goals, strategies, key moves, and a timeline. *Congratulations.* Your goals set the stage for your career. You've answered the basic questions: What do I want to accomplish? Why do I want to do it? How will I do it?

You've allowed a picture to form in your mind's eye to guide you. You self-assess, you map it out, you create timelines, you journal and brainstorm, but ultimately it comes down to action. You begin to take the steps to get there. Remind yourself that you are moving your career into the world from a central idea, a mission if you will, and all that you create will feel right. Then follow your action steps to your goals.

As you picture yourself making a meaningful impact in the studio or on the job, start now to imagine balancing all of your roles at work, in the community, and at home. See yourself as effective. As you clarify your vision, your goals begin to make more sense and take on a feeling of "this is really doable." And that's a great feeling. Then creating your action plan is a piece of cake.

Remember that any map, any chart, any list, any tool that helps you keep your focus and maintain momentum is a strategic tool. The trick is finding the right tool for you. How do you know which one is right for you? If you try it, and like it, and repeat it—it is the right one. It's the one you *do*. It is as simple as that. Doing is the best strategy to make your dreams come true.

That is why there are hundreds of career planning books on the market, each one offering a different version or a slight variation on the themes I've presented here. I love the visioning and focusing that arises from intuitive insight, and I love the self-exploration process. I find that if you understand the elements that motivate you, you can use these clues to how you are wired to give you the resources you can draw upon to strategize for your own success.

These are the tools that have fueled my own success and well-being. I offer them to you to try. Your job is to experiment and keep the ones that work for you because you are drawn to doing them. All roads can lead you to success if they speak to you. Knowing what you want is your first task. Walking your talk and getting there, is the second.

The more energy you put into the clarity of your vision and the groundwork for reaching your goals through understanding your internal resources, the sooner you will get there and the happier you will be. You will know the steps to take and you will take them.

Then, when you set up your action plan, you'll follow it. Following a happy plan you have defined is the bottom line.

# ⁊8⁊

## *Clarify Your Vision*

*"To exist is to change, to change is to mature, to mature is to go on creating oneself endlessly."*
—Henri-Louis Bergson

Clarifying your vision means testing your dreams against what you know about yourself and what you know about your field and defining the details. It is both moving your vision to a new level by adding a reality test to your equation and seeing/feeling that the ideals you have created are doable and reachable. You clarify your vision to get clearer about your direction and the results you are looking to attain. You begin to move out of the realm of "me" into the realm of "you," and see where they meet. Let me explain.

According to the Merriam-Webster dictionary the definition of *clarify*:[17]

—to free of confusion <needs time to *clarify* his thoughts>

—to make understandable <*clarify* a subject>

You clarify your thoughts and your visions and then make them understandable to others, so they get what you are trying to say and how you want to affect the world. Then they can purchase your work, hire you for work, pay you for your labors. Doesn't that sound wonderful? To be an artist and be understood and to be free of confusion? And on another level, to understand what you want and how you will get it? To know your value in the marketplace and your value to yourself and your community can be two different visions, both requiring clarity and serendipity. Imagine how that clarity would bolster your belief in yourself. To clarify, to understand. To be assured.

One of the first advantages of clarifying your vision is that it reinforces your self-confidence. When you know whether to turn left or right, you feel more

secure. The use of visualization is ideal for this purpose so you can begin to delve deeper into the details and see each one as you would like to see it and as you would like to feel it.

Adding this level of detail to your vision and career plan will help you make a deal with reality that provides the impact you desire. Your aim is to lay a solid foundation for your action steps.

## INTEGRATE YOUR IDEALS AND YOUR ABILITIES

Let's start out with a career foundation exercise. Write down your answers to the following questions.

---

### EXERCISE—YOUR CAREER CLARITY

*Motivation*
*1. I know what motivates me to try harder, excel, go for it, grab the brass ring. What motivates me to work this hard is:*

*2. I know what I both like and dislike in my work, in working for others and with others.*

*What I like:*

*What I dislike:*

*Expertise*
*3. I know the skills, abilities, and expertise my field requires. I can offer clients, collectors, dealers, curators, editors, directors, and employers a lot!*
*I can offer:*

*4. I can communicate my expertise, talk and write about what I do well and enjoy doing in my field.*
*I like to talk about:*

*I like to write about:*

---

Thoughtful visioning and clarifying the details you offer streamlines the remaining steps of putting your career into motion. You take that knowledge

and move the focus onto who is the right audience, partners, galleries, cultural organizations and companies that would be compatible with your goals and abilities. Then you market yourself with a foundation of knowledge and confidence.

Clarifying your vision is a lifelong practice, one that most people return to again and again over the course of their professional careers. As you gain work experience and your audience grows, your creative direction, your vision, and your interests and values are likely to grow and shift as well. You can return to these exercises to help you move confidently into new areas of work and career throughout your life.

## YOUR IDEAL LIFE AND CAREER

Let's take a closer look at your ideal career scenario through the following meditation on your ideal life.

---

## VISUALIZATION—YOUR IDEAL LIFE AND CAREER

*Get Ready.*

*Bring your attention to the normal rhythm of the breath by simply focusing on your breath in and your breath out. Relaxing as you breathe. Don't worry if you are doing it right or not. Just let it happen. You are developing a "witness" attitude. Just watch it all happen as it happens, without judgment. Promise yourself: today I will not judge anything that happens. Enjoy this feeling of sitting, breathing, and enjoying the stillness and a quiet mind. Breathe in and out. When you feel calmness and a sense of quiet, allow yourself to be in this stillness. Enjoy it.*

*And following your breath, let yourself relax. Releasing worry, releasing deadlines. Just taking this moment in time for yourself to explore your authentic voice. Take a few deep breaths, let them out, and when you are ready, let your breath return to normal.*

*Imagine you are living the perfect life. What is your perfect life? Picture yourself living it in your mind's eye. See yourself. What are you doing? Where are you? Is anyone else there? Allow this image to form. You are living the perfect life and you are happy, you are productive, and you are successful.*

*Let the image become clearer with each breath. Allow the details to materialize right before your eyes. You are doing your work; you have an awesome creative career. You are happy, you are productive, and you are successful. What is your ideal life like?*

*What do you do when you get up in the morning? Do you do yoga, pilates, run in the mornings, meditate? Do you go to a gym or for walks? Where are you living? What is your social life like? Who are your friends? Your family life? What are your hobbies and interests?*

*Now focus in on the details of your creative career and on your work life. Imagine that you can see it working seamlessly, happily. What is it like there? What kind of people do you work with? How do they dress? What kind of work are they doing? What does your work entail?*

*Observe the atmosphere, the culture. What is it like? Is it low-key, relaxed, with elements of routine? Is it fast paced and filled with lots of projects and variety? What is your role?*

*See all of this in as much detail as possible. Allow the power of your imagination to guide you, and your self-awareness to ground you. See how you nourish yourself artistically, spiritually, politically, or socially. What are you contributing to the world? How do you give back?*

*Add any further details that are important to you and sense this experience as if it were already happening. Now imagine you are sitting in a beautiful chair, and you notice a coffee table beside you. On it is a magazine with your photograph on the cover. You reach over and pick it up and it is such a great feeling. The magazine is filled with articles and features about you.*

*Articles about your work and accomplishments, your home and family life, filled with photos and illustrations. You look at all the photographs, smiling as you notice what you are wearing and who is with you. You read the main article that is quite lengthy, about what you gave to the community, your creative gifts, and your accomplishments. You read this carefully, noting that they got it right; what really mattered to you is talked about accurately and presented beautifully.*

*There is a section on all the people who helped you and whom you have helped along the way. It is a career path you are proud to have lived. You place the magazine back on the coffee table and lean back, enjoying the feelings of fulfillment and satisfaction at what you have created over the years and who you have touched. Your vision is clear.*

*And when you are ready at the count of three, open your eyes. One, two, and three.*

---

JOURNAL NOTE:

*Take a moment to write down how it felt or anything you saw, heard, or discovered.*

As you explored your ideal life in this last visualization did anything surprise you? Does your ideal job change? Does your creative career become more public or private? Sometimes we strive to create creative careers for ourselves and we discover that everything we touch has a creative flair or idea behind it, regardless if it is an object or concept. It's an interesting question to answer if we can identify as artists whether we create an object or not for public display.

Your work may be a conversation with your own soul or it may be a line of toys you have designed. It might be a performance piece in the MoMA project room in New York City or an idea for a transmedia web TV series. Your medium

can be your personhood, your blog on civil liberties, or choreographed public actions as part of the Occupy movement.

As you clarify your vision and image of who you are and want to be, your image of your ideal audience or client, and your image of your ideal business and location, is there a thread that connects your ideals with your business and audience regardless of what you are providing to them? Is there a message and demographic that is beginning to look like a target market for you?

Let's use your senses a little differently to clarify your vision as you write down the details. It will stretch your definitions and be fun.

---

## EXERCISE—CONNECT THE DOTS; USE YOUR SENSES

*Write down every detail that comes to mind including the sights, sounds, and smells of your life and career.*
*What does your ideal life sound like?*
*What does your ideal career smell like?*
*If you were to do one thing in your personal life that would have the most positive impact, what would it be? If you were to do one thing in your professional life that would have the most positive impact, what would that be?*
*Are they related? Is there a thread between them, a way to connect the dots?*

---

### SERENDIPITY AND SYNCHRONICITY

Opportunities come along all the time. Some we feel we have orchestrated and others feel like they are happenstance. Serendipity and synchronicity are part of the process. If you find a resonance with an opportunity and it is connected in some way to what you have envisioned for yourself, that is a clue to go for it. See where it leads you. However, if it puts you on a different road completely than the one you have visualized in these exercises, then perhaps you need to ask yourself if this the right opportunity.

Be willing to consider any opportunity as right for you or wrong for you. Ask yourself if you will you lose your way if you follow a different path? You will know. Because you have seen it, sensed it, smelled it, heard it, drawn it, mapped it. Trust your instincts. Let your intuition and your knowledge of what is possible guide you so you can feel the strength in your choices, no matter which path appears before you. Trust that you will recognize your opportunities and find a way to walk your talk, no matter what it looks like from the outside.

The concepts that you sketch out from your visualizations and exploration exercises are what guide you. They help you to understand the details that you are

searching to actualize. Recognize them as concepts that are representative of what is possible. Let your clarified vision lead you to do the things in your professional and personal life that would have the most positive impact for you and for your community, and the details will follow. Let yourself fail and change and you will never lose your way because you know where you are going.

Now let's chart the road and mark the map to see how you will get there.

## PART 3:

# How Will You Get There?

*"Whatever you can do, or dream you can, begin it. Boldness has genius, power and magic in it."*

—Johann Wolfgang von Goethe

# ↝9↜

## *Assembling an Action Plan*

*"First principle: never to let oneself be beaten down by persons or events."*
—Marie Curie

We've spent a lot of time together dreaming, visualizing, planning, and keeping career goals at the forefront. In this chapter, we are going to pull it all together into an action plan for the coming year.

Concentrating on career action steps and creating your work at the same time is a skill that takes practice. You will not get far if you do either one with half a heart. Creative mind and business mind need to be bridged. If you resent the business side, it's just not going to happen. Doing work in the world requires visioning, planning, and taking action steps. If you are not a staff person and are an independent creative, artist, photographer, or run your own studio, be prepared to spend 50 percent of your time marketing your services.

Truth be told, I hate planning. I have to force myself to sit down and make my lists of steps and when. But a funny thing happens when I do: I feel a flow happening and a confidence building. And I know from experience that I can just about do anything if I set my mind to it. So I ask myself, how I can help myself reach my vision? That picture of meaning that drives me forward. I picture it and brainstorm the steps. You can picture it—you already have. Now it's time to get serious about brainstorming your steps. You will find that keeping your eye on the prize is easier because of it.

## PLANS ARE FLEXIBLE TOOLS

Plans are guidelines, not rules. There are some things you cannot control, some outcomes that are part of your goals that just are not going to fly. So you will find over time that you will have to let them go. Your plan and your lists are flexible and changeable. Like your goals, your plans are dynamic. Accept that doing some things is necessary in order to reach your desired goals. And this does not mean you are "selling out," or buying into either the myth of the art-star or the starving artist.

You can focus on what the intention is of your work and why you need to put it out there into the world. Your desire to plant recognition seeds through a series of steps you take and meditations you practice is a very worthy effort. There is no reason why you cannot come up with a plan to earn a fair profit from your work. This is practical and creative combined. You can follow a map you have designed as you allow the destination to be changeable. And all the while, you remain fluid and nimble.

Fluid destinations are the great paradox of planning. We need to organize and lay out steps, while understanding that we might just create something other than what we planned. That's probably the part of planning I actually like. Being open to serendipity and surprise.

But regardless of how you feel about planning, the fact remains that you must get things done and you must take steps to move it along. This means trying out new angles on your career and life dreams, while reinforcing your will to do them with purpose. This will allow you to set priorities and focus your willpower. Once you focus and harness that will, you can use your intuition and your smarts to make clear business decisions that mean something to you. Your intuition and smarts are the foundation of a good life plan, and your focus and will are what it takes to act on it.

## ACTION PLANNING—BIG LIST OF SMALL STEPS

It's really not that hard to write up an action plan. There are a series of steps to take, and before you know it—voila! First step, you clarify your vision. Second step, you clarify your goals. Third step, draft a plan of bite-sized steps to move you in the right direction.

To make sure you don't get overwhelmed, you break everything down into smaller and smaller steps, put them on your calendar, and reward yourself for getting them done!

As we did with your strategies to reach your goals in chapter 7, let's start with what you want to accomplish in the first year. You already have four basic goals for the year and the strategies to reach them from your Mind Map—My Strategies for the Year exercise. Let's do a quick visioning exercise to clarify your goals, and then we'll be all set to lay out your action steps.

## EXERCISE—VISIONING YOUR GOALS AND OUTCOMES

*Close your eyes, and get a visual picture of your clarified vision and the goals you outlined. See your strategies leading you to the expected outcomes, both personally and professionally. See where you want to be in one year. See where you want to be professionally and personally. See it clearly. See your strategies working, your goals being met. How will you know when you have reached your goals and milestones? How will you measure your success? Let the answers come to mind. Feel that out for a moment with no worries, no judgments. Just get a sense of what you need to do and how you will know that you reached a successful resting point.*

Now let's brainstorm your to-do list. This is a list of actions you can take to make the strategies work and meet the goals of the next year. You are going to brainstorm every action that you can think of. Yes, this is going to be a really big list. You will need a few sheets of paper to write it all out in your journal, or you can type it up in your notepad on your phone or iPad.

You have an idea of the strategies you want to initiate. At this step, you are focusing on generating a really, really big list of steps for those strategies. Write down any step you could take, as many different options and ideas as you possibly can, that will help you to reach your goals. For each action you write down, just keep asking yourself, "how will I do that?" And write it down.

Write down more and more ideas as they come to your mind. Don't judge, don't analyze, and don't censor any of it. That comes later.

## EXERCISE—ACTION STEPS

*My business, financial, personal, and creative goals for the first year are:*
*1.*
*2.*
*3.*
*4.*
*My really big list of action steps:*
*I will do this/these steps in one month:*
*I will do this/these steps in three months:*
*I will do this/these steps in six months:*
*I will do this/these steps in nine months:*
*I will know I reached a resting point when:*

Now get up and take a break. Go for a cup of tea now. Take a breather. Then come back.

Look at your list of action steps; what do you think? Now is a good time to start to edit some out. Ask yourself, what is needful here? What is probably not going to do much for me? Put a star next the ones you feel will be the most effective steps. This is the beginning of prioritizing, and it helps you to remain sane to sort the list and pick ones to focus on first. We don't do everything on our lists! That's the trick; we pick and choose and allow some items to wait.

OK—so you have put a star next to some of your steps. Which ones do you drop or cross out? The ones you feel won't have a significant effect on the outcomes you are trying to accomplish, or the ones you really feel can wait a while. Important tip: don't forget to mark the ones that you know you won't do. If you would rather put pins in your eyes than actually do that step, mark it as something you have to hire someone for. Some steps we don't do ourselves; we hire people to do them.

Now comes the organizing and prioritizing. Take a good hard look at your steps and move them around so your steps actually start to look like a plan. The flow of what you will do in one month, three months, six months, and nine months is starting to make sense to you; that at least is your goal on paper. So look at your list of action steps and decide on the order of your action steps.

Then as a double check, look at all of the actions that you marked earlier with a star. Read each one, and, one by one, ask yourself what other steps you need to complete before you take that action? Is there anything that has to happen beforehand to make that starred action make sense. If so, add that step to your list. If not, you are ready to create the sequence of steps. Excited yet?

---

## EXERCISE—SEQUENCE YOUR ACTION STEPS

*Rearrange your action steps and rank your ideas on your list into a priority order. Include your starred steps and all the following steps in a sequence of first, second, third, etc. That way, you know what you will focus on for each time period. Make sure the steps are in the right timeline: one month, three months, six months, or nine months. Don't be afraid to move stuff around until it feels right to you and the sequence of the steps makes sense to you.*

---

You have the beginning of a plan of action. Look it over, walk away, and then come back to it. Does it seem too complicated? If so, simplify it. Maybe you should really do less, maybe should really do more. Think about it. Then take the first step. Just do it.

Climbing a mountain of 10,000 feet starts with the first step. Reward yourself. Do something fun and know you are on your way. Keep your eyes open for omens, and new hunches, and then make an addendum list and add it into your action plan. Each time something occurs to you, tie it into your goals and see when that step should happen and fit it in. If it doesn't fit with your goals, ponder why it comes to mind. Should you do it? Will it distract you or enhance you? Be honest. File it away or do it. That's all there is to creating action plans.

Career and creative direction is often revealed in retrospect—when we look back after a million steps and many mistakes and hours in the studio or on the job. Your plan is a guide, not a rule book. It is OK to be afraid to take that first step or the last step. It is OK to fail. I'll say that again: *It's OK to fail*. Do it anyway, try a different route. Your action plan is a dynamic plan, which means it changes as you see what works and what doesn't. You might not get it right. So what? Some strategies are effective where others are not; you will only know by doing. Your action plan will be a way to keep you organized so you can easily access the steps you take to reach your goals and milestones. And take the pressure off yourself; know you will figure it out.

Your goals are moving targets. Your life plan—what matters to you most about the life and career you are creating— well, that is what guides the whole process; your intentions are everything.

I first read about using life plans as the prelude to writing a business plan in the book *StartupNation* by Jeff Sloan and Rich Sloan when I was researching advice for entrepreneurs. A life plan is a guiding map of what matters to you, and they advise you to fit your business ideas into your life plan, not the other way around.[18] Love that!

Your clarified vision is the base of your life plan and it allows your vision to have impact in the world by putting it into an action plan. Your action plan is a written guide to help you focus your efforts. As you move and grow with your career, your action plan will build confidence in your ability to be a business person, and it will keep you organized. You might not even notice that you are being a good business person.

It will flow if it is tied to your life plan. And you will feel good about getting out of bed in the morning, because you know that what you are doing matters

and will have results. You have a plan for your life, for your art, for your business, and it is all in sync with what matters to you.

Make sure that your action plan has specific tasks for you to do. This is going to be where you lay out what will be done and by whom. Place your actions into the right time frame, don't rush it. Your timeframe means when it will be done, so that part has got to make sense as well. The last consideration for your action plan is to keep in mind the resources you have, both internal and external, along with any limitations or constraints you have to work around. What specific funds are available for specific activities, how have you budgeted to do the things on your list, and what and who can you count on? Knowing what and who is supporting you or holding you back can make a big difference.

Empower yourself with good business practices to help move your career goals forward. There are so many great books to refer to for this, so make sure you check out the resources section at the back of the book. You can be just as creative in business as you are in the studio. And you can hire or barter with people to help you in the areas that you are not comfortable with.

MAP STEPS FOR BUSINESS, CREATIVITY, MONEY, AND COMMUNITY

To make sure you have accounted for all the steps you need in your first-year action plan, let's map it out and see if you missed anything. This will also reinforce your commitment to take action and give you visual clues to follow. Include any additional steps that come to mind such as:

a) Business steps: steps to build audience and steps to build your brand
b) Creative steps: steps to build skills and steps to build your portfolio
c) Financial steps: steps to secure funding and steps to make money
d) Personal steps: steps to grow and steps to form community

---

### EXERCISE—MIND MAP OF ACTION

*Go with it and have fun with it. Allow any additional ideas to create new action steps to enter the picture. Be as specific as possible. See the sample on the following page for an idea of what your blank template could look like.*

---

# More Ideas for My Action Plan

## Creative Goals for the first year
- Steps to build skills
- Steps to build portfolio

## Personal Goals for the first year
- Steps to grow
- Steps to form community

## Business Goals for the first year
- Steps to build audience
- Marketing
- Steps to build brand

## Financial Goals for the first year
- Steps to building funding
- Sales/Grants/Commissions
- Steps to make money

Perhaps making a traditional table in Word for your action plan appeals to you more. Here is one to fill in:

## EXERCISE—MY ACTION PLAN TABLE

*I plan to accomplish:*

| Specific actions to take | When I'll do this | Resources I have to do this | Resources I need to do this |
| --- | --- | --- | --- |
| Step 1 | | | |
| Step 2 | | | |
| Step 3 | | | |
| Step 4 | | | |
| Step 5 | | | |

Action plans require commitment and they require follow-through. They require self-reflection and self-editing. While following your action plan, look at it as a test of your dreams where there are many right answers. So if you take a series of steps and they don't seem to be working, you can change the steps. Be willing to test your dreams against what you know about yourself and what you know about your field, while assessing which steps work and which ones don't.

Commit yourself to making glorious mistakes with your action plan. Then adjust it and try it a new way. Your plan will help you take the steps you need to evaluate your progress. Don't give up. Work it. Push it through. There is magic in being you.

Let's finish this chapter with a visualization meditation on casting your intentions out into the world.

## VISUALIZATION—MY INTENTIONS HAVE WINGS

*Get Ready.*

*Bring your attention to the normal rhythm of the breath by simply focusing on your breath in and your breath out. Relaxing as you breathe. Don't worry if you are doing it right or not. Just let it happen. You are developing a "witness" attitude. Just watch it all happen as it happens, without judgment. Promise yourself: today I will not judge anything that happens. Enjoy this feeling of sitting, breathing, and enjoying the stillness and a quiet*

*mind. Breathe in and out. When you feel calmness and a sense of quiet, allow yourself to be in this stillness. Enjoy it.*

*And following your breath let yourself relax. Releasing worry, releasing deadlines. Just taking this moment in time for yourself to explore your authentic voice. Take a few deep breaths, let them out, and when you are ready, let your breath return to normal.*

*Let the silence and calm within you and around you envelop you. Let that level of being, of spaciousness, comfort you. Then let a picture or series of pictures of your goals come to mind. And then release each picture, each one of these goals, into the wind, as if your goals had wings. See this, imagine this. Your goals all have wings and fly on the wind. See each picture, each goal, flying up and into the wind to be carried and fulfilled.*

*See your wishes for a successful career have wings and fly. Imagine your intentions of your success as a flicker in your awareness and release it on the wind. Your intentions have wings and can fly on their own. You can create excellence in the world, and release that beautiful intention of excellence as a flicker of your awareness. All of your goals, all of your good intentions, have wings and fly on their own.*

*Your ideas are part of the fabric of creative potential and you can cast your intentions out into the world and make your world and your community a better place. Hold this beautiful image in your mind's eye as your goals take off and fly. Your actions and your intentions are released to blossom in fertile ground. Know this to be true.*

*And when you are ready, at the count of three, open your eyes, feeling charged, replenished, and ready for action. One, two, and three.*

---

JOURNAL NOTE:
*Take a moment to write down how it felt or anything you saw, heard, or discovered.*

Can you plant the right seeds for your career this year? If so, what or who is supporting you? If not, what or who is holding you back? In the next chapter, we will create a momentum calendar and create a series of momentum gifts to keep it all moving along smoothly.

# ↰ 10 ↱

## *Create a Momentum Calendar and Vision Board*

*"My philosophy is that not only are you responsible for your life, but doing the best at this moment puts you in the best place for the next moment."*
—Oprah Winfrey

This chapter is about building a visual system to help you with time management and attracting your visions to you through visual clues. A momentum calendar will inspire you and remind you of what to do and when. A vision board is a collage of your goals that you design, which will reinspire you and, some people believe, will draw to you what you are reaching for. Both tools will build your momentum and guide your intentions.

To do this, you select a series of pictures to represent your visions from meditation—pictures that represent your goals and milestones—and then create a collage. This vision board and calendar will move your momentum forward and help make your dreams reality. Time management has never been so much fun, creative, or so ultimately satisfying.

### VISUAL TIME MANAGEMENT TOOLS

As we discussed in earlier chapters, goals and action steps require start dates and end dates. When fixing your mind on your creative goals, business goals, financial goals, and personal goals, your time management system becomes very important. How are you going to juggle all the demands on your time and mind? Break everything down into pieces and pictures. Pieces are manageable steps and pictures are representations of what you desire that inspire you to take those steps. Keep it

visual, and keep it inspiring. Pick a picture that represents the start, pick a picture that represents the end, and place them both on your calendar.

An artist's logic is vision driven. You are more logical than you think. You do things because they make sense to you and usually because you feel compelled to do them. We are not talking about binges or addictions here; we are talking about creating. The images you create, the products you produce, all make sense to you. Maybe not to your parents, or your children, or your partner, but to you they do. Only you know what matters to you and what you can see as your future. Only you can decide which pictures or photos will aid your momentum. Pick pictures that represent ideas that make you light up inside. Pick photos to represent the highest road for you and what your visions will look like in the world.

## INSPIRE YOUR NEXT STEPS WITH A VISION BOARD

We each have an individual calling accompanied by visions and the necessity to lay out our next steps. The logic behind why certain pictures give you momentum while others don't, and the reasons you choose to tell your career story with certain colors and patterns instead of others, will be driven by an inner reasoning that resonates with your own individuality. And this will help you to take the right steps.

The pictures or photos that you choose to represent your milestones and goals will build your momentum and allow you to manage your time and your goals. Each time you look at these photos you will feel energized.

You created a timeline already and a few mind maps to guide you. Now it's time to put pictures where your mouth is (so to speak) and illustrate your goals, action steps, and results of your actions steps with pictures. The intention here is for your vision board and calendar to guide you and motivate as well as inspire you to take those steps, energized and organized.

You've written out your visions, dreams, and ideas in many different forms throughout this book. As you get ready to create the vision board and momentum calendar, stop for a moment and reflect. Review your mind maps and journal notes. Are you planning for the creative career you really want? Is this what you really want? If you find that you are repeating the same answers over and over but not getting to the heart of your work, stop for a moment. Make sure you are passionate about your dreams. Go back and change something on your vision statement or action plan. Reassessing and making changes is a natural process; our goals are dynamic and flexible, or at least they should be. Sometimes our dreams have passed their sell-by date, and we didn't even realize until now that this is not what we want anymore. Before you create your vision board, switch it around until you find yourself excited about it.

Ready? Let's make a vision board first. What is a vision board? A vision board is a way to express the images that arise in your mind's eye from your visualizations and meditations. It's probably the most fun tool in this book. It is a very powerful tool, because it works on the idea that, in addition to what we vision for ourselves, through the power of focusing on concrete imagery, we can direct our focus and help ourselves bring those images into the world. Vision boards are sometimes referred to as goal boards, goal maps, or even treasure maps.

For creatives, this is a great way to plot out your steps because it is so visual. Similar to the mind maps where you used words, now you are going to work with pictures or photos. Think of your vision board as a collage of career and life elements you need, wish to have, wish to actualize, and wish to see yourself doing or becoming or having over the course of your career. The purpose will be twofold. One, it will aid you in activating your consciousness to recognize what you want to attract and create in your environment. Two, it will aid in focusing your choices and allow you to choose wisely, because you will recognize what you see as what you have planned for. You will also see how it fits into your planning process and timetable of milestones.

## THE GIFT OF RED

The mind moves towards what it imagines. Many times we move closer to our intentions because we have visualized them. We program ourselves to recognize a series of images as important because they matter to us. These images carry our attention and focus. In truth, we see what are looking for and we do not see what we are not looking for. Below is a simple exercise that will illustrate this point for you. Through practice and refocusing, you can put that power of intention and attention to work for you towards your goals.

In his book, *Attack Proof*, John Perkins talks about developing awareness as a simple yet effective form of self-defense. It's an awesome book, and I felt when I read it that his concepts of awareness, of the "importance of training yourself to casually notice your surroundings all the time," could lend itself to life and career planning in a big way. I took his passage about "notice people wearing red shirts or men with moustaches" to a different purpose.[19] I have adapted the following exercise for my clients and art students. Try it.

---

### EXERCISE—SEEING RED

*Next time you are walking down the street on the way to your studio, job, or school, pick a color to look for, any color. I usually suggest the color red. Walk*

*down the street and look for each instance that you see the color red. Count the number of times you see something that is red. Count street signs, store signs, cars, clothing, flags, anything at all that is the color red. Feel how present you are and aware as you walk. Notice everything, but count the objects that are red only. Do the same thing the next day, on a new block. Look for how much red you can see. The same block you have walked a million times but never noticed all that red. Now you will, everywhere you go.*

You will be amazed at how much red you discover. You see it now; you see it today—because you are looking for it! That is the key. It has always been there but you did not see it before. Now that the color red is on your radar, you will see it everywhere.

The same logic applies to your career visions and the elements of your career plan. This is why you take your images from meditation and create a vision board. It helps you to remember what you are looking for, and when you can see it. In the case of your career, you can do something about it. If you do not see an opportunity, you cannot take action. As you train your mind and eyes to recognize the opportunities and uncover the possibilities that the pictures on your vision board represent, you can take actions on these opportunities as they present themselves. That is the gift that keeps on giving. The gift of red. And that is an amazing tool to have in your career tool box.

The process of meditating and visualizing was the first step. Creating the mind maps and the self-exploration exercises and journaling was the second step. The third step was your action plan to put in motion. Your fourth step is to create the vision board and allow your conscious mind to follow your dreams and goals through to the pictures they represent.

## PICTURES AND PHRASES

It is easy and fun; we will simply add pictures to what you have mapped out already. Look at your list of goals including business, creative, financial, and personal goals. Brainstorm a list of key words for each of your goals; if there was one word or two to describe each goal, what would that be? These words will guide you to find the right pictures. Use photos you've taken or draw the pictures or find them on the internet. Look through magazines and Flickr. There are no limits on what pictures you use to inspire and motivate yourself.

Your visualizations have already given you a sense of what you are searching for. You can represent your goals metaphorically on your vision board or literally, it's totally up to you. Look for pictures or images that resonate with you and find as many pictures that relate to your career plan as you can.

You can also include words or phrases, poems, or parts of stories to enhance the visuals on the vision board. Words are powerful as are images, and the combination reinforces the deep connection you will have to your vision board.

I probably don't have to say this, but, when looking for images from your meditations, look for images that make you really happy. Your momentum is going to be fueled by your passion and determination and be reinforced by your vision board. This is such a personal process—choosing images that represent the joyful meeting of your goals. Allow yourself to use pictures you love. Every time you look at your vision board you want to be reminded of what you care about, the meaning of your goals, and what they can help you do in the world.

It takes self-discipline to maintain a studio practice, to get started with a new business, to be a creative in the community and in the workplace, and to stay with it until you reach your goals. Start dates, end dates, pictures of what we want it to look like, feel like, even smell like, will help you stay in touch with your goals, stay organized, and keep going.

A few ground rules before you start copying, cutting, and pasting. Keep it authentic, personal, and positive. Be careful of the negative tapes that sometimes play in your head, the "I can't" mindset. Don't choose small pictures that do not inspire you to be all that you are. Do not sabotage yourself by saying your dreams can't happen. Dreams can be adapted—this is not an all-or-nothing life we live. There are many interpretations and ways to apply your creativity in the world; as long as you stay true to the value of what matters, the details can shift. Let yourself be flexible and positive.

Once you finish the vision board, make sure that you hang it up where you can see it, or use it as your screensaver on your computer or handheld. If you print it, take a picture of it and carry it in your wallet. You want to reinforce these positive images of your vision so your momentum will take on an inspired quality from looking at it often. Be careful of giving your power away to others to judge you, however. If you feel that you will have to justify the images to anyone, or will be criticized about your dreams, do not place it where it becomes a conversation piece you have to defend. Keep it private, keep it perfect, and keep it as a powerful guidance system for you to use as you need to.

Let's do it.

---

## EXERCISE—CREATE YOUR VISION BOARD

*Step 1: Create a folder on your computer to place the images you find or use jpgs of your own work. All of your image research is just that: research. Collect all of your pictures without censoring or judging them. Just save them to your image research folder. Initially you want each image to represent an aspect of your visions, dreams, milestones, and goals. If you are drawn to an image, put it in your folder!*

*Variety: You can have pictures that represent your home, your artwork and designs, your ultimate career. A good test to make sure that the images you have selected resonate with you is to ask yourself: Does this image make my heart happy? Does it excite you just to look at it?*

*Match it: Does this picture match your goals, business, creative, personal, and financial? Try to put as many of these elements in your research folder.*

*Step 2: Prioritize and select your images. Go through the pile of pictures and select the ones that truly move you and are the absolute best—the ones that make you feel passionate about your path.*

*Sizing: Crop them so you are working with the central idea of the image, make the image into a share in your life for your vision board.*

*Step 3: Arrange and edit. Be creative. Don't worry that this is a work of art on its own; it is a visual guide of your dreams. You can do this on the computer in Word, Indesign, or Pages. Or you can print the images and make a poster. Edit your images and pick the ones you want to use and in what order.*

*Step 4: Create the circle of success—your vision board! Here is one format you can use:*

*Center of the page: In the center place the image of your big idea for success. That is the largest image and the central one. This image will be surrounded by a series of circles, each circle will be your goals and milestones.*

*First circle from center: Place the images that correspond with your first-year goals. Which ones do you select? Pick a category, perhaps your creative goals, to place first. Select the pictures that illustrate each milestone along the way.*

*Second circle: Next category, perhaps business goals. Place the pictures of your business goals and what those milestones will look like.*

*Third circle: Next category, perhaps financial goals. Place the pictures of your financial goals and what those milestones will look like as you reach them.*

*Fourth circle: Next category, perhaps your personal goals. Place the pictures of your ideal home, ideal partner, perfect health in mind and spirit. Place the pictures of your personal goals and what those milestones will look like as you reach them.*

*Keep in mind that you are using images that represent what success looks like to you.*

There are so many patterns and varieties you can choose for your vision board. Another pattern you might follow could look like this: First, put your picture in the center of what success looks like for you. Write, My Vision (this is the "what I want" picture), and perhaps add an image of who inspires you at the top

as well, followed by an inspiring phrase, and then add pictures of your action steps to success. So it could look like this:

My Vision of Success/Picture to guide me/A picture of who inspires me

An Inspiring Phrase

Reaching my successful goals:     Picture 1     Picture 2     Picture 3     Picture 4

My Steps (this is the "how" I'll do it)

Picture 1     Picture 2     Inspiring Phrase

Follow this with pictures of your support system

Picture 1          Picture 2          Picture 3          Picture 4

What do the pictures you have chosen tell you? Perhaps the process of picking pictures was easier and more authentic than writing about your goals or thinking about them. Go with the flow. Allow your career plan to be dynamic. Is the picture of your goals and big creative career idea what you thought it would be? How do you feel? Make a note in your journal. Write about the experience of creating goals and action steps and finding the pictures to represent your goals. Write about creating your vision board. Let yourself be your best guide to where you want to go. Trust yourself. Think for yourself. You can make a deal with reality and still create the career you long for. Illustrate your own story and see what you learn.

Your vision board should be gorgeous, inspiring, and full of passion for what you are trying to envision in your career and in your life. Update it as your vision changes or as you find better images, ones that carry even more energy and emotion for you. The key is for this vision board to have an impact on you, to create and help you maintain momentum. It should continue to inspire you to take the steps and recognize the opportunities as they appear.

MANAGE YOUR MOMENTUM WITH PICTURES

Once you have completed your vision board and feel passionate and excited about it, it is time to create your momentum calendar. A momentum calendar is a concept I came up with while I was running the alumni salons at the School of Visual Arts. Artists need ways to persevere and maintain momentum. Once again, that time element comes up for discussion. Start dates and end dates are important components of time management. Having a to-do list is not going to be enough

to inspire you to keep going. What do you need to do to take the steps you have outlined throughout this book? To enhance your vision board and your action plan, an interesting idea is to place some of these images on your calendar, to start and to end. You will be amazed at how nice it is to have a calendar that you create with images to inspire you.

Put your goals and key moves for this year on your calendar so you can work toward them. Represent their successful completion with an image on the start date, on the assessment date in the middle, and at the end date. This will reinforce your momentum with images of your success.

I use iPhoto for this, scanning images and then uploading to Apple to create the calendar. You can drag photos to any date and create large monthly images. There are many other companies that do this as well, such as blurb.com and lulu. com. Or you can design and draw your own.

---

### EXERCISE—YOUR MOMENTUM CALENDAR

*Decorate your calendar. You need to want to look at it! It will help you enormously, I promise. Create a header for your calendar using your vision statement and your goals. I suggest that you place it at the top of your monthly calendar as a reminder:*
*My vision is:*
*My goal is:*
*Then pick an image for each month and place it at the top as well. Follow this by placing images from your vision board onto the dates that matter in your timeline.*

---

You know you have broken things down into small enough pieces when you look at your calendar and you go, yes, I can do that. And the picture you have chosen to represent it makes you really happy. If you look at your calendar and you feel totally overwhelmed, don't panic. Simply take the first action step and ask yourself, how can I break this down into smaller steps? Your goal can stay the same, but it might need to be done in five key moves instead of one key move. Maybe you need more time, so adjust your dates. Adjust your plan.

Another way to create a momentum calendar is take your big picture image of success from the center of your vision board and make a few miniature copies of it. This image represents the goal you have in mind. Place these thumbnail images on your calendar at the top of each month's page. And throughout the calendar,

pick one date per month as your inspiration date, using this image as a reminder and motivator. This will help to guide you and make you smile.

Using these tools will help you reach beyond your thinking mind. Let the pictures of what is possible be enjoyable and refresh your resolve. As you move through your life and question what you want out of your career and your creativity, you will find different images to represent success. Update your vision board and momentum calendar with new pictures and new insights.

Creating a vision board and momentum calendar might not be for everyone. But we can get so stressed out by the material world that you might as well find a fun and image-driven way to plan for the present and live your future. You might find that they take the pressure off planning, meeting goals, and thinking about action steps. And the best part is, they work.

# ᛥ11ᛡ

## *Visualizing Great Business Relationships, Research, and Referrals*

*"The more we dwell on what we don't want, the more we get exactly that."*
—Louise Hay

A core principle of any career or life change is pondering and then dwelling on what you do want. If you constantly think about what you don't want, that becomes your focus. What a depressing idea. In this chapter, we are going to focus on what you do want, and expand it to include your market and your audience. Do you know who your market is? Knowing your market means knowing who your audience is.

So many books tell you that you should know this, but no one tells you how to figure it out. You can use self-exploration tools along with your intuition and visioning skills to find the clues, then research and assess what you find to uncover your market and audience profile. This will help you turn your personal vision into a business vision.

Market and audience are key words for the public dialogue your work has with others. Making images is a public conversation. It necessitates an audience. This could be an audience of one or one thousand. Understanding who your audience is helps you to stay creative over time because you do not work in a vacuum. If you think about it, you are working in seclusion but in dialogue with an unknown other. Very romantic really.

I like to think of career building as a romantic endeavor; it is a dance of my truth meeting your mind. How more intimate can you get? You are building a

bridge to your public through your work. And in the process, you evolve your career no matter how you define success and no matter what you do as a career. We are all in this together. We are a community. And, as we have said so many times before—it is not about you, it is about the conversation your ideas and your productivity have with "them."

Over the course of your career, you will come back to self many times to check in and help you to sustain your business. And then you will go back to your audience to build your business, expand your business, and at times redirect your business based on what they need and how they understand what you provide.

And through it all, you will find ways to form community and keep on going through the lonely times and the "oh my god, I can't believe how successful I am" flush times. It is a back and forth between private searching and public testing, through "don't know what I'm doing," to this worked out great. Creative mind says, "let's make that again," while business mind says, "let's figure out why it worked and see if we can replicate it and make it a model for other markets or other audiences."

## FINDING THE RIGHT AUDIENCE

In career management, we say you gather info on self and then gather info on others. You find where they fit together through research, relationships, and referrals, which are the building blocks of a career. An artistic career is built from the same building blocks. You start with knowing yourself. Then you move on to knowing who is out there, who would appreciate, need, buy your work, hire you, assign you, commission you, and why.

Part of understanding your market is understanding why they want to experience your creative ideas and your artwork and how it makes them feel, what it makes them think, and what it makes them want in their lives. You fill a need and provide a benefit for your market.

Building an audience is like building a relationship; it is give and take and always a two-way conversation. You have to learn to listen generously. You learn to communicate what you mean in ways that others can understand. You figure out if you are being understood and change how you communicate your message if you are not. You listen to what they need and then provide the message of your work so it is meeting that need.

If you understand that, then you will begin to market your work in appropriate and successful ways. You will find that you talk about your work and present your work in the right venues to the right audiences. Your marketing works. And you will feel like people "get" you. That's a great feeling; when they "get you," you feel your work is appreciated and you feel satisfied.

You pick a segment of the market to test your work. Then, based on who purchases your work, talks about it, commissions it, and recommends it, or writes about it, you begin to see who is resonating with your message, your style, and your method. In fine art, this will also tell you who responds to your values and who shares a belief system that your work exemplifies. That is going to be vital to your definition of audience because this gives you clues to your market demographic. Who you are matters to your clients and to your market.

So ask yourself:

---

## EXERCISE—FROM ART TO MARKET

*Who are you?*

*Why do you tell this particular story?*

*How did that start? What happened to you that your message became important?*

*Why do you use the materials you use? The subject matter? The process?*

*What is your story?*

*What is the story you are trying to tell?*

---

For example, does being kind to the environment play a part in your creative practice? Does industrial ecology and sustainability matter to you? Does being gay? Being a feminist? Do you see that reflected in your approach to your subject, or in the materials you use or ideas that you reclaim? Are your values reflected in the topics you photograph or paint or design, etc.? Who might be enthusiastic about that, too? Why would it matter to them? What is their story?

Being able to answer these questions gives you clues to your elevator speech, your artist statement, book copy, press releases, or pitching proposals, etc. . . . all that necessary marketing copy. And it gives you honest, descriptive, and sincere talking points about what you do and why "I" (whoever the I is in this case) should care. That is relationship building 101 and it is necessary and needful. Let people in and give them a chance to connect to you and your vision in a direct and honest way. Let them find themselves in what you do and who you are. Let's go a little deeper in this process and see it in your mind's eye.

The next visualization meditation will focus on markets and the clarity of that market, and what can you bring to mind. Relax. Make a promise to yourself. Today I will allow clarity about my audience to rise into my mind. Today I will be myself and start to understand how to connect myself to an audience. I will make this year a success and connect to others. I will be myself and think about others. I can navigate the roads in front of me. Tell yourself this.

At this point there might be a bit of negativity entering the picture, a few "I can't" talking notes entering your mind. If so, let them, but don't dwell on them. It's natural to doubt. It's also natural to hope. It is the hope factor that you want to encourage and dwell on more. Added to hope comes skilled visioning and planning, and before you know it, you are moving in the right direction with a lot more energy than you thought possible.

## VISUALIZATION—WHAT WILL YOUR MARKET LOOK LIKE?

*Get Ready.*

*Bring your attention to the normal rhythm of the breath by simply focusing on your breath in and your breath out. Relaxing as you breathe. Don't worry if you are doing it right or not. Just let it happen. You are developing a "witness" attitude. Just watch it all happen as it happens, without judgment. Promise yourself: today I will not judge anything that happens. Enjoy this feeling of sitting, breathing, and enjoying the stillness and a quiet mind. Breathe in and out. When you feel calmness and a sense of quiet, allow yourself to be in this stillness. Enjoy it.*

*And following your breath, let yourself relax. Releasing worry, releasing deadlines. Just taking this moment in time for yourself to explore your authentic voice. Take a few deep breaths, let them out, and when you are ready, let your breath return to normal.*

*Allow your focus to be on the rise and fall of your abdomen. Rising, falling, rising, falling. Feeling your relaxation deepen with each breath. You make a promise to yourself. Today I will allow clarity about my audience to rise into my mind. Today and every day I can navigate the roads in front of me.*

*Now, allow a picture to form. See an image of yourself talking to your ideal customer, the ideal client for your services, your products, your artwork. Perhaps your ideal client is the ideal gallery owner, the ideal collector, the ideal creative director, an appreciative fan—your ideal customer.*

*Imagine that you are sitting with this ideal person sharing a cup of tea or coffee. See the two of you sitting together, talking, and enjoying each other's company.*

*You really listen to your ideal customer telling you very clearly his or her most critical, creative needs. What does your ideal customer need? What does your ideal customer need from you? Imagine this. Imagine that he or she tells you how to make decisions on who to hire, on who to refer, on who to purchase. Let your ideal customer tell you how to meet his or her needs.*

*You understand now that there is an opportunity for you in this market. You are perfect for this market. Imagine that you meet your ideal customer's needs. Imagine that you can solve his or her problems and can bring the benefits of your creative thinking and productivity to your ideal customer.*

*Imagine that you can provide the style, the product, the edge your customers are looking for. You fill their needs. See this in your mind's eye. Listen with your inner ear to what they tell you.*

*Your potential clients tell you how to describe your service, your products, and your benefits to others. What do they tell you? Your potential clients tell you what you should feature on your website. What else do they tell you? They tell you where to spend your marketing time and your dollars, so they and clients just like them can find you. What else do they tell you?*

*Imagine that your potential clients are telling you everything you need to know about them, what they need, how you can reach them. Listen generously. Affirm to yourself: I can clearly define my target customers, my ideal clients. I know what they need. I know how to benefit them and reach them.*

*See yourself successfully doing just that, see yourself with a growing number of new clients, new assignments, new exhibitions, new products you will launch. You know what you are reaching for and who you are reaching. See yourself reaching these targets, getting these assignments, having these exhibitions, reaching your target markets. Imagine you are on the leading edge of this market. And when you are ready, at the count of three, you can open your eyes. One two, and three.*

---

JOURNAL NOTE:
*Take a moment to write down how it felt or anything you saw, heard, or discovered.*

## CONNECT YOUR STORY TO YOUR AUDIENCE

In these early stages of creating a road map for your life and career plan, your story line is how you define your creative practice. It will impact your market. As you grow your business vision for your artwork and creative production, it will define your market.

Your story line will grow directly from your vision but it will help you to add a potential market demographic segment to it. Your market consists of anyone in a position to hire you or refer you, or anyone interested in what you have to say. This includes direct collectors, customers, clients, creative directors, art directors, editors, reps, gallery dealers, press, Facebook friends and fans, Twitter followers, classmates, and students, etc. Your market will connect to you through your vision and through your story. Why? Because it is their story too.

Simon Sinek talks about "your why" in a great TEDx talk available from his website. He calls it "inspired action." Sinek says that your market is going to support your creative career in large measure because of "why" you do what you do, because they care about that too. It resonates with them. It is a shared belief or a shared like or a shared value that resonates for them strongly. There is an inherent benefit that they gain from experiencing your work and it motivates them to buy it, support it, talk about it, and want it. Basically you inspire your audience to action. What a fabulous idea.[20]

It is this scary unknown factor—your audience has a shared belief in what you do—that is your true market. I have a hint to share with you: it is not all that

scary, in fact, because your audience is just another version of you. Your work is a reflection of your deepest visions and ideals and values. The market that responds best to your work resonates with those values. They are your mirrors. In truth, we are all mirrors for each other. Deep.

Beauty, harmony, intrigue, diversity, confrontation, making lots of money—whatever it is that you value, your market will value too. Your personal vision is now morphing into business vision. Your clients, customers, and audience will share a belief that you communicate either in your work or in your marketing message. And it benefits them in a way that motivates them to buy your work, recommend your work, write about your work, and support your work. When this happens, you have gotten in touch with the collective "think/feel." These are at times collective conscious attachments and at times unconscious attachments. And all you need to do is put it out there and get the resonance ball rolling.

Whether you create jewelry from mother of pearl or sculptures from reclaimed found objects or create typography from recycled cardboard and animate it, your ideas and values are found in your work. Use that information to uncover knowledge about your market. In your research, pay attention to the language you use to reach them. Spend some time thinking about which market your work is for, based on yourself and your attachments. Then think about why they might need what you produce and what are the key words to use to communicate that impact.

A very good way to start this process of parsing out your audience and the language to describe it is to begin to interview your friends and family, your peers, your support network. Gigi Rosenberg talks about this in her wonderful book *The Artists Guide to Grant Writing.*[21] This is an exercise I love, and it will offer you some great insights. Simply talk to people you trust and interview them about your work. Ask them the following questions and see how they respond. You might be surprised by what you learn, and you can then use this to market your work better.

---

### EXERCISE—INTERVIEW YOUR AUDIENCE

1. *When you look at or experience my work, what questions come to mind?*
2. *Does my work make you think about anything, ponder something, or consider something from a new point of view?*
3. *What are the top three words that come to your mind about me or my work?*
4. *What do you enjoy most about my work?*
5. *Why would you recommend it to someone?*

---

Think about what your friends have shared. What can you do with their answers? How can you incorporate their views of who you are and what you do? Look at your logo, your tagline, your website, and your "About Me" profile. Do they reflect the views of your audience?

When you take a look at the values of your market and your clients, it will allow you to add their point of view to your personal vision. This can create a tie that your audience can relate to. You can then eventually add this to your business plan and use this in your marketing plan. What are the values you share with your audience? This is the heart of your life plan. It all connects; it is all honest and sincere and authentic. Life is good.

Let's do the following exercise.

---

## EXERCISE—MY IDEAL CLIENT AND MY IDEAL MARKET SHARE MY VALUES

*What values are reflected in your creative business or through the artwork or products you make?*

*Name three qualities that define your creativity, your artwork, your business, and your products.*

*How would you describe your ideal client?*

*How would your ideal client describe you?*

*How would your ideal client describe your creativity? Your objects?*

*When push comes to shove, what would you really like to be known for?*

*What would you totally regret people not knowing about you?*

*How would you like the world to be different because you created, laughed, and lived in it?*

---

Think about your relationships and how you network and build community. Are you communicating what you believe in? Can you admit that you need others, and that you need to network? Say to yourself, "I need relationships and I need a network." Repeat this to yourself over and over, because all creativity is a conversation and you need other people to have this conversation with.

## COMMUNICATING HONESTLY AND STRATEGICALLY

Many creatives are afraid of audience and hide in a way that communicates an uncaring attitude. I think you should consider the feelings your work evokes and the ideas your work stimulates. Why and what kind of people are drawn to your

work? What are you interested in thinking or feeling from your own work? What are your intentions for your audience? Thinking this out just might help you find more people who would be drawn to it and to the network your community builds.

From answering the phone to delivering the finished piece, your "brand," your personality, your mission statement, and your artist statement—YOU—need to come across. Your ideal clients expect it and you have to deliver it. Whether you like it or not, you are a collectible. You have a tone and a style. The good news is that what you are delivering is authentic. You just have to know what it is and, in this way, you can strategically share it.

Next question, do you have a brand identity? Do you know how to talk about yourself and your work? Here is a really good exercise to help you think that out. You've already answered these questions in earlier exercises. Now we are going to put it all together in an elevator pitch. Yes, that dreaded phrase. Artists like elevator pitches just about as much as they like networking. But if you think about networking as simply building relationships, and elevator pitches as simply talking about what you value and the value you bring to your work, it gets a lot easier. The trick is to talk about your work in a targeted way.

Here is an exercise that will help you.

---

## EXERCISE—TALKING ABOUT MYSELF

*Before writing your script of an elevator pitch, jot down your answers to the following:*
*1. What matters to the client, to the collector, to the gallery director, the art director, the residency panelists, or the photo editor you are pitching your work to?*
*2. What kinds of projects do they care about and hire for? What exhibitions do they curate? What artwork do they purchase or fund?*
*3. What are they really interested in? Is that you?*
*4. What have they purchased, exhibited, and hired artists for in the past?*
*How is that similar to your work, your ideas, your products, or your projects?*

---

Now that you have answered those questions, practice writing your pitch in a way that meets what they are interested in.

*A good elevator pitch answers the following:*

*1. What you do;*
*2. Why you do it;*
*3. How you do it;*
*4. Where you do it;*
*5. Who you do it for.*

In a few sentences, gather your answers from both exercises above, and merge that info of your ideal client's needs and what you do into an elevator pitch. It usually takes at least three drafts to get something down on paper that you feel comfortable with. So don't be afraid to start brainstorming your ideas and writing out a few sentences. You will organize and analyze it later. What do you say? How does it sound? Practice. Practice with a friend; practice before you go to the next panel or opening or conference. You might feel really silly at first. But when you can identify what matters to your market and then practice putting a little speech together that meets their needs, you begin to identify what is true for you and for them. I find that if I turn it into a game and have fun with it, then I'm not so terrified or nervous. The more you do it, the more confident you will become about talking about yourself.

Doing this much research and thinking about your "appeal" and who it is for, and then practicing writing it and stating it, will also help you "sell" yourself to the right audiences. You cannot expect people who are not interested in what you do or why you do it to be a good match for your work. You can save yourself a tremendous amount of rejection by researching the right demographic, the right ideal client and collector, and the right venue for your work and ideas. And in this way, expand your reach and stay true to your passion and vision. Express it and find the audience that appreciates that expression.

So do your research, know who your ideal clients and customers are, because they are a good fit for you. You know what matters to them and this is what counts. A good elevator pitch is simply a way to express yourself and show that the fit exists to people who don't know you well. Targeted and researched networking raises awareness about you and your work.

Think about networking as building awareness, building relationships, as making friends. Yes, as making friends. Doesn't that sound better than building audience? So impersonal; build friendships instead. Think about what you will do to create awareness among your friends, your target customers, to ensure you are on their radar when the need arises. You need to identify ways that you can create awareness. Back in the day, artists would meet at the bar in the village and talk about ways to create awareness and they called it a movement. You can too.

Lots of things to think about, I know, but building and maintaining relationships and networking takes thought and a sense of purpose. Building relationships should be a thoughtful process, when it is done truly. Make it meaningful. Art and creativity is meaningful.

Ask yourself often, how can I add value to these relationships? How can I help this person or this market remember me and gain value from what I create?

You need to have a strong vision and then you need to connect with the right people. As we've already covered, you have to understand what makes you unique, understand who your audience is, connect with your audience on multiple levels,

and then deliver work that is personal and means something. A client cares because your skill or service will benefit them. Your relationships, your efforts to research, and the referrals you receive and make for others need to be based on this give and take, focused on what benefits your clients.

When talking about your work, sharing stories is a great way to help people connect to your ideas and to you. Some stories to share could be about former clients, your giant successes or giant flops and what you learned from them, or stories from childhood that paved the way for you to do what you do now. Any relevant projects that you've done can work as a great story as well. Be specific with your stories. People love stories. You will not be bragging—you will be educating with examples so the people to whom you are pitching proposals will get an idea of what you have accomplished and be entertained at the same time. Stories make us real to others.

---

### EXERCISE—FUNNY SUCCESSES TO REMEMBER

*Make a list of a variety of your former clients, collectors, and customers. Then, under each one, share a story of a project you did and what was accomplished. What made it a success? Did anything funny happen, interesting, unique, anything at all? Add all of that to your stories. And then, when you are done, read them through and try to come up with your top five success stories. Include the impact you had, the benefits you provided, the results your actions had on the buyer, collector, editor, etc., in each of these stories. Look for something human, funny, or odd, but that had impact. Come up with five stories to share:*

*1.*

*2.*

*3.*

*4.*

*5.*

---

Read your stories over again. Don't you feel more confident now? Knowing that you have specific stories to share with prospective clients or editors and collectors will add a unique element to your relationships because you are sharing personal stories that are unique to you. And you will feel more confident. Stories connect people to us, and these stories will matter to them and help them to relate to you. This can add an element of ease to your relationship building because you will have things to talk about. And it can put you and your work into a context for a prospective buyer.

Now envision yourself telling these stories to a mythical client, collector, gallery dealer, etc. in our next visualization meditation. You'll see, relationship building can be fun!

---

## VISUALIZATION—CLOSING THE DEAL

*Get Ready.*

*Bring your attention to the normal rhythm of the breath by simply focusing on your breath in and your breath out. Relaxing as you breathe. Don't worry if you are doing it right or not. Just let it happen. You are developing a "witness" attitude. Just watch it all happen as it happens, without judgment. Promise yourself: today I will not judge anything that happens. Enjoy this feeling of sitting, breathing, and enjoying the stillness and a quiet mind. Breathe in and out. When you feel calmness and a sense of quiet, allow yourself to be in this stillness. Enjoy it.*

*And following your breath, let yourself relax. Releasing worry, releasing deadlines. Just taking this moment in time for yourself to explore your authentic voice. Take a few deep breaths, let them out, and when you are ready, let your breath return to normal.*

*Close your eyes and picture a networking event. See it clearly. See yourself walking in the door, going to the food table, and making yourself a plate of snacks. As you start to relax, take a few deep breaths as you survey the room. You notice who is there, what they are doing, and who they are talking to. Finish eating and pour yourself a glass of juice and take a sip. You set a goal before coming to this opening that you would talk to two people who you did not arrive with—new people. You decide who you want to talk to.*

*See yourself walking over to the first person you decide to talk to. Smile and say hello. Now from start to finish, visualize introducing yourself and then listening generously as he or she responds. Your new associate enjoys talking, and you enjoy listening. You relax even more, you feel confident and comfortable. He or she makes a joke, and you laugh. You are both feeling more confident and more relaxed. He or she asks you what you do.*

*See yourself sharing your elevator pitch, see yourself very comfortably saying what you do, why you do it, how you do it, and then sharing a story of a recent client success. See yourself launching into this story and telling it. Your companion is interested and listens to you attentively. You feel a connection.*

*Imagine asking this new associate if you can send further materials about your work to him or her. He or she says yes and hands you a business card. You shake hands and say you will be in contact in the morning. See this as the start of a great working relationship. See this deal coming to a very successful close.*

*Visualize yourself closing the deal, getting the work, and making the relationship work for both of you.*

*And then when you are ready, at the count of three, open your eyes. One, two, and three.*

---

JOURNAL NOTE:
*Take a moment to write down how it felt or anything you saw, heard, or discovered.*

## RESEARCH MATTERS

You need both a target market as well as a target industry and target companies, whether these are galleries, museums, advertising agencies, animation studios, flea markets, or design studios. Who is the right person to call or write to? You need to research this. Research is simply detective work. Nothing is hidden from public view. You have to roll up your sleeves and use the web, talk to people, read, and discover. Is there a marketing director, art director, gallery manager, or producer that handles finding the new talent they use? Do they only take artists based on other artist's recommendations? You need to know who would be in a position to refer you, such as a colleague, and you need to know who the person in a position to hire you or commission you or exhibit you would be. Who do you need to know who can bring you in on a project?

When researching for a referral, always start by looking for a contact. A warm contact, someone you know or someone your community knows that you can reach out to in order to get the inside scoop. Alumni societies, your alma mater, are an excellent place to start.

Sometimes it is appropriate to ask for an introduction, sometimes not. You will have to find out, test the waters, and be prepared to make contact or not as is appropriate. Relationship building is not a desperate act, done out of panic. It is a timely, continuous process. Usually it takes longer than you'd like or think it will. But making friends takes time. Sometimes lightening strikes and we are in the right place at the right time. Sometimes it takes seven or eight contacts before we build trust and get to know each other. Either way, building relationships, doing research, and getting and giving referrals is a lifestyle. Start now.

Email panelists you've met at events you've attended just to stay in touch. Research on LinkedIn for names of people that might be good to meet over time, and read their blogs. Follow them on Twitter and read articles they have written. Subscribe to rss feeds for reviews about their agencies in newspapers and magazines, and see which parts of your field are doing well and where you might want to reach out. Build, cultivate, and gather info. Don't blindly email everyone or every place asking for a meeting. That is ineffective.

Every industry has its own submission policy, but no matter the industry or the medium, everyone needs contacts, and your job is to build yours and learn how to get the referrals you will need to build your business. Your ideal clients hang out somewhere and you need to find out where. So you can know where is

the best place to advertise your work or meet your future ideal clients at an opening or panel or conference.

Yes, you probably have a fear of rejection and a fear of the unknown. Most creatives do. But keep in mind that relationships, research, and referrals takes momentum and persistence.

If you think about relationships as something you can provide and a way that you can help, then staying in touch with clients has purpose. You are not selling, selling, selling. You are giving, giving, giving.

This nurtures you and your clients at the same time. Start small. Make a list of your top five collectors or photo editors, etc. If you do not have five good clients yet, this would be a good goal. Simon Sinek suggests that you think about how you could maintain and build these relationships. Take them out to lunch. Give gifts. How will you stay in touch?[22]

---

## EXERCISE—HOW WILL I STAY IN TOUCH?

*Client One:*
*I will maintain and build this relationship by*

_____

*Client Two:*
*I will maintain and build this relationship by*

_____

*Client Three:*
*I will maintain and build this relationship by*

_____

*Client Four:*
*I will maintain and build this relationship by*

_____

*Client Five:*
*I will maintain and build this relationship by*

_____

---

When you nurture your relationships, your success grows on all levels.

# ৭ 12 ৮

## *Affirmations for Achievement and Success*

*"But in the fine arts, in music, literature, and cinema, it is possible to reach a deeper stratum of truth—a poetic, ecstatic truth, which is mysterious and can only be grasped with effort; one attains it through vision, style, and craft."*
—Werner Herzog

Being creative can be a lonely enterprise. We need community to keep going. We need artist buddies to check in with, who help us stay on top of our planning process and creative process. We need a supportive community so we are not left all alone with our thoughts and our demons. Every creative person knows what I'm talking about.

A supportive community is filled with inspiring and passionate people. Some folks help you to reflect, who you can read and feel enlightened by, who help elevate your thinking to a new level. Others you can talk to and receive feedback on your ideas and initiatives, who then encourage you to greater heights. And mentors—folks to follow so you don't have to reinvent the wheel—should be thought of as role models to emulate, who have placed footprints in the snow so you can follow and not fall down. Support, plain and simple, helps us.

### SUPPORTIVE COMMUNITY IS ESSENTIAL

You need to be around supportive ideas and supportive people to help you keep going, as well as to negate the bad tapes running on a loop in your head that whisper, "you can't do it," over and over again in your ear. Yes you can! You can do anything you set your mind to. It's called perseverance. You also need to avoid

the people who, though well meaning, undermine your confidence. Those who say you are crazy to want to be an artist, or who are just plain uncomfortable with your creative thinking. You know who I mean. They could be family, friends, peers, schoolmates, or colleagues. There comes a time in every creative's life when you have to let go of the negative influences that keep you small and make you think you do not have a right to grow, to write, and to create.

With the right amount of support and community you can create the discipline to take each step one at a time and keep going and keep growing. You can persist and persevere and have a long career, an adaptable career. Probably the hardest part of creating an art career is to find the right ways for you to persevere. Cultivating that part of your strategy and accessing the part of your personality that allows for a steadfast attitude is a learned skill. A supportive community helps you hone that skill.

You can learn follow through and develop a steadfast attitude through reinforcing your vision, appreciating your style, and honing your craft. The missing ingredient is believing in yourself. You can learn to persevere and develop a steadfast attitude through positive reinforcement from within, and you can reinforce it from your environment through positive reinforcement from your community. This is why you need the right community.

Invite people into your community, into your network, who in addition to wishing you well, do not judge you or your definitions of success just because they might be different from theirs. Steadfast supporters are those who want you to keep going and not give up, even when you are blocked, even when you are broke. Or depressed. Or lost. There is always a way to express your creativity in the community and carve out a part of your career to meet both the market need and your inner need to create. A creative career might support you financially. It might support you emotionally. It might support you spiritually. You will define what it means to have an art career, a creative career. No one else can. And you will define what it means to say "I can do it."

Expressing your deepest held values in creative ways for a public audience is a skill we develop over time. Creating an ongoing stream of beauty or controversy because your survival as a creative depends on it has to be part of your career plan and your life plan, because many times your sanity depends on it. Deep down you have a creative impulse that is so fulfilling when you allow it breathe, that it makes your life richer, nicer, happier, and more satisfying regardless of whether you do it for a little money, a lot of money, or no money at all.

Creating an art career is different to other careers. Creating an art career is carving out a role for yourself in the community and sharing your vision and changing your world. When you add beauty to possibility you create a renaissance in the culture. And if you can earn a living through it as well, life is good. If you

can augment your living through it, life is good. If you can just keep on making your work and creating a career as a life-long process while working a day job, life is good. Do you see where we are going with this? Keep creating no matter what. And then, life is good. Perseverance is your key. Your key to your success, no matter how you define it.

Affirming your right to create a career, maintain it, and stick with it even as you change, redirect, and redefine it takes a support group and a personal commitment. Creating a visualization and meditation routine will feed that commitment and help change those negative tapes into "I can." Visualizing and meditating on your know-how, your dreams and visions, begins to build an inner confidence that no one can shake. So far, if you have done the exercises in this book, you've begun to experience that for yourself.

CHANGE FEAR AND NEGATIVE BELIEFS INTO POSITIVE AFFIRMATIONS

Adding an affirmation component to your visualization routine will help enormously. Affirmations reinforce the "I can" message you are trying to achieve. Affirmations change negative images into positive images. Many times there are negative tapes and beliefs playing in our heads. These negative tapes keep us from believing in ourselves and keep us from creating a career that is satisfying, fulfilling, and true for us. When we play those negatives tapes, whether we recognize it or not, we tend to surround ourselves with negative people. In a strange way, it's a way of undermining ourselves unconsciously. And we all do it. It reinforces the "I can't" and plays like a loop, over and over. We hear the message from friends and family, and trip over ourselves.

The fact is you cannot do career alone, you need a village, which is why you need a supportive community first and foremost. But perhaps even more important, you need to believe in your right to be creative in the first place, and then to have a village that supports you. Do you believe in your right to be creative? It's a tricky question for a lot of artists to answer honestly.

Believing in your right to exist as a creative individual will allow you to connect the dots between your personal creative vision and a business vision. So here's a new tape for you. "*You can*" and "*You will*." That's the new tape, easy to say, hard to do, I know. The energy that fuels your willpower and helps you transition your "I can" and "I will" is reinforced through each meditation, visualization, and affirmation.

Many times our "I can't" messages are fear based, which is simply false evidence appearing as real. A dear friend and mentor Elaine Valdov once suggested that I look at all my fears that kept me from growing as little children who were afraid of being abandoned. She suggested I take them each by the hand, and invite them to the table. Let them have their say and then send them to play together,

and then the fears of surviving as a creative in the world would lessen. I wouldn't be repressing my fears; I would acknowledge them, observe them, and not be controlled by them. As hokey as that sounds, it worked. I took my fears with me on the subway to work and checked in with them periodically, asking—what am I afraid of? What can I learn from this? Instead of shutting down into "I can't."

Eventually I quit my day job and became a full-time artist, and I wasn't afraid at all. I was in touch with my fears instead of being afraid. Big difference. This helped me be courageous to take action to fulfill my new path. My courage was rewarded: I met serendipity halfway through planning and happenstance and was able to recognize opportunities as they arrived. I was centered and grounded, aware of my fears, but with plans in place to deal with what might come up. My fears did not stop me.

I developed the following visualization, which I still practice when I feel fears and insecurities rising to mind. Try it.

## VISUALIZATION—WELCOME YOUR FEAR CHILDREN TO THE TABLE

*Get Ready.*

*Bring your attention to the normal rhythm of the breath by simply focusing on your breath in and your breath out. Relaxing as you breathe. Don't worry if you are doing it right or not. Just let it happen. You are developing a "witness" attitude. Just watch it all happen as it happens, without judgment. Promise yourself: today I will not judge anything that happens. Enjoy this feeling of sitting, breathing, and enjoying the stillness and a quiet mind. Breathe in and out. When you feel calmness and a sense of quiet, allow yourself to be in this stillness. Enjoy it.*

*And following your breath, let yourself relax. Releasing worry, releasing deadlines. Just taking this moment in time for yourself to explore your authentic voice. Take a few deep breaths, let them out, and when you are ready, let your breath return to normal.*

*Then let a picture form. You are sitting at a large circular table with many chairs. Imagine that each one of your fears is a little child and you invite that child to come join you at the table. Notice how many children come to join you. What are their ages? What are they wearing? As each child gets settled, you ask each one, "Why are you here? What are you afraid of? What can I do to help you?"*

*Imagine that you can listen generously to each child's story. Take it in. Breathe deeply. Let go. Listen. Learn. Then, imagine you get up and go over to sit with each child at the table in turn, listening some more. Knowing that with knowledge and understanding, you can take care of the part of you that is afraid. Imagine taking care of each child—perhaps giving each child a hug or shaking his or her hand. Ask again of each child at the table,*

*"What do you need?" and then make a promise to take care of that part of yourself that is afraid. You will provide what is needed.*

*Then allow the image to shift. Beyond the table where you sit with your fear children is an archway. And through the archway is the path forward for you, for your confidence, for your ability to move your life forward to where your vision leads you. Imagine joining hands with all of your fear children and together walking through that archway.*

*Imagine that you have the courage to move forward with all your fear children in hand, not stymied, not frozen emotionally in place, but filled with knowing and resolve. See your courage from facing your fears fueling your ability to take action. You have a strong inner note within you that plays a melody of comfort and action. Imagine that you create an evolving, growing, adapting sense of self-reliance with every step you take.*

*And when you are ready, at the count of three, you can open your eyes. One, two, and three.*

---

JOURNAL NOTE:

*Take a moment to write down how it felt or anything you saw, heard, or discovered.*

What did you learn from your fear children? What are the reasons you cannot achieve the creative career you want? Let's get it out of your system. Have you buried judgments from family, from teachers, from peers? Do they rise to the surface when you close your eyes? All of us have given away our power at times and given the power to judge us to so many others.

Time to turn it all around into a stream of positive movement and seed the ideas of "what if . . ." once more. Let's change fear into perseverance.

---

## EXERCISE—CHANGING FEAR INTO PERSEVERANCE

*Step 1: Write down what you learned from your fear children visualization. What are the reasons you are afraid to have a creative career? What is holding you back from trying? What is holding you back from achieving? What judgments do you carry within you? Do you remember any comments from family, teachers, or significant others that made you feel "I can't do it"?*

*Step 2: Once you have written down each fear and/or negative statement, go back over your list one by one and force yourself to turn those negative beliefs into positive statements. Be creative. Forget you are talking about yourself for a moment. You don't have to believe the positive statements or imagine they are real yet. We will practice imaging the positive statements afterward. But first, write them down. If you have internalized negative beliefs, you can counter*

*them with awareness, practice being the witness to these beliefs, and substitute*
*positive ideas and action steps for negative beliefs and inertia. Do this now.*
*Write out a positive for every negative on your list.*

Let's take a look at a few samples of what you might have on your list, along with a positive statement to turn it into:

Negative: I'm not talented enough to have a creative career.

Positive: I am talented, creative, and productive and I will figure it out.

Positive talk works. Practice telling yourself positive statements; read through the ones you wrote in the above exercise. Create your own visualization and meditate on the positive statements. Add affirmations to your meditation, and affirm your right to be creative. Your affirmations might be: *I can make money and be creative. I have plenty of time to be creative. I can build my creative career. I have an inner passion and vision to create. I have a right to be who I am.*

What else would you like to say that's positive about your creative career and your right to have one? What else would you like to say that counters the negative beliefs that keep you scared and feeling unsure? Have fun with it, be the cheerleader you've always wanted in your life.

Set aside five minutes every day to read over and repeat to yourself each of the positive beliefs and statements that you wrote down, the ones you need to affirm. And then add them as affirmations to your meditations. Close your eyes and affirm your right to be who you are and succeed.

Start your day with a meditation with these positive affirmations; end your day with a meditation with these positive affirmations. Go to sleep at night with your positive affirmations playing in your head—let them into your dreams. Write them on the wall, pin them up, and carry them in your wallet. Read them before going to bed and when you have your morning coffee or tea.

You might need to come back and practice this exercise often. Any time you find a negative tape playing in your head, telling you that you can't have a creative career, that you can't be creative in the world, *stop!* Take a breath. Then close your eyes and imagine yourself centered; talk to that fear child and help him or her relax. Then breathe and see yourself doing your work, feeling fulfilled, successfull, and silently repeat your affirming positive statement, the one you most need to believe in.

It might take fifteen minutes a day for a week, a month, a year. The more consistent and dedicated you are to centering, calming down, and building the belief that when you believe in yourself, anything is possible, the more it will become a habit on autopilot. You will find yourself accomplishing awesome things. When you become more confident and honestly believe in your right to be creative in

the world, you do start to draw more positive people into your life. It's funny how that works. As if the energy you put out is drawn to you in support. You create a new resonance of positivity and action.

"When you believe in yourself, anything is possible." That phrase used to hang in my son's school library and I loved it. As an artist, I needed that reminder daily. We can be so full of doubts and negative self-talk. That is why we need to be surrounded by an inspired, passionate community; that is why we need to surround ourselves with supporters not haters; that is why I wrote this chapter. Validating your self-worth and your right to be a creative in the world is one of the keys to creating a creative career and turning your personal vision into a business vision.

## COMPASSION AND SELF-RELIANCE

Every time I start to hear a negative tape go off in my head, I stop and observe it. I witness the process as much as I can and note it. I note it by saying, "Ah, interesting, why is that happening now? Where is this feeling coming from? Feel it, observe it, and release it." Sometimes I note it as, "There I go again . . . interesting!" And then I let it go. By doing this, I pull away from the black hole of sinking down into the despair of "I can't" and becoming that "I can't" feeling, which can turn every obstacle into inertia.

Instead, I use my internal inner note of self-reliance and compassion for myself and my fears to move through any setbacks or upheavals, chaos or disappointments, that cause insecurity in my life and rise to mind or rise around me. Response to life requires adapting, having compassion for yourself and for your "baggage," and having compassion for your community as well. Then every moment can become a teacher that transforms you and your choices into "*I can*" moments and frees you from what blocks you.

Here is a visualization that invites you to free yourself from blocks and lets your creative success flourish.

---

## VISUALIZATION—FREE YOURSELF OF BLOCKS

*Get Ready.*

*Bring your attention to the normal rhythm of the breath by simply focusing on your breath in and your breath out. Relaxing as you breathe. Don't worry if you are doing it right or not. Just let it happen. You are developing a "witness" attitude. Just watch it all happen as it happens, without judgment. Promise yourself: today I will not judge anything that happens. Enjoy this feeling of sitting, breathing, and enjoying the stillness and a quiet mind. Breathe in and out. When you feel calmness and a sense of quiet, allow yourself to be in this stillness. Enjoy it.*

And following your breath, let yourself relax. Releasing worry, releasing deadlines. Just taking this moment in time for yourself to explore your authentic voice. Take a few deep breaths, let them out, and when you are ready, let your breath return to normal.

Then, let a picture form in your mind's eye. See yourself in your studio, at the computer, or at the drawing table. See yourself wherever you create your work. See yourself working on a particular project in your mind's eye.

As you are working, notice any resentments or anger in connection to where you are working. Notice the location or size of your creative space, and who you work with or for. Do you have any fears or resentments about the project you are working on? It does not matter how petty, picky, or irrational this resentment may appear to your adult self; to your artist inner-child, it can feel very real and disrupt your inner harmony and path forward.

Perhaps you resent being the second artist in class to speak, not the first. Perhaps the reviewers on the residency panels, or curators, or art directors to whom you submit your work are not really getting what you are doing. No matter how small or how large, simply breathe and let any resentments come up for air. Do not identify with the feelings, just observe them, and witness them as they come to mind.

Are you afraid your work is not good enough? Are you afraid your work is very good but no one will acknowledge it? Are you are afraid your ideas are outdated or ahead of their time? Do you feel undeserving of support or appreciation?

Let any fears you have rise to the surface, come up for air. Ask yourself if there is anything at all you are resenting or afraid of. Let it all come up for air. Then ask yourself, what have you got to gain by your fears? Is there something you gain by listening to your fears?

Then let the image shift. And see all of the fears or resentments you have allowed to come up for air turn into birds, as if each resentment is a bird, a crow, or raven, or hawk attached to you by a long string that you hold. And then imagine that you cut the strings that bind your fears to you. You release the birds and see them carry away from you all the fears or resentments that have made you small and kept you in the dark. Imagine that the birds take from you all that you no longer need, all the resentments and the incessant chatter in your head. Tens, hundreds, perhaps thousands of black birds rise up and free you of what blocks you or drives you into fear.

See yourself being freed of blocks, freed after all these years of negativity, and let them go. Watch them fly away. There is a wind of freedom blowing your creative energy out into the world and filling the freed spaces within you with energy, resolve, optimism. Let this positive energy fill you, let it surround you. Allow a feeling of certainty, of your creative energy, flow freely throughout your body, mind, and spirit.

You have a creative vision. Allow your creative vision to lead you, ground you, and guide you. See yourself making your work, being totally awesome. See yourself being totally perfectly beautifully accomplished. See your work framed, published, exhibited, commissioned,

*written about, funded; see assignments and job offers coming, see your art making a difference in the world.*

*Affirm to yourself: I am a creative, an exquisitely beautiful, powerful, and eloquent artist. Imagine that you can release, relax, and replenish yourself at any time. You can let go of the birds, the fears, the chatter that makes you small.*

*Now let the image shift and imagine you are sitting and flourishing in a place of beauty—you feel safe, you feel accepted. See your creativity growing like a beautiful garden, you are amongst friends. All of your creative ideas are like happy children; invite them to join you in the garden. You promise to protect them, nurture them, help them grow.*

*Imagine that all of your fears of failure feed your success and happiness, your risks will make you laugh and your skinned knees will teach you endurance. You will grow and learn through experience. You affirm and understand that fulfilling your creative impulse is a sacred trust. Your inner knowing and your guidance from your intuition fills you with a sense of meaning and purpose. You are fulfilled and walking the right path. You have a right to create, and you are all that you need to be successful.*

*See your creative success and generosity to others flourish; your creative success is yours to practice and perfect—you give and you receive. See this as true for you, always.*

*And then when you are ready, count to three: one, two and three. Open your eyes.*

---

We can dream it and we can do it. We can make a deal with reality and adapt the form our dreams take. That is the heart of the creative career, being fluid and changeable. Your creative mind can lead you to what has meaning for you. Your business mind can turn that into satisfaction and fulfillment. You have come a long way. Get in touch with the elements you need for a successful and heartfelt business vision, and nothing can stop you.

It's really perfect. I've lived it, I know. I continue to live it. Let me help you do it, too. Though my work in the world has changed drastically and may change again, the threads of what matter to me are simply transformed into a new medium, a new form, a new connective thread. When needed, I return to the image of releasing the black birds and let them carry the distracting chatter away and free myself to create something wonderful, something new, something meaningful. The form may change, and usually does, but the meaning is a constant. And that is sustaining and makes me happy. You can do it too. Be authentic, find what you value, uncover your market, and persevere and adapt.

Next, let's explore the entrepreneur within and put it into practice.

# ❧ 13 ❧

## *Artist as Entrepreneur*

*"Flying may not be all plain sailing, but the fun of it is worth the price."*
—Amelia Earhart

What does it mean for an artist to identify as an entrepreneur? How do you create a right relationship with your vision, your mission, and see yourself as an artist in business? It requires a certain mindset, different than more traditional business start-up ideas. I think what separates most artists from other entrepreneurs is that we don't like thinking that we are a business. Instead we want to wave a magic wand and be discovered for being brilliant, not dirty our hands or complicate our thoughts and identity with money issues, billing, marketing, taxes, audience, etc. Ah . . . well file that one away somewhere.

Think instead of being a creative being with a shining role in the community, and defining being an entrepreneur as taking the initiative and taking an active role to share your creative persona and projects. Imagine that you have and can create a right relationship with what you value and what your community values. Use your authentic voice. Know that voice so well that you are not afraid to share it or need to justify it.

Allow yourself to have a right relationship with money, too. This means imagining you have a right to a fair profit from your work, not underselling or overselling yourself. Imagine what it would feel like if you had a comfort zone around money and could with ease ask for money, budget both the inflows and outflows of cash, and charge for your services and products, fairly and profitably. Imagine yourself not stressing over where your fees will come from or having a cash flow plan. Imagine having a series of contracts and being able to work with people you trust.

Some artists need to take money out of the equation entirely, to remove the pressures and stresses of depending on income from their work. Some artists need to take vision out entirely, and hone and perfect their skills that are commercially relevant. Success and failure, money issues, business ideas threaded with artistic ideas. Scary stuff I know. Has to be talked about. It does not have to be all or nothing.

Ultimately, what we are really talking about here is freedom. Cultivating the intuitive authenticity that allows you to innovate business ideas circled around your vision and your art making and designs into the marketplace. The freedom to make the work you need to make and then plan how to share it. An entrepreneur is someone who is willing to take risks on an idea they believe in. And then be public about what they have to share and go for it.

To be an artist and an entrepreneur requires that you create visibility streams, income streams, and marketing streams that all converge on the path you walk with your work. You need to have faith in yourself, you need to prove yourself to yourself, and you need to plot out a series of steps, so that each step leads you towards the big picture. That means you need to be organized. It also means you don't try to do it all by yourself; you can define roles for other people to get the business side done. More on that in the next chapter.

## BE A BEACON IN THE COMMUNITY

To be an entrepreneur, how we've defined it, does not mean that you quit your day job. It means you find ways to make it work and find ways to give and build from there. You find ways to shine. In a way, an artistic entrepreneur is the beacon at the top of the hill, so career is defined as becoming a shining light of your community. Maybe we have to redefine career totally. Call it your role in the community, and think about what you do that others need, and show them the way. Then charge what is fair.

Anyone can teach you basic business principles. That's not the role I've taken on. I want to teach you that the light that exists at the base of your creativity is worth sharing, and, by adding a layer of business savvy to your life plan, you can earn the respect you need for a product that is inherently you. Your heart, your art, your designs, your creativity. That is being an artistic entrepreneur. And you can create a business plan from there.

So how do you go about that? By interweaving your life plan, which is what you value and what motivates you, with a business idea of what to share and what to charge. What do you want to bring to the marketplace? First off, think of the marketplace as your community. Then think of what you bring to it as a shared gift, a tool, or a series of products and services. Connect what you do with what

others need help with. Entrepreneur and avid student of life Derek Sivers says it best. "Share what you got."[23] I love that and why not me? Why not you? Share what you got. What do you want to make? Who do you want to reach? What do you have to share? Let's take a look.

---

## VISUALIZATION—SHARE WHAT YOU GOT AND MAKE IT A BUSINESS

*Get Ready.*

*Bring your attention to the normal rhythm of the breath by simply focusing on your breath in and your breath out. Relaxing as you breathe. Don't worry if you are doing it right or not. Just let it happen. You are developing a "witness" attitude. Just watch it all happen as it happens, without judgment. Promise yourself: today I will not judge anything that happens. Enjoy this feeling of sitting, breathing, and enjoying the stillness and a quiet mind. Breathe in and out. When you feel calmness and a sense of quiet, allow yourself to be in this stillness. Enjoy it.*

*And following your breath, let yourself relax. Releasing worry, releasing deadlines. Just taking this moment in time for yourself to explore your authentic voice. Take a few deep breaths, let them out, and when you are ready, let your breath return to normal.*

*Like a tunnel into the future, into your planning process, imagine that you have decided to start your own business. An art business selling creative and beautiful objects or ideas and services. Art is many things. You love what you do so much that you are determined to make it work and put it out there. See yourself sitting down at a desk or on your bed with a laptop. You are ready to write your ideas down on paper, and put fingers to the keyboard.*

*Imagine you are writing down a business plan, a creative sketch of what you want to share and why. Imagine you are outlining your strategy and your vision. See yourself writing page after page, you are amazed at how well you know yourself. You make a commitment to identify next a target market or two, and you do.*

*Imagine you are talking to people, reading on the internet, networking with colleagues. See yourself, you have identified a target market or two and you are so excited. It works, it feels right. Imagine this to be true. You review in your mind, and read through your journal, your list of skills and talents, services and products, and you know you have a creativity and a service that perfectly fits your markets.*

*See your business taking off. Imagine how easy it is to amaze and be amazed by the steady growth of your business. You have a cash flow plan, you save and spend wisely, you do not suffer from lean times; you have savings. You adapt, you build, you conserve, you plan well. You can find funding and sales as you need them and build your business.*

*Imagine that doing your taxes is easy and never an issue. See yourself carefully managing your expenses, offsetting revenues, working with a great accountant. See yourself handling mishaps with calm and determination, well insured to handle anything that comes up.*

*Imagine you can function in chaos and be flexible as needed, with a strong sense of self-reliance within you to handle whatever happens in the business and outer world. You are a creative, an artist, and you can do business with the best of them. Imagine that you can look back at all that you have accomplished, your fantastic creative career that you created, and exclaim that you did it!*

*See yourself having all the courage you need to launch yourself into the world. See yourself having all the determination you need to persevere until you create something of value from your efforts. Imagine you are flexible and curious and you can learn to tackle anything that comes up. See yourself with a strong emotional foundation and a sense of personal security within you. Demonstrating your personal power with creativity and flair, self-confident and determined. Enjoy this image.*

*And then when you are ready, at the count of three you can open your eyes. One, two, and three.*

---

JOURNAL NOTE:

*Take a moment to write down how it felt or anything you saw, heard, or discovered.*

Start viewing your creativity from a business perspective and keep expanding on "what if . . ." Using your intellectual know-how as a reminder that you can do it, you can research how to do it and what form it can take. You can figure it out. Think creatively, just like you do with problem solving in your own work. It takes determination and perseverance. You have to have a willingness to learn and employ certain business principles. But when you do, you end up building a secure sense of self-reliance and a strong emotional foundation. Then you can weather the storms, have the flexibility to change, and if one way does not work you find another way. Like a body of water, a river always returns to the sea. You cannot stop it—it will find a way. That can be you.

It does not mean you will be a star or get rich, you could—I don't know. You need the right karma for that, of course, but that's a different book. You can make a commitment to be creative, make it a business, change with the times, and keep growing, and share your vision in as many different ways as you can. A business plan with integrity, each choice, each day giving, communicating, working, sharing, wouldn't you like that? A good question to ask yourself is how would you like to live each day, working in your right livelihood, making choices with integrity? What does that mean to you?

## THE RIGHT NOTE FOR YOUR BUSINESS PLAN

Start your business planning on that note. The right note for you. If you integrate that note, that right livelihood sensibility into your business planning, it will be reflected in your business mission and vision statement. This will help you to draw the right audience to you. People will resonate with what you do and have to say because your planning starts on the note of what matters to you, your vision, and your mission. People work with people, people they can get to know and like. It sounds old-fashioned but it is coming back. As it should. Social collaborations will build your business out into the community.

In her 2011 ebook *Wonder Thinking Business Plan-o-Rama,* Tricia McKellar suggests that the first step of your business planning is to articulate your vision and mission. This is your business idea, from a business perspective from the perspective of your buyer. Look at your action plan and milestones that you have already created and let's take it to the next level to create the first part of your business plan.[24]

---

### EXERCISE—BUSINESS VISION AND CREATIVE MISSION

*Business/Vision Description—Write a short description of the kind of business you plan to create. What do you do? What do you want to do?*
*Artistic/Vision Description—What is the big picture for you and your business? What do you see in your future? Who do you help? Who do you reach? How do you help? How does your work grow?*
*Mission Statement—Write a few sentences that explain your artistic purpose and creative philosophy. Here is your authentic voice that will provide your business a foundation, direction, and language for your marketing efforts. Think about what inspires you: people want to know this. How did you get started doing the things that you do? What do you love about the things you make or design? What is important to you in your business? What do you hope your customers will find in your product/service?*

---

Niches. Targets. Segments. You've heard these words before. Most coaches recommend that you have a narrow focus instead of being all things to all people. This helps you market your ideas to an audience that is interested in the same focus. Try not to rebel against this idea. People want to feel they are hiring, exhibiting, commissioning an expert in their area. Think about what you do in those terms and think of it as having a specialty. A specialty that can be described and qualified with a series of key words to describe it.

It is taking what you are interested in and who you are, and describing it as a business idea as clearly as you can. Your specialty is what sets you apart from the crowd when it is mixed with your personality. This specialty, this focus, can be perspective, style, subject matter, talent oriented, or product based.

For example, my specialty is inspiration. I inspire others. Whether through my coaching, my classes, my artwork, my relationships, my writing, and even my cooking. That in large matter is why I do what I do and how I do it. Over the years, my collectors felt inspired by my drawings, sculptures, and paintings, so they bought them and collected them. My students feel inspired by my courses and workshops, and keep taking them and they tell new people who then sign up to take them, and word of mouth grows. I am very grateful to both my collectors and my students and I show it every chance I get. I share what I got. I inspire them and they inspire me. So I look for a connective thread in all of my "products" and services that inspires. From a business perspective, this helps me define my audience and my ideal collector, who are looking to be motivated and inspired to reach deeper within themselves.

Photoshelter.com has a variety of wonderful free ebooks with many exercises to help you think out your audience and create a marketing plan to reach them. The following exercise is adapted from their *Photo Business Plan Book*, which you can download for free. I love their guides and they will aid your thinking and help you create a marketing plan.[25]

Think about what you can share. This will help you to market it, define your ideal audience, and build your business plan around it. It will be authentic and sincere and feel good, and that is being an artistic entrepreneur.

Art transforms the landscape in which it exists, and your business can participate in the world on that level. Transform yourself, your work, and your community. What can you share?

---

## EXERCISE—YOUR SPECIALTIES: WHAT CAN YOU SHARE?

*To help you figure this out, create a list of your favorite ideas, objects, and services that you have to share. These might be your art objects such as your paintings, photos, films. Or products that are less one of a kind and more edition-oriented, such as a greeting card line or T-shirt designs. This could be your services that are knowledge-based, such as teaching others how to create an exhibition submission packet, how to talk to gallery dealers, how to write grants, or how to create user interfaces for webblog templates. This might also be your top design services that you are hired to perform, such as app design or web design, curatorial critiques, exhibition project management.*

*Which of these ideas, objects, and services do you currently sell a lot of? Do you find people ask for more than others? Which are the most popular? Which do you love doing the most? Are there any that are popular enough (lots of people like) or big enough (lots of volume) or pricey enough given the volume to cover your costs of doing business and turn a profit? Which ones can you build out more? Take some time with this and flesh it out a bit.*

Now think about how you will spread the word about what you to have share. We will cover this in more detail in the next chapter, but it is always worthwhile to be thinking about marketing. As freelancers and artists marketing ideas, products, and services, this is going to become a habit and it's a good habit to get into. Business perspective and community perspective. Creative mind and business mind. Your role as a shining beacon, with your needs met and your community's needs met. Good stuff. All lead you to that important exchange of talent and resources.

Marketing via word of mouth and social media will contribute to spreading the word of your images and ideas to collectors, clients, editors, buyers and creative directors, gallery directors, curators—all the people who you want to think of you when they have a need to fill. Filling that need and reaching out to these relationships should be a part of your business plan. What do you say to them? You have a collection of ideas and images to share and an idea of your vision and mission statement. Let's parse it out a bit more.

Let's meditate on your business plan and community next and see your ideal client or customer evolve before your eyes in your mind's eye.

## VISUALIZATION—CREATIVE BUSINESS PLANNING

*Get Ready.*

*Bring your attention to the normal rhythm of the breath by simply focusing on your breath in and your breath out. Relaxing as you breathe. Don't worry if you are doing it right or not. Just let it happen. You are developing a "witness" attitude. Just watch it all happen as it happens, without judgment. Promise yourself: today I will not judge anything that happens. Enjoy this feeling of sitting, breathing, and enjoying the stillness and a quiet mind. Breathe in and out. When you feel calmness and a sense of quiet, allow yourself to be in this stillness. Enjoy it.*

*And following your breath let yourself relax. Releasing worry, releasing deadlines. Just taking this moment in time for yourself to explore your authentic voice. Take a few deep breaths, let them out, and when you are ready, let your breath return to normal.*

*Imagine your favorite customer. See them walking into your studio, or your shop or place of business, and standing right in front of you. Watch them walk around the room looking at your work on display, flipping through your portfolio, watching your presentation. Who buys or hires or commissions you and your work? How would you describe your clients, your collectors, your customers, the people who hire you? Your favorite ones? Who are they—your clients, your collectors, the art directors and photo editors, gallerists—who choose you? Who is your perfect client?*

*Imagine you use your strengths to your best advantage. You use your strengths to create your creative business. You use your strengths to market your business, to build and maintain your business. You know your strengths, see them in action. What do you need help with? How do you get the help you need? See yourself getting the help you need.*

*Imagine your products and services are clear and defined in your mind's eye. What techniques do you use? What are your materials, staging, props, or special features or concerns? What picture comes to mind when you think about your work? What are the patterns that best describe what you do?*

*Imagine you can see an article about you, or an exhibition catalog, or the perfect website about your work. What is the unique selling point of your work, of your products, objects, or services? What draws people to hire you, commission you, assign you, exhibit you? What makes your work attractive to your audience? What is it about you that attracts others?*

*Imagine there is a market for your work, a large group of people with shared interests, shared characteristics. Your market. The people that will buy your product or services. When you describe your market to yourself, what is the first word that comes to mind? See your market growing. Why do they buy what you make? What benefits do your customers get from your ideas? Dive as deeply as you can into the benefits your work brings to others and see it unfold in your mind's eye.*

*And when you are ready, at the count of three open your eyes. One, two, and three.*

---

JOURNAL NOTE:
*Take a moment to write down how it felt or anything you saw, heard, or discovered.*

You are an entrepreneur. You are an artist, a creative. How do you stay viable in a changing economy and still be yourself? You initiate, you build, you adapt. Then build community, inspire yourself and others. Keep learning, keep making new relationships and honoring the old ones. Care deeply, believe in yourself, and get things done. And remember that change is good. Be authentic and transcend and release what you no longer need as you reach the point of release to replenish and start again. Business cycles, emotional cycles, financial cycles, and creative cycles all run through this type of evolving course.

So it is a moving plan, a dynamic process of reflection, evaluation, and action. Read through your answers to all of the worksheets you've done so far, and follow

your intuition. Ask yourself the questions that we have explored throughout these chapters and periodically close your eyes and see your future. Revisit your visions. Remind yourself of what five, ten, or thirty years down the road will be for you. What will you leave behind?

Keep looking, keep writing, keep creating. And then do it. Follow your own lead and ask for help as you need it and write it all down. Writing it down will help you get organized and stay organized.

The next step in your business plan is to describe your work and your audience in a series of one sentence answers. This will help you clarify your market message of what you do, why you do it, who you do it for, how you do it, and what you are saying with it. This is fun to do, so play with it. The more clarity you bring to this process, the easier it will be to talk about, write about, and spread the word about your process to those who will buy and support your work.

---

## EXERCISE—YOUR ONE-SENTENCE ANSWERS

*My one sentence artist statement is:*
*(this is your vision/mission statement)*
*Next: what do you make (in one sentence)?*
*My Objects or Products are:*
*My Services are:*
*Next: who do you do it for (in one sentence)?*
*My Markets are:*
*My Customers are:*
*Next: why do they care (yes, one sentence)?*
*My benefits that I provide are:*

---

Pin this up on the wall next to your Vision Board. Read it every day, and smile. You have begun to define yourself as an artist and entrepreneur. See what happens, make adjustments. When your core is strong it is what you stand on. Your work in the world can flow from there. If you know yourself really well, then everything can change, and you can go with the flow and test the waters, because you know who you are, what you are doing, and why.

## RESOURCES: ATTRACT THE MONEY YOU NEED

We've defined your business and started a business plan, now let's take a look at your resources. Money is a resource and so is your self-worth and self-confidence, as well as your talents and your relationships in the community. You need a

combination of all your resources to live and work well and to feel successful and worthy of success. You also need funding and cash flow.

You need to create a right relationship with your resources. There are many books (see resource section) on creating budgets, planning for cash flow, and estimating overhead and pricing. I want to present you with ways to define your resources from the inside and vision the outer resources to manifest them. Joanne Wickenburg's work on resources and how we use them in our lives is presented in her wonderful book *In Search of a Fulfilling Career*,[26] which I've adapted for the meditation below.

Let's visualize your resources to build a creative business. We'll look at your perceptions and intellectual resources, your support system and emotional resources, your finances and your practical resources, and your momentum and inspirational resources. You need all of these resources in different measure to create your business and put your creativity out there. When you can vision and focus on abundance you will be able to see yourself receiving the funding you need, and then you are halfway there.

---

## VISUALIZATION—ATTRACT THE RESOURCES YOU NEED

*Get Ready.*

*Bring your attention to the normal rhythm of the breath by simply focusing on your breath in and your breath out. Relaxing as you breathe. Don't worry if you are doing it right or not. Just let it happen. You are developing a "witness" attitude. Just watch it all happen as it happens, without judgment. Promise yourself: today I will not judge anything that happens. Enjoy this feeling of sitting, breathing, and enjoying the stillness and a quiet mind. Breathe in and out. When you feel calmness and a sense of quiet, allow yourself to be in this stillness. Enjoy it.*

*And following your breath, let yourself relax. Releasing worry, releasing deadlines. Just taking this moment in time for yourself to explore your authentic voice. Take a few deep breaths, let them out, and when you are ready, let your breath return to normal.*

*Imagine that you have all the independent resources that you need. You can initiate what you need, take the action steps, make things happen. See yourself as courageous. See proving yourself to yourself. See yourself allowing fear to exist but not to hold you back. You still take that first step. Feel the energy of being an entrepreneur. You have the resource of courage.*

*Imagine that you have all the practical resources that you need. You can persevere and produce work. See yourself developing skills and talents, being useful in the world. You are determined and stick with your creative career. You produce results and attract all the money you need to survive and flourish. Feel the energy of earning a good living. Every day and in every way, you get richer and richer. You have the resource of money.*

*Imagine that you have all of the communication resources that you need. You are versatile and curious, flexible and able to adapt. You welcome change and can connect the dots between what you make and what people look for. See yourself as a great communicator, working on multiple projects, acquiring all the information you need to be successful. You have the resource of perception and communication.*

*Imagine that you have all of the emotional resources that you need. You can nurture your projects and nurture your talents and skills. You can keep going and care for yourself and your career, everything is in balance. You have the focus to let your ideas marinate and evolve. Feel the energy of a deep well of inner security and self-reliance that you can stand on and rely on. You have the resource of creative resilience.*

*Imagine that you have all of the expressive and creative resources that you need. See yourself and your authentic voice confidently reaching your audience. You have a great capacity to vision what is possible and express that vision in the world. See yourself sharing your shining talent for the community to appreciate. You have the resource of creative expression and audience appreciation.*

*You have all of the shared resources that you need. You have relationships that aid you emotionally and financially. You can see many points of view and can put yourself in your client's shoes. See yourself handling competition and chaos calmly. You share what you know and are appreciated.*

*You are anchored with a strong sense of belonging. You have all the resources you need to succeed. You have the resource of funding and the support of the community. See yourself having all the resources you need. You have the resource of partnerships and emotional support. You can see what your responsibilities are and can learn to bring form to your visions. You can rely on yourself and build a solid career path to reach your dreams and goals.*

*You can attract the resources you need.*

*And when you are ready, at the count of three you may open your eyes. One, two, and three.*

---

Think about your resources and your instincts for success. What do you need to establish as a foundation upon which your work and life can be built for you to identify as an entrepreneur and flourish? Living in the world requires that we all, as individuals and as artists, become aware of the resources available within us and around us. We need to have practical, emotional, artistic, and financial resources that we can draw on.

When you can feel assured of your resources, then you can ask what does the community need that you can provide without feeling anxious. Knowing this relative to the resources you have at your disposal will help you to determine what is valued, how to price it, and how to expand it. You will not be underselling or overselling, both compensations for lack of knowledge and panicky

decisions around resources. There is a driving need in every creative to create, to make work, reproduce work, and be appreciated for that work. Finding your right audience is going to be a trial and error process, finding your right price point will be too. You are going to have to test market your ideas and determine the value.

Knowing you can create self-reliance and maintain your equilibrium in the face of audience approval and acceptance will help you take risks and see what works and what doesn't. Knowing that you can dive deep into yourself in order to determine what unique and individual resources you inherently possess, will help you establish a lifestyle, a price point, and a business that reflects your individuality. Planning fiscally with a responsible budget for inflows and outflows will make this work. Keep your overhead low—almost goes without saying.

But little is often said about the discovery and exploration of your inner resources, which will help you enormously to understand what you value and what others value, and set appropriate prices. How you relate and market your work and ideas to other people, and their values and lifestyles, will drive sales. We've talked about this before, but so many artists have money issues and never take a look at their internal resources and how they affect their ability to build and attract assets.

When you look within to find stability, your business plan can generate a will and determination that will sustain you. You can join hands with others who are like minded in order to group your efforts, form a micro-market community, for example. There is power in numbers, where all the members are unique within the group.

You have a tremendous amount of energy within you to actualize your inner resources and your sense of creative purpose in your career. To be the director of your own movie, yet link it to tangible form in the world, socially relevant and meaningful. If you want to earn a living or part of your living from your work, then you need to link that work to the needs of people and society, so your creative vision can root and resonate with the audience you touch.

This next money visualization is part self-confidence booster, part law of attraction, part healing the belief that you cannot earn money from your work. Give it a try. Cultivating a strong belief in yourself is always a good business practice, and taking that belief into your budgeting and marketing plan will help make it happen from a "this makes sense place" in addition to "this is my wish" fulfillment place. I like working with both.

Good planning and visualizing my wishes coming true calls up many positive mental images to guide both mind and actions. There is a struggle in most of us

in the creative professions to let in the light next to the dark, let in hope next to despair. We have to learn to manage both. And that takes practice. Ways to let the dark lead us to wisdom is articulated beautifully by Steve Forrest, with whom I studied with for many years in his AP program in evolutionary astrology. The following meditation was influenced by his wonderful books *The Inner Sky* and *The Book of Pluto*.[27]

---

## VISUALIZATION—CREATE RICHES IN MY LIFE

*Get Ready.*

*Bring your attention to the normal rhythm of the breath by simply focusing on your breath in and your breath out. Relaxing as you breathe. Don't worry if you are doing it right or not. Just let it happen. You are developing a "witness" attitude. Just watch it all happen as it happens, without judgment. Promise yourself: today I will not judge anything that happens. Enjoy this feeling of sitting, breathing, and enjoying the stillness and a quiet mind. Breathe in and out. When you feel calmness and a sense of quiet, allow yourself to be in this stillness. Enjoy it.*

*And following your breath let yourself relax. Releasing worry, releasing deadlines. Just taking this moment in time for yourself to explore your authentic voice. Take a few deep breaths, let them out, and when you are ready, let your breath return to normal.*

*Imagine it is a perfect spring day and you are sitting under a beautiful tree. Flowers are in bloom all around you, birds are singing, the air smells sweet. Feel beams of sunlight, gentle and energizing like a stream of nectar surround you and descend into your body, filling you with the purified sense that all is well in your world, and all will be well.*

*Let the nectar of light fill your body and feel rich and whole. Feelings of lack, feelings of scarcity, are transformed from dirt to light, from empty to full, from poor to rich.*

*Let the beams of light from the sun, the nectar of light from the sun, fill your mind with abundance, fill your mind with the abundance of ideas and creativity. Your speech and ability to communicate is filled with light and your message feels rich and whole. Your ideas and ability to share them are filled with light, richly shared, richly received.*

*There is a vase next to you, filled with wish-fulfilling treasures. Emitting clouds of hope and fragrant joy. It transforms all your thoughts of lack and scarcity into abundance and joy. Imagine that with each inhalation of this fragrant aroma, your doubts, your dissatisfactions, your fears disappear. Fill yourself with this wish-fulfilling treasure, this energy of purpose and determination.*

*And visualize the funding you need, visualize yourself receiving all the funding you need. See your business spirit and structure flourishing. See all the obstacles going up in a cloud of smoke. A rain of wisdom falls, a summer shower, and washes away all doubt, all fear, all that keeps you from being real, being you, being great.*

*Allow a symbol to form to guide you. This is a magnet of power and wealth. See it drawing to you all that you need to be strong, creative, and abundant. Imagine and feel your internal sense that you are wise enough, cunning enough, worthy enough, fierce enough, creative enough, to deal with whatever comes along. Feel your confidence growing. Your confidence is forged in a spirit of creative venture and risk.*

*Security is an inner state. Feel your inner security rooted, as you sit under this tree. Feel the nectar of light, the aromas of joy, the energy of hope and fulfillment flowing throughout your mind, body, and imagination. You have a deep set of roots to hold you steady. Your roots to your creative purpose, your work, are strong.*

*Your work represents your essential truth, you are not easily lost. Imagine you have money in the bank. Imagine you have a good paying creative role in the community. Imagine you have an excellent credit score and no debts. You have a symbol, a magnet of power and wealth to guide you. See it drawing to you all that you need to be strong, creative, and abundant.*

*Feel the roots of practical support underlying your life. You have all that you need to be abundant. Money flows into your life easily. Imagine this. You are filled and surrounded by abundance; you claim the abundance of life.*

*You feel abundant. This contributes greatly towards your feelings of security. You feel secure. You feel confident. You have the right attitude. You have the ability to survive in this universe, to create, to land on your feet no matter what comes your way.*

*You have funding, resources, and abundance. There is a variety of financial support in your life, sources of resources. You have a symbol, a magnet of power and wealth to guide you. See it drawing to you all that you need to be strong, creative, and abundant.*

*You have practical sources, knowing that you possess the skills, an array of skills, that make you valuable to others, knowing that you have a supportive community, that you are linked to other people and networks. Imagine this. Feel this. Know this.*

*You have the right tools and the knowledge of how to use them. Imagine you have all the money, plain and simple, that you need. You can attract all the money that you need. Imagine this now. See it clearly. See yourself depositing a check for one million dollars into your business account.*

*Image money, selling your ideas, attracting customers, dealers, collectors. Keep it simple, keep it logical. You have faith in your imagination; you have found practical applications for your creativity in the world. It's just that simple. You are rich. You are successful. You are abundant. You have a symbol, a magnet of power and wealth to guide you. See it drawing to you all that you need to be strong, creative, and abundant.*

*See this symbol of wealth and creativity glowing and guiding you. You are all that you need to be successful. Feel it to be true. See it grow and become real in your life.*

*And then when you are ready, at the count of three, you can open your eyes. One, two, and three.*

JOURNAL NOTE:
*Take a moment to write down how it felt or anything you saw, heard, or discovered.*

Now create a budget for yourself, straight from this meditation. Be adventurous and true. How much do you want to earn? What is the funding you need? Write it down, put it on a Post-it note, and carry this idea in your wallet. Add it to your business plan. Quantify your dreams and make a budget, cash flow and outflow. Enter it into Evernote, or Numbers, or Excel, or make a Word document or Notepad entry on your computer, iPad, or iPhone. Pick a number and aim for it and plan for it.

In addition to www.Photoshelter.com, check out the Small Business Administration and public libraries who have resources for writing business plans. Go to www.sba.gov for traditional business plans, see Tricia McKellar's *Wonder Thinking Plan-o-Rama,* as well as free templates from www.startupnation.com and articles from www.ladieswholaunch.com. There is a list of resources in the back of this book for other worthy sites for templates and guidance.

Next we will outline your relationships and ideas for your marketing plan and see who will help you make this number a reality.

# ᔟ 14 ᔤ

## Building Productive Relationships

*"Common threads are living a life of meaning, tapping into the energies of archetypes, synchronicity, and spirituality and making a difference."*
—Jean Shinoda Bolen

Relationships. Partnerships. Collaboration. You need people. You need the right people and the right community. You need to define what the right community is and develop relationships, depending on your specialty, with many different clients, vendors, collectors, editors, dealers, buyers, reps, agents, curators, etc. You need to attend things so you can meet people. Attend events and happenings, trade shows, conferences, anything where your ideal audience will be in attendance as well as people in a position to hire you. Let's call these folks your relationship pool.

When I was a fundraiser, they called prospects your suspect pool. So you get the idea: who is a likely suspect for your work, projects, ideas? Funny way to talk about it—I like relationship pool better. Who do you want to swim with? Who should be in your relationship pool? Who do you need to meet? In this chapter, we are going to visualize many different ways of building rapport with people you don't know. A great series of exercises for the introverted artist in all of us.

Relationships mean you have to meet people. Make connections. Not something most artists are comfortable with, but you do not exist in a vacuum. You make things for people to enjoy, to want to look at and hold, or view in relation to a story or product line for a long time. You are only one part of the equation; the other half is your audience. To do relationships well, you need to figure out what it is that you offer to this audience and who exactly is this audience that you want to offer it to.

Asked another way, who are your target customers, your ideal audience, and what do they want? You can't create a career, a role for yourself in the community, and market that role, until you can define this. Even vaguely is better than not having a clue. Think about what you offer, and who might want it, and be as specific as you can.

For me, using this book as an example, what I offer are creative exercises, meditations, and visualizations. My audience tends to be creative people looking for meaningful ways to think about and produce their work, or spiritually identified creatives looking for career advice that honors their ideas and values and helps them identify a career plan and role in the community. To help people be more creative is important to me and important to my audience. My skills that this audience needs are my ability to inspire and motivate and put ideas into action through practical, one step at a time strategies. I also have clients who like my unique products, drawings, and paintings, the tangible products and objects that I create. There is an audience for everything we do; sometimes they overlap.

## IMAGINE THAT YOU CAN BUILD RELATIONSHIPS

Imagining that you can connect with people and build relationships with confidence is an excellent practice. It will help you fine tune your intuition to parse out who is responding to your work and who is not. It helps the introverted need to pull back and still radiate connection, a welcoming vibe. Try the following visualization and see your relationship pool growing, happily and confidently, from a peaceful center.

---

## VISUALIZATION—MY RELATIONSHIP POOL

*Get Ready.*

*Bring your attention to the normal rhythm of the breath by simply focusing on your breath in and your breath out. Relaxing as you breathe. Don't worry if you are doing it right or not. Just let it happen. You are developing a "witness" attitude. Just watch it all happen as it happens, without judgment. Promise yourself: today I will not judge anything that happens. Enjoy this feeling of sitting, breathing, and enjoying the stillness and a quiet mind. Breathe in and out. When you feel calmness and a sense of quiet, allow yourself to be in this stillness. Enjoy it.*

*And following your breath let yourself relax. Releasing worry, releasing deadlines. Just taking this moment in time for yourself to explore your authentic voice. Take a few deep breaths, let them out, and when you are ready, let your breath return to normal.*

*Imagine that you wake up in the morning feeling a sense of calm and attractiveness, and this feeling stays with you throughout the day. There is a source of great joy and power within you. You feel connected to life. Imagine this as any source of power that comes to mind, any color, or light, or a feeling of personal magnetism. And imagine this source radiating within you and all around you.*

*This source of confidence and calm wakes up your body and mind, ignites your creativity, and makes everything blossom around you. You radiate warmth, bliss, strength, and openness. Imagine this. This infinite creativity that vibrates within you. It attracts people to you.*

*Visualize and feel that you can create relationships with all the people you need in your life, in your career. Your heart is open and you feel an amazing confidence in your ability to connect, to help, to give, to receive.*

*Then see yourself at a party. You are the host of this party. You are in a garden with a gorgeous pool and there are many people there. Their hearts are open and filled with happiness that they know you and you know them. As you talk with them, one by one, you can sense and see that they feel the source of creativity within you and in themselves. Like a great symphony, you and your audience collaborate. A great celebration is your work, shared, and received. You have many relationships, you give and you receive.*

*Imagine that your work connects to the compassionate mind in others, connects and grows as you build your career. You know what to say and are relaxed. You listen with great generosity. You meet and talk to everyone, you move around the party, calm and centered. There are multiple beams of light of various colors radiating from everyone; you can feel the harmonious nature of the light that connects you to all the people you meet.*

*And when you are ready, at the count of three, you can open your eyes. One, two, and three.*

---

JOURNAL NOTE:
*Take a moment to write down how it felt or anything you saw, heard, or discovered.*

Now that you are calm and relaxed, feeling confident about building relationships, here comes the word and process most of us hate to deal with. Marketing. In order to get the word out and meet more people, you have to have a marketing plan. Think of marketing as simply being considerate; putting the needs of your collector, your client, and your art-buyer first. Just like we think of networking as building relationships and finding ways to help others, think of marketing as a way to you put yourself in your audience's shoes and think of everything from their point of view.

In creating any kind of creative career, whether it is part of a job search or art career, we talk about the mantra "it's not about you, it's about them." All careers,

all roles, ask us to shine for others and provide ideas for them to learn, to enjoy, to purchase. Our goal is to have an impact. What we have to offer ultimately is about them and what they need. And we help them connect the dots back to us.

Most artists simply space out over the marketing piece and can't even think of spending the energy on it. Like with money issues, that tape, the one in your head that says "I can't earn money from my work," is a subtle form of self sabotage. "I can't do marketing" is probably the second most entrenched "I can't" self-sabotage response. But you can. You can do it your way. It takes practice and commitment, but that goes for any career ideas you have. Putting the energy and commitment into getting your work out there is what it is all about.

## MARKET YOUR AUTHENTIC VOICE TO THE RIGHT AUDIENCE

In his ebook *Marketing Your Music,* Derek Sivers talks about reaching out to others the way you would like to be reached.[28] I really like that. For example, I hate the phone. People call me all the time, trying to sell me their services, usually for things I don't want. I mostly let it go to voicemail. But if someone reaches out to me and writes me an email, which I prefer, that is real, personal, and heartfelt—I tend to respond. I like the personal touch in writing. I like to feel they know me and have done their homework, they know a bit about me and what I might want. So when I reach out and make contact, I email, but I do my research first. I make it personal and based on research; I show I know who they are.

## KNOW YOUR AUDIENCE AND GIVE THEM WHAT THEY WANT

This is a really important point when talking about marketing your work and spreading your "brand." I research who might resonate with me and my work and let go of those who don't. So my marketing efforts are going to my ideal audience. And my self-worth is not squandered on justifying my way and my services and products to those who are not my market and will not get "it" or me.

When marketing your work, look at every action as a learning opportunity. Not personal, just interesting. For example, you can say to yourself, "Today, I learned something. Yes, I learned something interesting. I learned who to talk to, who resonates with my 'way,' and who not to waste my time convincing I have a product or service that I think they need but they don't." I am not going to try to convince people because, chances are, they will never get it. They don't want it. So I am barking up the wrong tree and wasting my precious self-confidence.

This is not rocket science, it is research and a heartfelt approach to creating work and having the right audience for your brand of beauty. Finding the right audience, the right work for your community, means knowing what they need, want, and are willing to invest in.

If you're contacting collectors, buyers, editors, imagine what kind of image they would like to get in their inbox. What do they look for? What do they collect? What do they buy? What do they need? Do your research and find out. This way, every communication can be site specific. One more boring postcard with a photo image that is not their market or style they hire for, or another text inviting them to a show or a sale or an opening about something that is not in their interest, area, or style is a waste of your energy and emotional capital. What makes you think they will care? Relationship building 101 is knowing your audience and giving them something they will care about in the way they like to receive it.

Instead, make your marketing outreach an extension of your creativity. Set the tone. Perhaps you sculpt frightening superheroes conquering the world out of legos, or shoot spiritual feministas in cloudy mystical photo illustrations that are life-sized prints, or make videos of twisted metal cars with faces of babies in installation videos set to music, or paint delicate flowers in watercolor. Make your contact directly related to your medium and message. Send me a drawing of a sword that I can cut out and use while I learn about your work, or a piece of lace with the info printed on it that intrigues me, or dried flower petals that fall out of the envelope when I read your invite. Entice me. That's marketing. Make it fun. Or send me an image that is so beautiful it will take my breath away, because you know that is what moves me.

Marketing is setting the right tone. You can be creative, funny, unique, corporate, even mystical as long as it is related to what you make and provide and the audience receiving it. There are folks who are not your audience; your work is not for everyone. A very hard pill to swallow, I know.

Somehow we have all accepted the myth of the superstar creative who has millions of followers and we believe everyone will think we are brilliant if they only take the time to look at our work. Well, they won't. Some do and will, but most don't and won't. Find out who will, and who your work is really for, and then dive in. The numbers and the odds will be more in your favor. The rest, say "ah, interesting . . ." and move on. Everyone wants to be seen for who they are. Turn that into a marketing initiative and give your customers, clients, and prospective buyers some surprise or beauty in their day. Cultivate interest. Repeat that cultivation. Look to build awareness that is meaningful. Spread it out via different expressions and avenues.

## RESEARCH YOUR PARTNERS IN CREATIVITY

Research what is expanding and growing, what changes in your field, and what is retrenching, disappearing, or no longer wanted. Look at industry trends and market trends. This includes social trends, economic trends, communication trends, and cultural trends. Then you can choose what to keep and what not to keep. You need to know what is happening outside of your studio. You have to understand

how your marketing plan fits into market trends. Don't take this on as a monumental task all by yourself. Do it with friends, do it in a group. Collaborate and help each other, then make choices based on what you have discerned.

This is a great time to create collaborations and micro-markets with like artists to jointly get the word out there. Form a group or a meet-up of creative people in a mix of fields and industries. Create a movement and market that movement. You move from audiences not knowing anything about you, to groups of people talking about the "movement." How do you find like-minded souls? Take the traditional elevator pitch (yes, that old thing) that you created in chapter 11 and look at it as a basis for commonality to form a group think. Who else is doing what you are doing? Using the same language as you? Colors or forms or visions to change the world?

Perhaps you can join together and become a micro-market together. Maybe together you will come up with a new business idea as well as be the center of this new micro-market. Look at Etsy or Kickstarter for example. They set up micro-markets of handmade work for sale and creative projects that needed funding. Why not you? Become the next Etsy.

A great way to learn who is doing what in your field, as well as how to market your work more effectively is to pay attention to what is written about and advertised in your field. Read. Read about new art and artists. Notice what gets you excited about a work or a product or who did it. Look through art magazines, trade magazines, blogs, Zines, and Youtube and Vimeo videos. Subscribe to Tumblr and Flipboard. Follow on Twitter.

From everything you see, read, and notice, only a few are going to really make you excited. Observe that reaction. What makes you want to spend money? Ask yourself why? Step back for a moment and study it till you get an "ah, interesting . . ." response. Before you do a thing, analyze it. This is doing market research. What was it that intrigued you? Was it the headline you liked? Or the images themselves? The concept? What made you curious about either the work or the creative idea? Perhaps it was the person—his or her personality, process, childhood, story, or even clothing that worked for you.

No detail is trivial; learn from what made your heart beat a bit faster and motivated you to want to buy it, or copy it, or join it. Figure this out. And then apply it. See how you could use this same technique in your own marketing. I love that, finding like organizations, like artists, new role models. See who is successful and see who just plain moves you. No need to reinvent the wheel.

Find your common ground and find your language. Your tone, your voice, and your niche. Then define it—define who you are and share it. Use your smarts and your research. Then make the kind of marketing plan to go with your business plan that will get you to a sustainable level of success. You don't need a big gallery behind you or a big agency behind you. You do need a community behind you. That way you'll win no matter what happens. You will have built a following

of cultivated relationships and stay true to your vision. We are back to success on your terms. And if that includes having a big gallery or a big agency, then go for it.

Ilise Benun, founder of www.marketing-mentor.com, has great marketing strategies for creatives. One night, over a glass of wine, she asked me how many people I plan to meet this week as part of my marketing plan. She told me if I knew that, then I could figure out what I needed to attend each month. Since there are so many openings, so many events to choose from, this was a way to do it strategically.

I learned from Ilise that if I plan to meet two new people every month, then I could schedule myself to attend one event, and build from there. That sounded reasonable. As a creative, no matter if you are emerging, mid-career, or in a reinvention phase, you have to get out of the studio on a regular basis and make it a point to meet new people in the field. Whether you do it every week, every month, every year, you need to do it. You figure out what you can do, and then go out and do it. For an introverted artist like me, that is a fearsome idea. Weekly is not my style. Instead, I do this monthly for a few months, then give myself a break and stop going out, then I get back into again. This system works for me. I can set a goal on how many new people I would like to meet and schedule myself accordingly. That is how you add people to your relationship pool.

After you meet, you need to stay in touch. Get to know the people you meet. What are they looking for in business, in life, in art? And then, my favorite part, based on what are they interested in, figure out how you can help them. Always think how you can help someone else. It's good karma, good business, good people skills. I always ask my intuition when I meet someone, how can I help them? You can meditate on it before contacting them, or while talking to them. Silently asking, how can I help this person?

If you are open to this idea, here is a visualization to try.

---

## VISUALIZATION—NETWORKING MADE EASY

*Get Ready.*

*Bring your attention to the normal rhythm of the breath by simply focusing on your breath in and your breath out. Relaxing as you breathe. Don't worry if you are doing it right or not. Just let it happen. You are developing a "witness" attitude. Just watch it all happen as it happens, without judgment. Promise yourself: today I will not judge anything that happens. Enjoy this feeling of sitting, breathing, and enjoying the stillness and a quiet mind. Breathe in and out. When you feel calmness and a sense of quiet, allow yourself to be in this stillness. Enjoy it.*

*And following your breath let yourself relax. Releasing worry, releasing deadlines. Just taking this moment in time for yourself to explore your authentic voice. Take a few deep breaths, let them out, and when you are ready, let your breath return to normal.*

*Imagine you are at a trade show, an art fair, a cocktail party, a conference, or an art opening. You are out and about and seeing a lot of people in the room. Imagine yourself going up to every single person at the event and introducing yourself, getting into great conversations, finding out what everyone does, taking notes. You are not talking about yourself. You are listening generously.*

*Every time someone hands you a business card, see yourself taking out your pen and writing down notes about that person on the back. See yourself periodically reading what you wrote on the cards and remembering their tone, their interests.*

*Imagine that you befriend hundreds of people.*

*See yourself having a show in a space or city you have never shown in before. Imagine that you go in on the day of the show and set up a few meet-and-greet interviews, or do a talk at a local college, promoting your work and ideas.*

*Imagine that you mingle at a panel discussion or participate on one, meeting hundreds of people with whom you could follow up and invite to be on your mailing list. See yourself answering every fan letter with a hand-written letter.*

*See yourself sending a thank-you note to everyone you meet, not asking for anything. Building relationships. And all the while, you are making your work, practicing your craft.*

*Imagine you can make everyone you meet feel like the most important contact, that what they said mattered, that they personally matter to you. See yourself following up with everyone with something genuine, being persistent but polite.*

---

JOURNAL NOTE:

*Take a moment to write down how it felt or anything you saw, heard, or discovered.*

Don't just reach out when you want something or want to sell something. Be the person who maintains contact, perhaps with some news that will make others happy. Keep in touch to make both of your lives better. You are building relationships, not always selling yourself. Have the confidence to know that being authentic, sincere, and genuine will sell you more than being a pushy salesperson. And see yourself networking, helping others, utilizing the power of partnerships. Marketing is not something we do once or twice a year when we have a show or need a freelance gig. It's a lifestyle for a creative person. You need people to share your world with. You need partners in creativity.

## REACH OUT AND ASSESS WHAT WORKS

You've written out your dreams and ideas in many different ways throughout this book. Ideally this has given you some new information and new challenges to address as you reevaluate, reassess, and start thinking about your work and your

audience and your partners in creativity in different ways. Remember to break everything down into bite-sized bits as you move your ideas from thoughts to actions.

Then lay it all out in a way that you can follow and maintain your momentum. Keep doing the visualizations and meditations I've shared with you to stay centered and aligned with your sense of purpose. In their book *Startup Nation,*[29] Jeff and Rich Sloan suggest that you look at where you stand now to move you in a direction towards a marketing plan that you will be comfortable following, and then do a reality test. Honest self-assessment will help you actualize your new vision. Let what you know inspire you to change.

---

## EXERCISE—WHERE DO I STAND NOW?

*Where do you stand now?*

*How does your ideal career and ideal life compare to what you do now, where you are right now?*

*Are the action steps you outlined in the previous chapters still the right steps? If not, what are the right first steps?*

*Assess your strengths and weaknesses:*

*Take a look at what you want to bring to market. What is successful about what you are doing and what is not? Can you improve anything, change anything?*

*Is there a market that already exists for your work?*

---

This is the hard part: You can set all the goals in the world but if it does not include an assessment of the marketplace, the strengths and weaknesses you bring to that market, you will find yourself with a plan that you cannot implement.

*Is there room for you in this market? Is it saturated? Can you "own" your niche?*

*Who do you need to meet?*

*How many new contacts do you need each week, or month, or six months?*

*How will you meet them and when?*

You are usually aware as you create what works and what doesn't. You instinctively know many times if the work is achieving what you want it to achieve, expressing what you want it to express. It is the same with being a business person; you need to be willing to catch and abandon certain creations and certain marketing efforts that aren't working, and enhance the ones that are. Easy to say, hard to do. We get very attached to our way of doing things and our way of thinking.

You have to separate personal work and projects from commercial work and projects, and review what is successful and what is not. There will also be a need to redirect finances and change and adjust to a marketplace that is in flux. To do that,

you have to have a system in place to assess your progress, creatively and financially, against your goals. That's where your action plan and your life plan come into play and you make any adjustments that are necessary. You put it into context and share it with the world through your marketing plan, which grows from your business plan. Everything is connected and is formed from your original vision.

You may ask, do I need all of these plans? I like breaking things down into pieces and together making a whole picture. This way I can change one piece and still have a variety of plans to follow, and all together it works great. Try it this way. If you find a better way, then do that. Remember, you are the author of your own story. All of these plans and ideas are different ways to keep you organized and moving in the right direction from a place of reflection and studied action. But think for yourself and do it your way. If my way works, great. If another way works better, great. Do what it is best for you. A good test of what is best for you would be the following. Let's do a reality test and then hone in on your marketing plan.

---

## EXERCISE—REALITY TEST

*Answer the questions below:*
*1) My life is real—there is stuff I have to deal with.*
*List the realities in your life that you need to work with and around to reach your goals for the first year. This could be family responsibilities, available funds, other jobs you work, time commitments, supportive or unsupportive spouse, etc.*
*2) Priorities:*
*What priorities in your life take precedence over your creative career? Can you work these into your first-year goal?*
*3) Work day:*
*How would you spend your workday/work week if you could plan your own working hours? What part of the day/week for creating, what part of the day/week for marketing, what part of the day/week for networking? In order to reach your first-year goals, how will you organize your time?*
*4) What fits you and what doesn't fit you:*
*You know where you want to be a year from now; you have created a one-year action plan. Write out the industry trends you see in your field and in the marketplace right now. Medium, size, message. What feels like you? What does not feel like you? What's hot? How do you feel about what's hot? How will you adapt? How will you change your focus? How can you capitalize on the trends to make your first-year goals happen?*
*5) Who is doing what you want to be doing?*

*Research and actively study those that have come before you. Read how they did it, figure out what it was that was key for them to move their work out into the world, and ask yourself—can I do that too? Can I work that into my plan? If not, how will you do it differently?*

Now let's sketch out the big picture of your marketing plan. I know, even thinking about creating a marketing plan can sound daunting and overwhelming, but don't stop now. You need to sketch out a plan for specific marketing tactics that will drive the new sales, new audience, and new recognition that you want to achieve. In the *Photo Business Plan Book* by www.Photoshelter.com, they present some excellent tried and true recommendations. Simply think about different marketing categories and then list out activities that you could do in each. This is a very basic plan below that I've adapted from the folks from Photoshelter.[30] It will get you moving in the right direction and help you to be effective. And that is what counts.

Keep in mind that one-time marketing efforts are not effective; you need repetition and you need variety. Like making friends out of acquaintances. I learned this at a fundraiser, and it is just as true for creatives in all fields, both freelancers and fine artists. This means you need multiple ways through multiple channels to get on the radar of the people you want in your relationship pool. You need to increase awareness of who you are and what you do, so more and more people learn about you and your work.

## EXERCISE—YOUR BASIC MARKETING PLAN

*Promotions: postcards, books, posters, invites*
*What have I created already?*
*What can I create next?*
*Who can I send it to?*
*When will I send it?*
*What will it cost?*
*What will it bring in?*
*Social Media: Tumblr, Twitter, Facebook, Google+, Website, Blog, Flipboard*
*What have I created already?*
*What can I create next?*
*Who can I send it to?*
*When will I send it?*
*What will it cost?*
*What will it bring in?*

*Networking:*
*Who have I already met?*
*Who else do I want to meet?*
*Where can I meet them?*
*How will I stay in touch?*
*What it will cost?*
*What will it bring in?*
*Attending things: trade shows, conferences, openings, portfolio reviews*
*What have I attended?*
*What else do I want to attend?*
*When will I attend?*
*What will it cost?*
*What will it bring in?*
*Staying in touch: newsletters, articles, coupons, videos, ebooks*
*What have I created already?*
*What can I create next?*
*Who can I send it to?*
*When will I send it?*
*What will it cost?*
*What will it bring in?*

Test your ideas. Create a good challenge for yourself each month or every six months so you can push yourself forward. How many clients or contacts do you want? Do you need? How many shows this year? How many dealers and curators do you want to meet? How will you reach them? Pick one area and then design a test and give it a whirl. See what happens. How many new followers to your blog or retweets? Expand on it if it worked. Change it if it didn't. Don't create too much stress around this. Look at it as if it is a giant social experiment and see what you get and what you give.

Let's look.

## VISUALIZATION—MY HOT BUSINESS MODEL REACHES THE WORLD

*Get Ready.*

*Bring your attention to the normal rhythm of the breath by simply focusing on your breath in and your breath out. Relaxing as you breathe. Don't worry if you are doing it right or not. Just let it happen. You are developing a "witness" attitude. Just watch it all*

*happen as it happens, without judgment. Promise yourself: today I will not judge anything that happens. Enjoy this feeling of sitting, breathing, and enjoying the stillness and a quiet mind. Breathe in and out. When you feel calmness and a sense of quiet, allow yourself to be in this stillness. Enjoy it.*

*And following your breath, let yourself relax. Releasing worry, releasing deadlines. Just taking this moment in time for yourself to explore your authentic voice. Take a few deep breaths, let them out, and when you are ready, let your breath return to normal.*

*Imagine you can write the story of your ideal art career and your ideal creative business model. You are devoted to expressing yourself; allow these images to rise in you. See yourself investing in you, investing enough emotional energy, psychic energy, physical energy into reaching for your dreams. Give yourself permission to create and market your work to the world.*

*Your ideal business model is like a budding flower in your mind's eye. See this flower as a bud. See it germinaing, growing, being watered, blossoming, flourishing, spreading across the fields of consciousness.*

*Breathe. Relax. Focus on the in and out of your breath, and slowly allow a series of images to form. See yourself as vividly as you can, actually living the life you have written about, dreamed about, imagined.*

*Notice the environment you work in—where it is, the type of building, the furniture, the setting, etc. Do you travel? Does your work travel across the globe? Where is it shown, seen, bought? Who do you contact, talk to, write to, perform for? For what purpose? See yourself developing relationships with many different people, forming deep bonds and social contracts across the country, across the state, across the city, around the world.*

*You have a series of core values in your life and in your work. See yourself expressing them in every marketing piece, every email, every phone call. True to your core. True to your work. Ask yourself, who do you wish to benefit and how? See your hot business model, true and benefiting others, reaching the world.*

*See yourself contributing to the larger good, see the world taking in your work, appreciating the contribution that only you can make. Imagine that you are satisfied and dedicated to your creativity. Your expression is an aspect of who you are. It fits into your vision of life. Allow yourself to see what matters most for you and your world reaching the outside world. Deepening your relationships, spreading the word, setting the tone. True to your message.*

---

JOURNAL NOTE:
*Take a moment to write down how it felt or anything you saw, heard, or discovered.*

In the next chapter, let's make your relationships and marketing reach sustainable and viral through a variety of social media ideas.

# ᔗ15ᔖ

## *Your Sustainable Art Career Online*

*"We are what we repeatedly do. Excellence, then, is not an act, but a habit."*
—Aristotle

We've covered basic marketing ideas up to now. We need to introduce social media as a form of conversation for our next step. There are loads of books out there by marketing specialists in every field from graphic design to the handmade movement to advertising on social media, all the dos and don'ts. My aim with this chapter is to give you some simple steps to get you started and help you to maintain your connections with people you know and people you haven't yet met. Social media can help you. Plain and simple. Let's start by easing your anxiety around the whole social media phenomenon.

The term social media usually makes older creatives anxious. I've seen this in my classes many times. The idea of using a variety of cyber channels brings up images of technology gone mad. Scary, unnecessary, and totally out of control. I remember the first time I sat in front of a computer in the mid-eighties, afraid to push the buttons. Now I have a laptop in the living room, a desktop in the bedroom, and an iPad (borrowed from my son) in the studio. I read through my Twitter feed in the mornings and end my day with a review of Facebook and Flipboard.

Technology keeps changing and the waves of social change and communication streams change faster still. Everyone says you have to join this game to stay marketable. Honestly, I don't know if you do, I do know that it is nothing to be afraid of and has proven results to sustain a creative career and build a loyal audience.

So if you are wired for it, you should do it. If you are not, then don't. But then don't complain that the world is passing you by. Technology is a great tool and you might want to ride this wave. Like everything else, it takes discipline and definition to get started.

Discipline and definition plus passion is what makes a creative career sustainable. Marketing your creativity requires a flexible and nimble marketing plan that reaches a wide audience with viral resources. Building longevity into your career means that your reach now has to include not only the web through your website, but also social media, and mobile apps, and perhaps YouTube and Vimeo, and on it goes. Now does that mean you have to update your website to make it mobile friendly for viewing? Can your work become an app on a variety of platforms? Do you even know what I'm talking about?

For object-based creatives, the web can seem like a foreign universe that speaks a foreign language that changes constantly. The modes of communication on it however, have a simplicity and a directness that you might not have noticed, and it is not hard to learn how it works. Like everything, it takes time. But social media is all about meaningful conversation and meaningful content. And that is wonderful. Yes, there is spam and crap on it as well, pictures of parties that I would rather not see and unfiltered meaningless drivel. But you can pick and choose how to use the social media channels out there and to what end.

## STEPS TO A SOCIAL MEDIA STRATEGY

So let's start with a simple definition of social media and outline a few channels available as of the writing of this book. Then you can choose the ones you want to use. Define what you want to use them for and what you want to accomplish with them. It is as straightforward as that.

It's important to note that by the time this book is published, there will probably be new cyber channels and social media outlets, I'm sure, and in three years, channels we haven't even heard of yet. But it does not matter. Social media implies a public conversation that is open and available to anyone and easily transmitted to large amounts of people via a device. Could be your computer, your phone, your wifi-enabled handheld device. As with all conversations, it is about sharing meaningful ideas with people. Think of social media just like networking, as a way to build relationships around what you think and what your work is about, and then you share it as a way to be helpful.

The forms of social media you use will depend on the people you are talking to and where they hang out online. Like all marketing, you go where your customers are. When you can understand how the audience you are trying to reach interacts with each other online, and where they do it, then it becomes easy to strategize which channels you want to use. This is basically how you use

social media to reach your audience, your community, and your future customers or clients.

Do your clients, collectors, art buyers, or animation directors hang out on Twitter and tweet regularly? Do they blog and comment on YouTube or Vimeo? Do the people who buy your work want to learn more about why you do what you do? Or how you do it? Ask what do they want to know about and then look to see where they hang out. That is the first step for you. Find out. Surf the channels and make notes. Research.

Regardless of the channel, the social part of social media comes down to defining what your audience needs to learn about. Discern what they need and then provide it. You seek out and use social media channels to communicate the ways you help them get what they want. What they want is not always obvious; I don't mean to infer that it is easy to figure this out. But what makes social media such an exciting forum is that, since you are helping people in a public space (cyberspace), you will and can attract more and more people who need what you offer as you figure it out. It is easy to test it out and see what works and what doesn't work for you in real time, and that is exciting. Welcome uncertainty and the unanticipated.

How? By sharing meaningful ideas and content, promoting others' meaningful content, sharing what you know, and see what grows. That's the basic concept. You introduce your products by sharing your ideas and expertise first. It is the opposite of advertising or telemarketing. This is not spamming everyone you know with constant invites to a show or a sale. Bombarding them with *buy me* messages will not work at all. That is simply annoying and not effective. Good use of social media is about building a following, offering people good reasons to visit your website, to follow your blog, and retweet your tweets because they learn something or get something they need.

Then they buy, or commission you, or refer others to you. They become part of the circle with you, and this is how you use social media to build your social brand. It's good for you, good for the community, and good for business.

Your social brand is what you would like to be known for out in the cyber world. As we've done in prior chapters, to create a social media strategy you are going to need to ask yourself what you would like to be known for, and how will you get there. But this time, how you will get there will be via your website, blog, Facebook, Twitter, Linkedin, Tumblr, Reddit, YouTube, Vimeo, or just one or a few of these.

Are you still breathing? You do not have to use all of these channels. And you can share a similar message and content on multiple channels at the same time. Let's start with a simple exercise. Ask yourself the following questions:

## EXERCISE—SOCIAL MEDIA BABY STEPS

*What type of information will you share?*
*What tone will you take?*
*Who will you engage with?*
*If you could set a social media goal off the top of your head, what would it be?*
*Which social media outlets do you know about?*
*What do you like about them? What don't you like?*
*Which ones do you want to learn about?*

Anyone who has ever sat down at a computer and started reading on the internet knows what a time suck it can be. Before you know it, you have clicked on a few links and found yourself hours later having accomplished very little and perhaps feeling a little lost about why you sat down in the first place. Social media can be like that as well. So it helps enormously to set a time limit for yourself. I will spend one evening a week online posting my social media content and reading other's posts. That's two to three hours a week. It works for me. In that time, I review, I research, I post, I tweet, I stop. So, first, set a timeline for yourself as an experiment and pick just one channel to use for now.

So time yourself; maybe make a promise to yourself.

## EXERCISE—SOCIAL MEDIA PROMISE

*I will spend _____ minutes/hours this week researching artists like myself and learning more about how they use social media. I will notice the content on their website and how it connects to their blog if they have one. I will see if they use Twitter to follow people or to tweet. I will see if they have a YouTube channel or Vimeo, and if they are on Facebook as a company. I will also see if they are on Tumblr or use Reddit and if their portfolios are on Etsy or Photoshelter or Behance, or any other group sites. Afterwards, I will make a list of everything I learned. I will then pick one social media channel to use as a test. The social media channel I will use first, based on this research, is going to be _____.*

What did you choose? If you already have an updated and easy to navigate website, did you choose Twitter? Or did you choose to create a blog? Perhaps you

chose Linkedin. If you feel daring, choose a few: update your website, add images to your blog, open a Twitter account, and sign up for Linkedin with an added portfolio app for your profile. Eventually, I suggest you do have a presence on all. But first, start slow and ask yourself to define why you chose the channel you chose.

*I chose this channel* _____ *because* _____.

What do you want to see happen by using social media? Try to clarify it a bit. Once you have clarified it, think about what actions you want people to take as a result of your social media presence. What do you want them to do with the messages you send out?

It is really important to know what you want to say and why. For example, do you want people to learn about what you do? Awesome. And then, what do you want to happen once they do that? Do you want to sell your limited print editions? That's a start. Let's get more specific. How many prints? How many people do you need to drive to your website to sell those prints?

One way to do that is to use social media to educate them about your prints, about the content your prints talk about, and your style, your process. As you get to know your audience, your shared belief systems or values will help to make the link and solidify your relationship with them. You will have common ground. That is what you are looking to define and build on with your social media efforts. You will connect past the store idea and into the shared interest that underlies your store.

Why should they buy your prints and not someone else's? It will be based on the link they feel with you, as well as the attraction to your images. So think about social media as a building relationships tool. And then make sure, as you educate your unknown audience, that there is a hot link back to your website where they can learn more and easily purchase when they are ready to buy. Make it easy for them. You use social media to cultivate, educate, and help people find their way to your website to buy those prints.

This is where social media is a great tool. Talking with your audience, educating the consumer, forming community. Building relationships. I will say that over and over because it's that shared conversation which is the key here. If you begin to think about your ideas and work as a shared conversation, people will come back to your site. Share your expertise, your process, and your products and ideas. Cultivate your relationships with future buyers. Build recognition and eventual sales, commissions, recognition will follow.

## CONVERSATION IS CONTENT

In my mind, social media is not an advertisement; it's a conversation and a conversion tool. Converting random visitors into followers into purchasers into community. The question then becomes how will you invite them to stay in touch? Social

media got them there, now perhaps you offer them a list of articles to read about the subject matter you work with, and learn something about it first. Perhaps after reading the article, you want them to come back, so you invite them to sign up for your newsletter or follow your blog, or follow you on Twitter. Sprinkled in between is news about new work and where it is happening.

You want to build interest in you and what you do, not just a one-time sale, or one-time visit. You really want to build a community. And to do that, you need to offer fresh content to your followers so you can attract more and more followers. That is what social media is so good at providing. You can balance self-promotion with building a following by sharing content that is helpful.

I like being helpful and I hate promoting myself. So I think about what people in my community might want to know about that I know about, and then I share it with my followers. That is how I make my social media goals specific to my community. And then, if they sign up for a class, or buy a book or a painting, it is all part of the same conversation and I am happy and they are happy. It's an ever evolving process.

This is what I suggest you do. Visit a few more websites, blogs, Vimeo and YouTube posts; read a few Twitter feeds and Facebook posts. See what you like or don't like about them. Is there content out there that you like? Ask yourself why you like it. Is it the tone? Is it the pictures? Consider how the sites you like and the way they are used relate to you and your work. Take it slow and research the ways people interact, observe how you react, and then come up with a strategy. There is plenty of time. Think about what you like about them and what don't you like. Would you return again to a particular site? Would you want to read or download anything? How about buy from them?

Try this next.

## EXERCISE—SIGN UP AND FOLLOW

*If you haven't done this yet, create accounts on a variety of social media networks that you know or think your audience visits. Pick a few artists, a few companies, and a few studios you admire and like. Follow them for a few weeks or even a few months. And take lots of notes:*

*Note which ones you like and why:*

*Note what you are learning about and how:*

*Note where you click and how often:*

*Note if you are interested to buy anything, read anything, do anything? How did they spark that interest? Note any call to take action in their follow-up with you, if any.*

## GO WHERE YOUR AUDIENCE IS

Summarize your findings, type it up, mind map it, draw it out, and read it over. Share it with a friend. See what they like and why. Compare. Ponder. And then create your initial social media strategy to add to your marketing plan. You go where your audience is and let them reach you the way they like to reach out themselves. So, if your audience is on the internet and is mobile savvy, think about translating your content for mobile devices, your website for the iPad. Translate your materials for the current technology. To stay marketable, you must advance your technology know-how. You will need to be where your audience is to sustain and grow.

If this is new to you and you find yourself resistant, simply start slowly and keep testing it out until you get more comfortable. Try one new social media effort every six months. Promise yourself to evaluate it at the end of the year. See what happens. Keep your eyes open and know where you are headed, and, when you are ready, slowly upgrade your materials to be where your community is. Make sense?

---

### EXERCISE—SOCIAL MEDIA ACTION STEPS

*For this exercise, pick two social media channels to use and compare. Then create three action steps to take for each of these two channels.*
*My social media channels are:*
*1.*
*2.*
*My three steps to take for _____ (fill in the name of the channel):*
*Step 1.*
*Step 2.*
*Step 3.*
*My three steps to take for _____ (fill in the name of the channel):*
*Step 1.*
*Step 2.*
*Step 3.*
*Remind yourself: What is your main goal this year? What do you want to accomplish by using these two social media channels? (be specific, quantify it, use numbers)?*
*How will you know if you reached it?*
*Date to start:*
*Date to evaluate:*

---

Sometimes the hardest part of social media is knowing what you are trying to achieve, and what those specific goals are. It helps to break it down into bite-sized pieces again. What is marketing anyway? It is building out your message to the community, letting folks know what you are known for and what you can share that they need. You do that by expanding who knows about you, and what people can do with that info, and welcome them to be a part of your community. Not constantly trying to sell them stuff, but including them into your circle of knowledge.

I love reading about what others think and why it matters to them, and having links to resources to expand my understanding. I want to get inside a process and not be sold to constantly. So, I use social media to share in that way. You can too. What way is your way?

Let's finish this chapter with a visualization on your social branding. Image yourself doing this brilliantly, successfully, and happily. And yes, you can!

## VISUALIZATION—YOUR SOCIAL BRANDING

*Get Ready.*

*Bring your attention to the normal rhythm of the breath by simply focusing on your breath in and your breath out. Relaxing as you breathe. Don't worry if you are doing it right or not. Just let it happen. You are developing a "witness" attitude. Just watch it all happen as it happens, without judgment. Promise yourself: today I will not judge anything that happens. Enjoy this feeling of sitting, breathing, and enjoying the stillness and a quiet mind. Breathe in and out. When you feel calmness and a sense of quiet, allow yourself to be in this stillness. Enjoy it.*

*And following your breath, let yourself relax. Releasing worry, releasing deadlines. Just taking this moment in time for yourself to explore your authentic voice. Take a few deep breaths, let them out, and when you are ready, let your breath return to normal.*

*Visualize yourself in cyberspace, working hard and working smart. You are reaching your ideal audience and marketing your message through social networking. You are so happy and confident. You are building viral word of mouth conversations through all cyber channels. See yourself sitting in a café, happily drinking a chai tea latte or frappachino. You have your laptop or iPad, your internet access is working great and fast, and you are having fun with it.*

*You never thought you could define yourself as a brand, but you can and you have. You are a brand that you are proud of. See yourself communicating who you are and what you stand for through the web. How do you communicate what sets you apart? What differentiates you from other creatives? See your branding in action.*

*Notice how what you are, what you do, what sets you apart impacts all that you put out to the world. See yourself answering the phone with your brand's special flavors, language, and tone. See yourself delivering your products with your brand's special flavors, language, and tone. You have a brand identity. You have a tone and style that is consistent.*

*See your logo in your mind's eye, it is perfect. It is you. Everything communicates the same message: your brand. Your visual identity, tone, and brand voice all work together. See it as professional, creative, effective. What does it look like? Sound like?*

*Confident in your branding, you create greater awareness amongst your community and your target audience about what you do and why it matters. See yourself creating awareness among your target customers, ensuring they remember you. How can you help them, why do they remember you? You are at the top of their minds when the need arises for your products. See yourself building this awareness, happily sharing, being helpful, educating, so when the need arises, they think of you. See this clearly in your mind's eye.*

*You are engaged in activities, your social media activities. What activities will help you engage your current and past clients? What can you give them, what calls to action can you create that give them a reason to stay connected to you? See yourself creative, being creative with your social media, engaging your audience, spreading awareness, and building your brand all at the same time.*

*All part of the same give and share idea. See it working, see it successful. See yourself reaching your social media goals. What actions did you take? How will you keep it going?*

*And then when you are ready, at the count of three you can open your eyes. One, two, and three.*

---

JOURNAL NOTE:

*Take a moment to write down how it felt or anything you saw, heard, or discovered.*

Vision plays a part in everything that you do. Make sure you have added your vision to your social media presence. Your vision, your passion, the heart of why you make the work you make. Remember that people love to get to know the artists they buy work from, or hire for their design needs, or assign photo shoots to. Let people in. This way your marketing is honest and strategic. Simply tie your activities to specific and expected results. You do not change the message; you stay authentic, expressing your value, and simply target it to the market you are trying to reach and persevere until you reach your audience.

So by staying true to your "brand" and testing it out, you have lots of opportunities to change what doesn't work and enhance what does work, and you will reach your business goals.

You can use social media to spread the word about your website and/or blog to market your work, advance your ideas, and build clientele and community. You can use Twitter to build followers by tweeting and interacting with your community, and you can establish relationships with other folks on social media to help spread the word about what you do and care about. You can write a blog post describing your experiences making your work or going to an opening or

performing a street action, and then post links to your status update on Linkedin and Facebook or Tumblr or Wordpress from your phone, all at the same time.

Include images in your posts or videos. Share, engage, and be generous with what you know. Using social media, such as Twitter, Google+, Facebook, Linkedin, etc. will help your message be more effective and grow your business into a sustainable form over time. Relationships, once again, are the key. And now you are building your relationships in cyberspace. And that's a really good way to build alliances and community, which is the heart of every creative career. It is so expandable that you can, at no- or low-cost, spread your content out, branch out, and stay real.

Have patience, have a goal, and be yourself.

# ❧ 16 ❧

## *Take Charge of Your Life*

*"A man is great not because he hasn't failed; a man is great*
*because failure hasn't stopped him."*

—Confucius

Success exercises for the long haul starts from a place of balance. We've spent the last section of this book talking about action; now let's bring it back to center. Action without centered resolve turns quickly into inertia. Being centered and aligned with your sources of support, confidence, and happiness in your process and routine is key to moving forward and staying the course. We do not separate or compartmentalize these parts of our lives if we want to live a successful and fulfilling creative career. So career sustainability starts with self and moves towards the other so we can provide the benefits that others need. It then returns to self to maintain our practice and equilibrium.

### HARMONY AND BALANCE WITHIN WILL ANCHOR YOU

What does starting with self mean? It means when learning to plan your career, live your life, sit and meditate, visualize your presence, and take a moment to stop and breathe—you ponder your choices and your decisions from an inner sense of *you*. This means you develop a sense of self. It is a true spaciousness, a beginning place, no matter how old you are, where you can acknowledge and begin to feel the presence of harmony that is an anchor within you.

An anchor, truly. Harmony can be an anchor; it grows from being aligned with who you are and where you are going. So stop for a moment, take yourself away from all the busyness and craziness of "I want" to "I am." You are a creative person, a visionary.

Said another way, make time to be—to become the observer, the act of observing, and that which is observed—all at the same time.

When we talk about creative careers and being a successful creative in the world, I think it is helpful to return to this idea of aligning with self, with stillness, because to make a creative career happen and sustain your dreams over time, you need to cultivate the right attitude and connection to yourself. And as we near the end of this guide book on being an artist in the world, let's end with exercises and practices to aid this realization of how to make a purposeful and meaningful commitment to being that shining light in the community through meditation, visualization, and self-exploration. How to awaken the leader within you. Your empowerment tools for success, for a career in action, for a life in harmony, starts with making time for silence.

One of my favorite books, *Seven Spiritual Laws of Success* by Deepak Chopra, talks about silence and movement as working together to access the fields of pure potential. I love that idea. For creatives, we access silence every time we make something and enter the zone of creativity. To sustain a career you must make time for that silence to feed your soul. To guide your product development as well as gain a sense of where your marketing initiatives should be aimed. This next meditation visualization will invite you to see where dreams and actions meet in the interior silence within you, from which all things happen in the world.

## VISUALIZATION—SILENCE LEADS TO ABUNDANCE

*Get Ready.*

*Bring your attention to the normal rhythm of the breath by simply focusing on your breath in and your breath out. Relaxing as you breathe. Don't worry if you are doing it right or not. Just let it happen. You are developing a "witness" attitude. Just watch it all happen as it happens, without judgment. Promise yourself: today I will not judge anything that happens. Enjoy this feeling of sitting, breathing, and enjoying the stillness and a quiet mind. Breathe in and out. When you feel calmness and a sense of quiet, allow yourself to be in this stillness. Enjoy it.*

*And following your breath, let yourself relax. Releasing worry, releasing deadlines. Just taking this moment in time for yourself to explore your authentic voice. Take a few deep breaths, let them out, and when you are ready, let your breath return to normal.*

*Now feel your feet flat on the floor, feel the earth beneath your feet. And imagine that there is a strong silk cord running from the very base of your spine, down all the way to the center of the earth. Connecting you, rooting you, to the center of earth. Use your imagination and envision a beautiful colored silk cord that connects you, it runs*

*through your body all the way down to the center of the earth. This is called grounding, and as you imagine this beautifully colored cord connecting you to the earth, you are well grounded.*

*With this grounded feeling and awareness, bring your focus and attention back to your feet. Imagine there is a light at the soles of your feet; a beautiful light that represents the energy of the earth. Imagine it as brown or red or golden, go with whatever color comes to mind. And feel it at the soles of your feet, as if it is rising up from the earth itself, feel it being drawn up through your feet and allow it to spread throughout your entire body.*

*It rises and spreads through your lower legs, up to your thighs, through your stomach and back, into your shoulders and chest, your neck and face, all the way up to the top of your head. Imagine that this energy and light travels up into your body from the earth, filling your body, arms, and legs, head and shoulders all the way to the top of your head.*

*Imagine this colorful energy and light flowing down your arms and flowing out of the palms of your hands and surrounding you with light. We call this area around your body the aura. Imagine that your aura is being filled with this protective energy of the earth. This beautiful, practical, energized, tangible energy to create and produce. Imagine and feel this energy residing within you and pulsing around you, energizing you. Energizing your dreams, your thoughts, your feelings, your sense of calm and repose.*

*Feel this energy feeding your strengths and talents, your ability to make decisions, your willpower to do what you need, to be who you are, to sit in silence and replenish your inner harmony. This energy is deeply felt and resides within you.*

*Then allow your focus to shift. And bring your attention to the top of your head, the very crown of your being. Imagine that a beautiful, shimmering light, the energy of the universe, the cosmic light, is moving through you from above, through the top of your head all the way down through your body.*

*From above, the energy of dreams merges within you with the energy of earth from below. Dreams of "what if?" and actions for "if only" meeting within you, dreaming and doing, together. Allow your imagination to fill your mind and body with these lights, these energies, and enjoy this feeling of silence, this feeling that all is possible, all is created and creative within and without.*

*Your dreams and your actions come together, mix together as one energy. Imagine you have the energy to dream and the energy to act on your dreams. Feel this flowing silence, this energy throughout your body. Feel your power to dream and act on your dreams flowing through out your entire body, earth, and sky. The vast silence of all that flows, flows within you. Your dreams, your ability to act on your dreams all grow and evolve in that inner silence.*

*And when you are ready, at the count of three, you can open your eyes. One, two, and three.*

JOURNAL NOTE:

*Take a moment to write down how it felt or anything you saw, heard, or discovered.*

Being present is a practice. Living your dreams as if they were present is how you implement this practice. You do this through your plans, you create steps to reach your goals, and you create and visualize your life plan happening in the world. We have spent many hours together identifying and grouping your ideas into actionable steps. To keep a successful career dream sustainable in both your heart and in practice takes a realistic and practical approach mixed with a visionary optimism.

## PRACTICAL STEPS MIXED WITH INSPIRING VISIONS

Realistic and visionary at the same time—that is how you stay centered with a sense of direction in your life. You created realistic and inspiring goals in earlier chapters, rooted in your self-knowledge. In truth, that is all you need. It simply comes down to that. Understanding your wiring and adjusting your plans as circumstances dictate, not losing sight of your vision or mission. You can extend what you value into the world through your authentic voice, your selection of a market for your work, and your network of relationships that support the actualization of your personal and creative career goals.

Making the time for silence will reinforce your capacity to stay on track, happily. If you fall off the road into vagueness, or find that your ideas become blurry without purpose, you will end up drifting. In my experience, when you lose your vision, nothing feels right. A successful career where you believe you can and become a shining light at the top of the mountain (so to speak) takes dedication. Sometimes you feel you are not capable of making a commitment on any level to your creativity and vision. Other times you might feel stuck in what could have been and forget what can be and what to do.

Success is like that; it pushes our buttons and, at times, you might find that you drift into fuzzy non-action, sometimes shades of darkness and melancholy overtake you. That is natural. And when that happens, seek out the silence, and the outer support you need, and ask for help to move through those times. Surround yourself with passionate and inspiring peers to help you move forward. If you tend to surround yourself with friends who support confusion and lack of action, you will not get past those times. We can undermine ourselves and let others diminish our dreams without even noticing that we are doing that, until it happens. To ensure your long-term survival as a creative in the world, as a working artist in any medium, your direction and validation must start from within, but it must be reinforced from your support system.

Direction. Motivation. Momentum. We have spent this time together exploring these concepts and drawing up plans to move our lives and careers forward. Where are you going? What are you becoming? What are the hopes and dreams that give meaning to your work and your life? What is "it" that beckons you, that calls your name while you sleep and while you ride the subway to your day job? There is an awareness in every creative that bubbles up and fills the gaps in your waking life. It is a quality of awareness that makes your creative career a compelling need, from dream to reality.

It is time to choose, consciously and purposefully with intention and attention, to become successful. To embody success. You can do this. Because you defined it for yourself, no one else can judge you as lesser or not having made it. It is up to you. This means you must adopt a strategy for your life and work that honors your visions and your direction.

That is a direction that is based on vision and directs you authentically. During the course of your career, moving with the ups and downs and the changes in life, you will revisit what matters to you many times. And for as long as what you value still feels relevant to you, to where you are and where you are going, you will find the flow to work and change to implement strategies. You will create new support systems and keep yourself alive, creative, and self-reliant with each metamorphosis. That is the natural order of change.

I suggest that you surround yourself with community, with peers who honor your intentions and support your attention on the meaning of your work and your expression into products and services. Your community reflects your goals and helps you feel you can do anything. Then you are living the four basic elements of being a creative in the world; authenticity, value, market, and perseverance. And you are not doing it alone.

It is up to you to uncover the alternatives that will keep you flowing and put energy into making it real, surrounding yourself with like-minded souls. Those who honestly share your drive, your vision, your values. They help us respond to the ups and downs of our career path with compassion for self, positive energy, and creativity.

You can become dominated by your need to be seen in the world and totally forget what your goals are. To be guided by the four principles with a support system will aid your long-term survival as a creative and as an artist. We need to give back and we need to receive. Proving yourself to yourself is a route to self-worth, and good self-worth feeds your success. Driven to be, driven to understand, driven to calm down and create and share it. You could do this through many outward accomplishments via doing. You could do this through entering the silence and the zone of creative potential through meditation. You can do both and combine both. Doing, being, nurturing, creating, living out in the world, succeeding.

What should you remember? Life takes time. When I was studying to be certified as a creative career coach at NYU School of Professional Studies, I was fortunate to have Five O'Clock Club coach and author Roy Cohen for a teacher, as well as Sharon Good from Good Life Coaching. Both were awesome mentors. I tailored these steps from what they shared and suggest you consider the following:

SUSTAINABLE CREATIVE PRACTICES FOR SUCCESS

Step 1: Understand yourself: your values, interests, skills, talents. The better you understand yourself and the more honest you are about it, the better you will be able to assess the opportunities that will come your way and those you need to create for your work.

Step 2. Figure out what you really want. What on this earth would be the best way for you to serve and be served? What should your future be like?

Step 3: Figure out how to get there. Create a plan, set goals, network, and research, reassess your goals. Build community, build relationships.

Step 4: Create a visualization and meditation practice to sustain you, guide you, inform you. Figure out what within yourself might stand in your way. You may have a conflict of values; or lack commitment to a specific path. If you can figure out what may be stopping you and resolve those issues, nothing can stand in your way.

Monitor how you're thinking and behaving, and try to stop negative thoughts and behaviors in their tracks. Ask yourself: Why am I thinking or behaving this way? What's the positive alternative? What might make it easier for me, now and in the future, to think or act positively in this type of situation?

A competitive world has two possibilities for you. You can lose your way or, if you want to stay on the path of heart, you can adapt and you can change. Don't let others define you. Set your own standards, your own measures of fulfillment and success. Know yourself and be yourself. Think for yourself. Develop a philosophy of your life as you want it to be. Be selective about how you spend your time and with whom. Make your own choices and decide what you want, then commit to it. It is never too early or too late to be who you are.

Life takes time, seeds blossom in their own right season. Breathe. Make time to laugh, look at beauty, run energy through your body, and relax your mind. There is nothing you cannot do.

In the next meditation visualization, we will explore seeing your artistic business as meaningful, purposeful, and fulfilling the law of *dharma*. Dharma is a Sanskrit word for purpose. As you continue to sustain your art practice and life

balance, look at what you share as part of your purpose in work and in life. Then develop and uncover your unique talents so you can begin to share this purpose, share your ideas with the world. Your creativity and your art career, your work in the world, no matter what form it takes, can be a service to the world, to your community. And what better way to view your work.

## VISUALIZATION—MY GIFT TO THE WORLD

*Get Ready.*

*Bring your attention to the normal rhythm of the breath by simply focusing on your breath in and your breath out. Relaxing as you breathe. Don't worry if you are doing it right or not. Just let it happen. You are developing a "witness" attitude. Just watch it all happen as it happens, without judgment. Promise yourself: today I will not judge anything that happens. Enjoy this feeling of sitting, breathing, and enjoying the stillness and a quiet mind. Breathe in and out. When you feel calmness and a sense of quiet, allow yourself to be in this stillness. Enjoy it.*

*And following your breath, let yourself relax. Releasing worry, releasing deadlines. Just taking this moment in time for yourself to explore your authentic voice. Take a few deep breaths, let them out, and when you are ready, let your breath return to normal.*

*When you are ready, close your eyes and breathe. Take a few deep breaths in and out. And just begin to let go of any tensions, any worries and judgments.*

*And let your breath guide you. When you are ready, repeat silently to yourself, "I intend to make full use of my creative talents. I am going to discover my unique talents and role in the world." In your mind's eye, allow your imagination to create a room that is special and unique for you, this could be your studio, your den, or any room that is special to you, whether it already exists in the world or not. This is going to be your treasure room. Imagine yourself walking down or up a steep staircase to reach this room. See yourself approaching the door, opening the door, and entering this beautiful, spacious treasure room.*

*This room belongs to your higher self. And in this room is a treasure chest. Allow yourself to find the treasure chest in this room and open it. Inside, you discover your unique talents laid out before you. And, like Alice down the rabbit hole, you see yourself entering into this chest, like a portal into timeless awareness and flow.*

*Allow yourself to enter the bliss of the treasure of your creative gifts. An imaginative, creative journey unfolds in front of you. Allow yourself to feel the joy, the pure enjoyment that occurs when you go into timeless awareness.*

*Ask yourself, how am I best suited to use my creative gifts to serve humanity? See yourself answering this question, and putting it into practice. What are you doing? See*

*yourself using your unique creative talents and serving the needs of your fellow human beings. What is it that you do?*

*See yourself matching the needs of your fellow humans with your creative desire to make work, to help and serve others. What is it that you do? Ask yourself, if money was of no concern and you had all the time and money in the world, what would you do? Would your artwork change? Would your creative vision manifest differently?*

*If you would still be doing what you are currently doing, feeling passion for your subject, product or cause, message and mode of expression—how would it deepen?*

*How can your work grow? Allow yourself to see an image of your discovery, your unique vision and unique talents in service to humanity. Serving humanity with your unique vision and talents. See yourself doing this now.*

*And as you do so, see yourself generating all the abundance and wealth that you want and need. See yourself with your creative expression matching the needs of your fellow human beings. This brings you wealth and energy, flowing from the un-manifested realms of potential into manifestation, into being.*

*From the realms of spirit to the realms of everyday form in life. Allow your imagination to flow and experience yourself as abundant, expressive, and of service.*

*See this as your natural, everyday state. Knowing true creative expressive joy. And the ecstasy and exultation of expressing yourself and helping the world.*

*Allow the true meanings of success to unfold for you, in front of your very eyes. And see it as real, as happening now. See your purpose in life, your creative purpose and mission joining with your unique talents and feel the joy of that centered grounded purpose.*

*Your vision guides you; your sense of accomplishment and service grounds you. And together you find your success. And breathe deeply. Letting your breath return to normal. And when you are ready, at the count of three, you may open your eyes. One, two, and three.*

---

JOURNAL NOTE:

*Take a moment to write down how it felt or anything you saw, heard, or discovered.*

Ensuring your long-term survival as an artist and creating a work/life balance that means something to you comes down to maintaining access to your true nature. You do that through practicing silence and creativity in action. Both. You create possibilities in the world through activity, while at the same time carrying the stillness of your eternal connection to your process.

It is an eloquent and exquisite combination of infinite access and individual expression. Your potential and peace of mind is within you. Your actions and expressions are around you. They are linked and grounded by understanding your foundation, your core story, allied by knowing and using your strengths,

knowledge, talents, and skills and following a plan to reach out and share. Your community will help you follow through. That's it!

Make your reality reflect your visions and actions. It is within your grasp. Your great work and all your creative works take self-discipline, community, and steadfastness. Your sustainable career and creative process is forever in motion, forever boundless and still. You are a vision-maker. That is a beautiful thing. Nothing can stop you. And if you need help, let me know.

# *About the Author*

**Rhonda Schaller** has been passionate about the use of meditation and visualization in art making and in life for over thirty years. She is the director of Schaller + Jaquish Art Projects; founder of Create Meditate; director of career and professional development at Pratt Institute; and faculty for the Masters of Professional Studies in Digital Photography at School of Visual Arts (SVA); Division of Continuing Education (SVA); and NYU School of Professional Studies. She cofounded the Ceres Gallery, NYC in 1984 and was a board member and faculty of the New York Feminist Art Institute until its closing. A graduate of Queens College (BA/1980), her works are in the permanent collections of the Memorial Art Gallery University of Rochester, C. Everett Coop Institute, Art of Healing Gallery Dartmouth University Medical School, the Exit Art/Reactions collection Library of Congress, and Franklin Furnace/Book Art archives Museum of Modern Art. She lives and works in Hoboken, New Jersey.

HOW TO CONTACT RHONDA SCHALLER:

*Create Your Art Career*
http://createyourartcareer.org

The author would love to hear your feedback. To meet your fellow artists and create a community for your journey, please visit our website and upload your stories, artwork, and comments at Create your Art Career: http://createyourartcareer.org.

Rhonda Schaller is available for lectures and speaking engagements.

Visit her other websites:
Websites: www.rhondaschallerchelsea.com and www.rhondaschaller.com
Twitter: http://twitter.com/createmeditate
LinkedIn: http://www.linkedin.com/in/rhondaschaller
Blog: http://createmeditate.wordpress.com

We wish you well on your journey. Stay in touch. We are a community. Shine your light and be a beacon for others.

All the best,

Rhonda

# *Notes*

CHAPTER 1

[1] "tool." Merriam–Webster. http://www.merriam–webster.com/dictionary/tool.

[2] Richard Webster. *Creative Visualization for Beginners* (Minneapolis, MN: Llewellyn Publications, 2005).

[3] "Need to Relax? Take a Break for Meditation." Mayo Clinic. http://www.mayoclinic.com/health/meditation/MM00623.

[4] Stephen R. Covey. *The 7 Habits of Highly Effective People* (New York, NY: Simon and Schuster, 1989).

[5] "ThinkBuzan.com." http://www.thinkbuzan.com/us.

[6] "About Us." http://mindnode.com/imprint.html#about.

[7] Julia Cameron. *The Artist's Way: A Spiritual Path to Higher Creativity* (New York, NY: Penguin Group, 1992).

CHAPTER 2

[8] http://casaa.unm.edu/inst/Personal%20Values%20Card%20Sort.pdf.

CHAPTER 3

[9] "success." Merriam–Webster. http://www.merriam–webster.com/dictionary/success.

[10] "Success." Wikipedia. http://en.wikipedia.org/wiki/Success.

## CHAPTER 4

[11] Kate Wendleton. *Targeting a Great Career* (Independence, KY: Thomson Delmar Learning, 2006).

## CHAPTER 5

[12] Sharon Good. "Good Life Coaching." http://www.goodlifecoaching.com.

[13] Michael Michalko. *Cracking Creativity* (New York, NY: Ten Speed Press, 2001).

## CHAPTER 6

[14] Michelle Ward. "When I Grow Up." http://www.whenigrowupcoach.com.

## CHAPTER 7

[15] Joanne Wickenburg. *In Search of a Fulfilling Career* (Tempe, AZ: American Federation of Astrologers, 1992).

[16] Ibid.

## CHAPTER 8

[17] "clarify." Merriam-Webster. http://www.merriam-webster.com/dictionary/clarify.

## CHAPTER 9

[18] Jeff Sloan and Rich Sloan. *StartupNation* (New York, NY: Doubleday, 2005).

## CHAPTER 10

[19] John Perkins, Al Ridenhour, and Matt Kovsky. *Attack Proof* (Champaign, IL: Human Kinetics, 2010).

## CHAPTER 11

[20] Simon Sinek. http://www.startwithwhy.com.

[21] Gigi Rosenberg. *The Artist's Guide to Grant Writing* (New York, NY: Watson-Guptil, 2010).

[22] Simon Sinek. "Start With Why." http://www.startwithwhy.com.

## CHAPTER 13

[23] "Derek Sivers." http://sivers.org/sharing.

24 Tricia McKellar. *The Wonder Thinking Business Plan-o-Rama* (2011). http://www. wonderthinking.com/wp-content/uploads/2011/01/The-Wonder-Thinking-Business-Plan-o-Rama.pdf.

25 *The Photo Business Plan Book*. http://www.photoshelter.com/pdf.

26 Joanne Wickenburg. *In Search of a Fulfilling Career*. (Tempe, AZ: American Federation of Astrologers, 1992).

27 Steven Forrest. *The Book of Pluto* (San Diego, CA: ACS Publications, 1994).

CHAPTER 14

28 Derek Sivers. *Marketing Your Music*. http://sivers.org/pdf.

29 Jeff Sloan and Rich Sloan. *StartupNation* (New York, NY: Doubleday, 2005).

30 *The Photo Business Plan Book*. http://www.photoshelter.com.

# Suggested Resources and Bibliography

Benun, Ilise, and Peleg Top. *The Designer's Guide to Marketing and Pricing.* Cincinnati, OH: HOW Books, 2008.

Cameron, Julia. *The Artist's Way: A Spiritual Path to Higher Creativity.* New York, NY: Penguin Group, 1992.

Chopra, Deepak. *The Seven Spiritual Laws of Success.* San Rafael, CA: Amber-Allen Publishing, 1994.

Covey, Stephen R. *The 7 Habits of Highly Effective People.* New York, NY: Simon and Schuster, 1989.

Csikszentmihalyi, Mihaly. *The Evolving Self.* New York, NY: Harper Collins Publishers, 1993.

Csikszentmihalyi, Mihaly. *Flow: The Psychology of Optimal Experience.* New York, NY: Harper Perennial Publisher, 1990.

Feinstein, Dr. David, and Dr. Stanley Krippner. *Personal Mythology: The Psychology of Your Evolving Self.* Los Angeles, CA: J.P. Tarcher, Inc., 1988.

Forrest, Steven. *The Book of Pluto.* San Diego, CA: ACS Publications, 1994.

Forrest, Steven. *The Inner Sky: How to Make Wiser Choices for a More Fulfilling Life.* San Diego, CA: ACS Publications, 1989.

McKellar, Tricia. *The Wonder Thinking Business Plan-o-Rama.* 2011. http://www.wonderthinking.com/wp-content/uploads/2011/01/The-Wonder-Thinking-Business-Plan-o-Rama.pdf.

Michalko, Michael. *Cracking Creativity.* New York, NY: Ten Speed Press, 2001.

Perkins, John, Al Ridenhour, and Matt Kovsky. *Attack Proof.* Champaign, IL: Human Kinetics, 2010.

Roa, Srikumar S. *Are You Ready to Succeed?* New York, NY: Hyperion, 2006.

Rinpoche, Tulku Thondup. *The Healing Power of Mind.* Boston, MA: Shambhala Publications, 1996.

Rosenberg, Gigi. *The Artist's Guide to Grant Writing.* New York, NY: Watson-Guptil, 2010.

Sivers, Derek. *Marketing Your Music.* http://sivers.org.

Sloan, Jeff, and Rich Sloan. *StartupNation.* New York, NY: Doubleday, 2005.

Webster, Richard. *Creative Visualization for Beginners: Achieve Your Goals & Make Your Dreams Come True.* Woodbury, MN: Llewellyn Publications, 2005.

Wendleton, Kate. *Targeting a Great Career.* Independence, KY: Thomson Delmar Learning, 2006.

Wickenburg, Joanne. *In Search of a Fulfilling Career.* Tempe, AZ: American Federation of Astrologers, 1992.

CAREER AND LIFE PLANNING ORGANIZATIONS, GOOD WEBSITES, AND BLOGS

Blacksburg Belle blog. www.blacksburgbelle.com.

Etsy Success blog. www.etsy.com/blog.

Five O'Clock Club. www.fiveoclockclub.com.

Good Life Coaching. www.goodlifecoaching.com.

Ladies Who Launch. www.ladieswholaunch.com.

Marketing-Mentor. www.marketing-mentor.com.

Photoshelter. www.photoshelter.com.

Sinek, Simon. www.startwithwhy.com.

Sivers, Derek. www.sivers.org.

StartupNation. www.startupnation.com.

When I Grow Up Coach. www.whenigrowupcoach.com.

Wonder Thinking. www.wonderthinking.com.

## VIDEOS

"You Think, Therefore You Are." YouTube.
www.youtube.com/watch?v=DL_07TQvhsQ.

"Need to relax? Take a break for meditation." Mayo Clinic.
www.mayoclinic.com/health/meditation/MM00623.

# Index

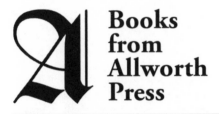

# Books from Allworth Press

Allworth Press is an imprint of Skyhorse Publishing, Inc. Selected titles are listed below.

**Starting Your Career as an Artist**
*by Angie Wojak and Stacy Miller* (6 x 9, 288 pages, paperback, $19.95)

**The Profitable Artist: A Handbook for All Artists in the Performing, Literary, and Visual Arts**
*by Artspire* (6 x 9, 256 pages, paperback, $24.95)

**New Markets for Artists: How to Sell, Fund Projects, and Exhibit Using Social Media, DIY Pop-Ups, eBay, Kickstarter, and Much More**
*by Brainard Carey* (6 x 9, 256 pages, paperback, $24.95)

**Making It in the Art World**
*by Brainard Carey* (6 x 9, 256 pages, paperback, $24.95)

**The Business of Being an Artist, Fourth Edition**
*by Daniel*

**Art Wit**
*by Wend*

**New M** ocial
**Media,**
*by Brai*

**Sellin**
*by Dai*

**The A**
*by Lyn*

**Legal**
*by Tad*

**Busin**
*by Tad*

**The A**
*by Tad*

**Fine A** Edition
*by Sus*

**Guide**
*by Elle*

**How**
*by Ed*

**The A**
*by Mo*

**The Q**
*by Peg*

To see our complete catalog or to order online, please visit *www.allworth.com.*